THE METROPOLITAN MUSEUM OF ART NEW YORK (repeated watermark)

Br. Mel,
Thank you for all of your wisdom & for all of your inspiration. The greatest complement I can pay you is to let your know that your have been one of my greatest teachers!! I eagerly await your return to St. Mary's.
Edward Yurevich

God Speed!
Have to bed wire of begin so long with such fantastic success
Best of luck
Thomas Jordan '67

Enjoy
for [...]

It's been great — and we know you are not really leaving — All the best —
Janet Edelmann

It has been a real honor to work with you. You will be missed. Enjoy!
David E. Perry

All best wishes in your new "life"
Martha Greser

Bro Mel
Best Wishes
Ed Bowman

Mel —
You're a wonderful religious and friend —
Paul Dorately

Thanks for the leadership, memories & friendship.
E. Martin Luck

Warm wishes always,
Brother Mel —
Mary and Norman

Anthony J. Garcia
Barbara E. Garcia
Class of Fifty —
Best wishes and thanks you for all you've done for the College

You are enlightenment for all of us and for the very best to your retirement!
— Libby Hurani Silveshi

Best wishes on "Retirement"
Dick & Dolores Logan

May the future be as wonderful as the past.
Marcia Spuffy

You are the greatest Brother Mel!!
Tony Dohieus

The Twenty Eight years have flown. Under your inspired leadership, St. Mary's College has sky-rocketed. As I said, you are the man of the century's
Carmen Turro

Greetings, Brother Mel, from a kindred spirit and long-time colleague, with great thanks,
Sister Samuel Conlan

Best wishes. Thank you for your support of the Nursing program. I look forward to working with you in the future also!
Carol Kraton

Congratulations on your wonderful Contribution to St Mary's College! Our children acquired not only terrific experiences & excellent education... but also a very extended St Mary's family as well!
Best E.H. Agia

Br. MEL:
BEST WISHES to you.
I'll REMEMBER MY College years 1980-84 very fondly forever. You WERE A HUGE PART OF THAT.
GOD BLESS You
Joe Balestrieri
1984

Thanks for all you have done for St. Giles' Episcopal Church. What a great model of ecumenical relationship for the next millenium – Congratulations on your many great achievements and fond best wishes. The rector, staff and people of St. Giles –

Will miss you Bro Mel
Good Luck
Tom Fikin

Dear Mel –
Ad Multos Annos!
Thank You!
Ray Bento

THE METROPOLITAN MUSEUM OF ART

Europe in the Age of
Enlightenment and Revolution

God bless you
Robert Rodriguez

To brother
Mel Rodriguez
Gloria Rodriguez
4/25/97

Have a Good Life
+ God Bless you
Steve & Mary Lee
Miranda

Brother Mel,
Thanks for a wonderful
four years! Enjoy your
retirement.
Andrew & Cynthia
Kidwell
class '85 & '84

Have a Good Life
Gilbert F. Alegre

Bro. Mel,
You'll be missed
but good luck anyway
God bless you
Norma D. Alegre
4-25-97
mom of Norman
alegre

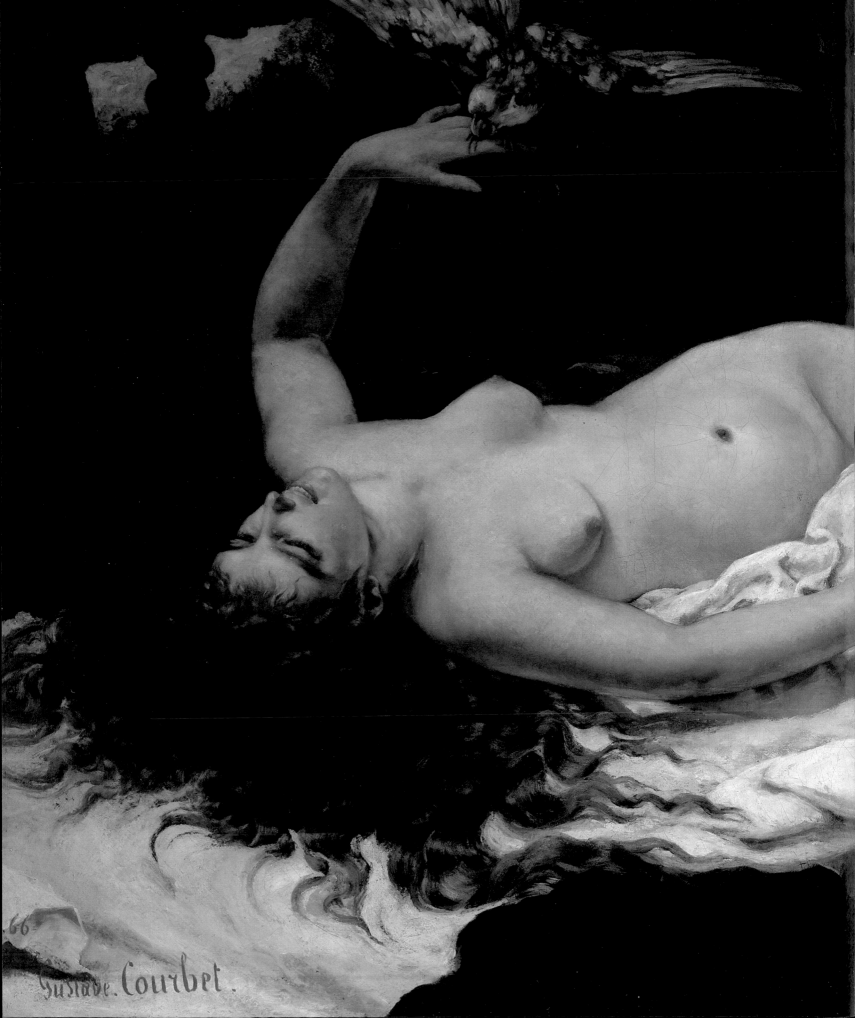

66

Gustave Courbet

MUSEUM OF ART

Europe in the Age of Enlightenment and Revolution

INTRODUCTION

BY

J. Patrice Marandel

**CURATOR OF EUROPEAN PAINTINGS
THE DETROIT INSITIUE OF ARTS**

THE METROPOLITAN MUSEUM OF ART, NEW YORK

PUBLISHED BY

THE METROPOLITAN MUSEUM OF ART
New York

PUBLISHER

Bradford D. Kelleher

EDITOR IN CHIEF

John P. O'Neill

EXECUTIVE EDITOR

Mark D. Greenberg

EDITORIAL STAFF

Sarah C. McPhee Lucy A. O'Brien

Josephine Novak Robert McD. Parker

Michael A. Wolohojian

DESIGNER

Mary Ann Joulwan

———

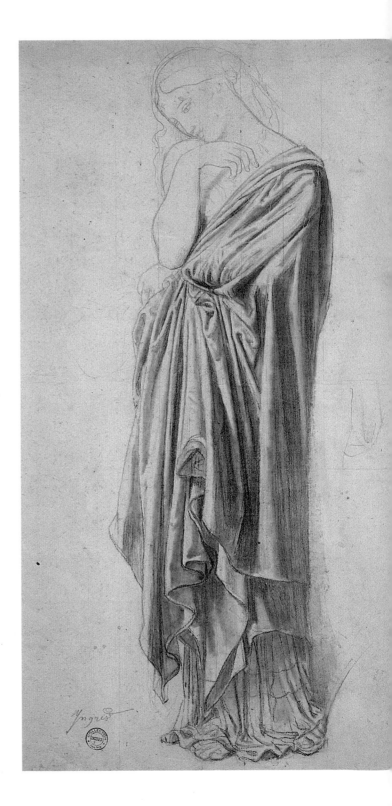

Commentaries written by Museum curators: Costume Institute: Jean L. Druesedow, associate curator in charge (Plate 19); Department of Drawings: Helen Mules, assistant curator (Plates 12, 46, 47, 50, 52, 83, 93, 104); Lawrence Turčić, research associate (Plates 4, 15, 22); Department of European Paintings: Gary Tinterow, associate curator, Susan Alyson Stein, research associate, Anne M.P. Norton, research intern (All Paintings); Department of European Sculpture and Decorative Arts: James D. Draper, curator (Plates 13, 31, 32, 45, 67, 69, 86, 87, 91, 122); Johanna Hecht, associate curator (Plates 10, 26–28, 34, 89); Jessie McNab, associate curator (Plates 25, 58, 78–80); Clare Vincent, associate curator (Plates 21, 96, 97, 109, 111); Daniëlle O. Kisluk-Grosheide, curatorial assistant (Plates 8, 29, 30, 33, 39, 57, 59, 60); Maureen A. Cassidy-Geiger, research assistant (Plates 17, 20, 24, 44, 119); Textile Study Room: Alice Zrebiec, associate curator (Plates 9, 40, 43, 61, 88); Department of Prints and Photographs: Suzanne Boorsch, associate curator (Plates 6, 7, 16, 53, 68, 74, 75, 77, 92, 108); Maria Morris Hambourg, associate curator (Plates 117, 121).

Photography commissioned from Schecter Lee, assisted by Lesley Heathcote: Plates 4, 8–10, 12, 13, 18, 20–22, 26–28, 31, 34–36, 40, 42, 43, 45, 48, 51, 56, 58, 63, 66, 69, 70, 73–76, 78, 80, 83, 86, 88–91, 93, 94, 96, 98, 100, 104, 107, 110, 114, 119, 122. All other photographs by The Photograph Studio, The Metropolitan Museum of Art.

Maps and time chart designed by Wilhelmina Reyinga-Amrhein.

TITLE PAGE

Woman with a Parrot, 1865–66
Gustave Courbet
French, 1819–77
Oil on canvas; 51 x 77 in.
(129.5 x 195.6 cm.)
Bequest of Mrs. H.O. Havemeyer,
1929, H.O. Havemeyer Collection
(29.100.57)

THIS PAGE

Study of Classical Drapery (Stratonice)
Jean August Dominique Ingres
French, 1780–1867
Black chalk, estompe, part. squared
in black chalk, on beige paper;
19⅜ x 12⅝ in. (49.2 x 32.1 cm.)
Gustavus A. Pfeiffer Fund, 1963
(63.66)

Library of Congress Cataloging-in-Publication Data

Metropolitan Museum of Art (New York, N.Y.)
 Europe in the Age of Enlightenment and Revolution.

 Includes index.
 1. Art, European—Catalogs. 2. Art, Modern—17th-18th centuries—Europe—Catalogs. 3. Art, Modern—19th century—Europe—Catalogs. 4. Art—New York (N.Y.)—Catalogs. 5. Metropolitan Museum of Art (New York, N.Y.)—Catalogs. I. Marandel, J. Patrice. II. Title.
N6756.M47 1987 709'.4'07401471 87-5547
ISBN 0-87099-451-4 ISBN 0-87099-452-2 (pbk.)

Printed and bound by Dai Nippon Printing Co., Ltd., Tokyo, Japan. Composition by U.S. Lithograph, typographers, New York.

This series was conceived and originated jointly by The Metropolitan Museum of Art and Fukutake Publishing Co., Ltd. DNP (America) assisted in coordinating this project.

Copyright © 1987 by The Metropolitan Museum of Art

This volume, devoted to the arts of Europe during the period roughly 1750 to 1850, is the seventh publication in a series of twelve volumes that, collectively, represent the scope of the Metropolitan Museum's holdings while selectively presenting the very finest objects from each of its curatorial departments.

This ambitious publication program was conceived as a way of presenting the collections of The Metropolitan Museum of Art to the widest possible audience. More detailed than a museum guide, broader in scope than the Museum's scholarly publications, this series presents paintings, drawings, prints, and photographs; sculpture, furniture, and the decorative arts; costumes, arms, and armor— all integrated in such a way as to offer a unified and coherent view of the periods and cultures represented by the Museum's collections. The objects that have been selected for inclusion in the series constitute a small portion of the Metropolitan's holdings, but they admirably represent the range and excellence of the various curatorial departments. The texts relate each of the objects to the cultural milieu and period from which it derives and incorporates the fruits of recent scholarship. The accompanying photographs, in many instances specially commissioned for this series, offer a splendid and detailed tour of the Museum.

We are particularly grateful to the late Mr. Tetsuhiko Fukutake, who, while president of Fukutake Publishing Company, Ltd., Japan, encouraged and supported this project. His dedication to the publication of this series has contributed greatly to its success.

The collections of the Metropolitan Museum are particularly rich in European art of the late eighteenth and early nineteenth century, and these collections have grown both through gifts of many generous donors and judicious purchases made possible by the Museum's acquisition funds.

Among the many donors of paintings, we must mention especially Jules Bache, Jessie Woolworth Donahue, Mrs. H. O. Havemeyer, Robert Lehman, and Catharine Lorillard Wolfe. The collections of European sculpture and decorative arts owe special gratitude to Samuel P. Avery, J. Pierpont Morgan, Mrs. Herbert N. Straus, and Mr. and Mrs. Charles Wrightsman. Important prints and drawings of the period have been donated to the Museum by Mrs. Robert W. Goelet and Robert Lehman.

Purchases in all these areas have been made possible through funds established by Gwynne M. Andrews, Harris Brisbane Dick, Isaac D. Fletcher, Henry G. Marquand, Joseph Pulitzer, Alfred N. Punnett, and Jacob S. Rogers.

In preparing this volume, the editors drew on the expertise of curators in several departments. We are especially grateful to Gary Tinterow, Susan Alyson Stein, and Anne M. P. Norton, in the Department of European Paintings, and James D. Draper in the Department of European Sculpture and Decorative Arts, for their invaluable assistance in organizing the book, selecting objects from their departments, and in writing many of the commentaries that appear in the book. Maureen A. Cassidy-Geiger, Johanna Hecht, Daniëlle O. Kisluk-Grosheide, Jessie McNab, Clare Vincent, and Alice Zrebiec, in the Department of European Sculpture and Decorative Arts, wrote commentaries on objects within their special fields of interest. Helen B. Mules and Lawrence Turčić, in the Department of Drawings, and Suzanne Boorsch and Maria Morris Hambourg, in the Department of Prints and Photographs, were responsible for commentaries on works from their departments. We are also grateful to Mr. J. Patrice Marandel, curator of European Paintings at the Detroit Institute of Arts, for preparing the introduction to this volume.

Philippe de Montebello
Director

EUROPE IN THE AGE OF

ENLIGHTENMENT

AND

REVOLUTION

By 1750 it had become customary for young English noblemen to make the "Grand Tour," a lengthy journey in quest of classical beauty and exotic sensation that took them across the Continent to Rome and Naples. Englishmen, although by far the largest contingent to make this pilgrimage, were not the only ones to do so. The French and the Germans flocked to Rome as did Scandinavians, Slavs, and—toward the end of the century—even Americans. A visit to Rome was not a new phenomenon in Western culture. At least since the Renaissance its monuments had represented an ideal toward which every artist strove.

For the French, whose culture was organized according to stricter rules than that of any other European country, a sojourn in Rome was virtually mandatory in the education of their artists. Indeed, in 1666 a French Academy had been established there in order to allow the promising young talents who had won the Prix de Rome in Paris to complete their training. The taxing program of studies at the Academy included above all drawing after the antique and copying after those artists who, in more recent times, had achieved a level of fame equal to that of the Greeks and Romans.

By the late eighteenth century, however, foreign visitors to Rome included not only artists but growing numbers of wealthy and well-educated tourists. Their expectations, the demands they made on both artists and the art market, and the ideas they acquired and brought back home contributed to a fundamental change in the culture of Europe. The changes in art, philosophy, music, and sensibility that we describe as Neoclassicism are to a large extent late eighteenth-century phenomena that could only have taken root and blossomed on Roman soil.

It was indeed in Rome that the fundamentals of the new aesthetic creed were formulated and first put into practice by a small group of painters that included some key ones of foreign origin. The theoretician of the new school was a German, the Saxon Johann Joachim Winckelmann, who worked in Rome as the librarian to Cardinal Albani, himself one of the most important collectors of antiquities at the time. Winckelmann's theories were based upon his studies of antiquity, and his mission was to regenerate the arts—which in his view had fallen into decadence—by the imitation of the highest achievements of the ancients. This simple but ambitious program was enormously successful: Winckelmann's theoretical works spread throughout Europe, and painters in his Roman entourage, inspired by his writings, in turn encouraged Winckelmann.

The "noble simplicity" and "calm grandeur," by which Winckelmann meant chiefly a harmony of proportion in the drawing of the figure and a well-balanced composition, are immediately evident in the works of Anton Rafael Mengs, whose international career and lengthy stays in Rome put him in contact with the German theoretician whose circle he joined. The most extreme example of the influence Winckelmann exerted upon Mengs is the fresco of *Parnassus* he executed in 1761 for the villa of Cardinal Albani. The cold, hieratic figures of this composition, arranged in a frieze (as if to deny the deep illusionism of Baroque ceiling painting) were much admired in its day. For many tourists in Rome it was the best expression of the new style and as such counted among the most visited modern monuments of the city. The fresco presents the painter's style at its chilliest, most forbidding, and most heroic. Yet Mengs was also capable of more intimate moments. His portrait of Winckelmann (Plate 5) in particular reveals his talent in this genre, and it eschews the facile brilliance of Rococo portraiture. For the defender of the "noble simplicity" of antique art, Mengs chose a deliberately stark presentation reminiscent of the austerity of some Republican Roman portraits, thereby introducing a note of troubling realism.

If a visit to the Villa Albani to admire Mengs's ceiling was de rigeur for travelers in Rome, they usually preferred having their own portraits painted by Pompeo Batoni. It is said that more than one hundred fifty Englishmen alone sat for him. His art, varied and attractive, was indeed immediately likable. Less radical than Mengs in his aesthetic choices, he nevertheless conferred upon his models an air of informal modernity by representing them in seminatural settings, often featuring Roman sculptures or archaeological finds the sitter had admired or even acquired. No less appreci-

ated by his patrons were Batoni's mythological—or even religious—compositions (see Plate 3). For many, Batoni's compositions embodied the very essence of the Italian school: a sense of drawing inherited from Raphael, volumes bespeaking a modest tribute to ancient sculpture, and a refined yet strong palette close to that of the Bolognese school. More than simply expounding a new aesthetic, Batoni was able to sense the taste of the day and thereby to satisfy the needs of a large and fashionable clientele. The fact that his paintings, charming as we may still find them, lacked the seriousness characteristic of great art and that their modernity was due more to the use of fashionable props than to a deep understanding of the art of the past, were already sensed by one of Batoni's English contemporaries, Sir Joshua Reynolds, who shortly after Batoni's death predicted—in his fourteenth discourse—the decline of his popularity.

The craze for Batoni's portraits resulted largely from his mastery of the discreet antique reference. Joyful and elegant rather than forbidding and austere, they became the perfect mirror of a society mad for the antique in all of its guises. The fortuitous discovery in 1711 of the buried city of Herculaneum, soon followed by that of Pompeii, gave the European intelligentsia access not only to works considered to be superior to modern works, but also to a whole civilization known until then only through its descriptions in literature. These once-buried cities, though jealously guarded by the king of Naples and only grudgingly shown to visitors, were the subject of quasiscientific publications. *Le antichità di Ercolano esposte* was published between 1752 and 1792, while Winckelmann in his *Sendschreiben von den herculanischen Entdeckungen* (1762) criticized the rudimentary excavation techniques still practiced in Naples.

Collectors, such as Sir William Hamilton, the British envoy to Naples, vied with the king in commissioning publications of their own large collections of antique vases. His *Antiquités étrusques, grecques et romaines,* published in 1766–67, ranks among the most lavish books produced in the eighteenth century. These folios, along with many others, provided a wealth of images that enjoyed an astonishing popularity at the end of the eighteenth and beginning of the nineteenth century. Perhaps even more importantly, they also helped to establish modern archaeological discourse. Indeed, there was not a single aspect of the visual arts that did not respond to the elements of this new grammar.

The eighteenth century was a particularly rich period for building in Rome. Such familiar parts of the Roman scene as the Fontana di Trevi or the steps on the Piazza di Spagna were great novelties at the time. To marvel at these, as many did, was also to recognize that the gap between the present and the past had finally been bridged. Painters celebrated these new monuments almost as fervently as they did the architecture of the past. Landscape, or view, paintings counted among the most attractive and collected souvenirs of the foreign traveler. The Venetians were then masters at publicizing the image of their city. Many of their painters, above all Canaletto, had built their reputation on exacting, stagelike renditions of familiar views of San Marco or the Rialto bridge.

Rome had had a tradition of view painters, of course, but the focus of their attention changed in the eighteenth century. In order to suggest the quality of the new sensibility, it may be revealing to contrast to the classically sedate earlier *vedute* of Rome and the Venetian panoramas of Canaletto to the new kind of view paintings encountered in Rome and Naples in the eighteenth century. The best exponent of this genre was Giovanni Paolo Pannini. He painted both modern and antique subjects, occasionally pairing his compositions (see Plates 1, 2) to emphasize the continuity of ancient and modern taste. In his more traditional views, Pannini eschews the optical effects of Canaletto but delights in the precise depiction of monuments whether antique or modern. In contrast to Canaletto, Pannini's theatrical effects gave his audience access to a more direct, candid slice of life. In his rich *vedute* of antique subjects, Pannini gives free rein to his imagination, heaping diverse monuments one upon another, using a sort of collage of the imagination to create views rich in effect and powerful in their suggestiveness. His landscapes are unmistakably Roman, not only in the choice of subjects but also in their sense of grandeur and nobility. They were, and remain today, the best propaganda art for the city they glorify.

Very different, and yet equally important for the development of the new sensibility, are the view paintings done nearby in Naples. Although the wealth of antique monuments in that city was in no way inferior to that of Rome—in fact it was, in many respects, superior to it—the view painters of Naples, often expatriates, did not respond to their environment in quite the same manner. The extraordinary setting of the city on its expansive bay, the special quality of the light and the life combined with the menacing—yet ever so fascinating—presence of the erupting Mt. Vesuvius led artists to shun the city and its monuments and to devote their attention instead to nature, thereby introducing into the culture of the late eighteenth century the first thrills of the Romantic sensibility.

Yet the taste for antiquity might have remained but a fad had it not been so vigorously taken up, transformed, and revivified by Giovanni Battista Piranesi, an artist whose medium, etching, and canny business acumen spread the imagery of antiquity across Europe. He worked in many areas —architecture, design, and, especially, engraving—and his genius cannot easily be classified. His intensely poetic vision was rooted in the fantasy world of his Venetian predecessors and completely lacked the dogmatism of Winckelmann's cold rhetoric. His enthusiasm for Rome was the zeal of the converted, having himself been born in Venice. Less at ease with the pen than with the etcher's needle, Piranesi tried to refute the German aesthetician's theories of the supremacy of the Greeks over the Romans, but his essay on the subject failed to rally the enthusiasm of the scholarly intelligentsia for whom this topic was very much of the moment.

Whereas the previous Roman *vedutisti* had created convincing images of the city—or fanciful imaginary views of it in which the antique ruins always played a picturesque part—Piranesi added a decidedly theatrical dimension to his compositions: Through the deftest manipulation of shades of black, the bold balancing of voids and volumes,

and the creation of originally sited perspectives, his etchings attain a heroic level that sets them above the perfunctory repertoire of places pictured by other artists. It was often with these compelling images in mind that some of the most enlightened travelers to Rome approached the city, only to be sadly let down. Goethe, in his *Italian Journey,* blames Piranesi for his slight disappointment upon seeing the Baths of Caracalla: Somehow the actual ruins did not live up to their image! For it was indeed Piranesi's genius to have been able to invent a picture of Rome, which, if not true to its reality, was nevertheless true to its legend.

Piranesi was also an expert in the restoration of antiquities, and thus he naturally dealt with foreign visitors, usually British, who were eager during their Grand Tour to acquire remnants of Roman civilization for their own homes. Piranesi's approach to restoration would be considered highly unorthodox today since he mainly "completed" antique fragments according to an approximate idea of their original appearance. For Piranesi this was yet another means of demonstrating his virtuosity: Just as his renditions of Roman sites acquired a new dimension, his proposals for and completed restorations of antiquities turned these objects into fantastic creations. These elaborations rapidly became part of the repertory of images and objects used by the many artists who helped diffuse his style. Among those were members of Piranesi's broad circle of foreign artists such as the Englishman Robert Adam or the Frenchman Charles Louis Clerisseau. Piranesi's influence, notably on architecture and the applied arts in England, was particularly felt in the last quarter of the eighteenth century. Many country houses were redesigned at that time in accordance with neo-Palladian precepts so that the important collections of antiquities so recently brought home might have an appropriate "classical" setting. In such houses chimneypieces might ideally derive from Piranesi's very designs, while the general look of the building would betray the archaeological concerns set forth in his prints.

Piranesi received numerous commissions from the English, and his prints were widely distributed there, but his influence pervaded Europe. Ever the wily entrepreneur, Piranesi established the Roman shop where his prints were offered for sale across the street from the French Academy where it could hardly be missed by the student artists.

Hubert Robert has a special place among those students at the Academy. Even though his work cannot be understood without constant reference to Piranesi, with whom he was friends during his lengthy stay in Rome, or without the example of Pannini, with whom he worked, what sets him apart from these artists is equally important. His views of cities, notably Paris and Versailles, strike a very different note from the somewhat mechanical views of Pannini: There is something natural and spontaneous in them that bespeaks a direct observation of nature. Often in a corner of his compositions Hubert Robert represented an artist sketching, thus indicating that nature was the best teacher. His own sketchlike technique exemplifies his nondogmatic approach. Even in his more elaborately fantastic vedute of ruins, nature is never absent. Although Piranesi's archaeological taste looms over Robert's work, the painter's delicate images never

reach for the heroic dimensions of those of the engraver. Unlike Piranesi, so concerned with the archetectonic manipulation of masses and volumes, Robert was intrigued by the more subtle art of garden design in which only a limited control might be exerted. And his architectural renderings were generally of fantasy buildings, the Hameau of Marie Antoinette at Versailles, for instance, or the queen's dairy at Rambuillet.

Hubert Robert first exhibited at the Paris Salon of 1767. That same year the Petit Trianon of Versailles was nearing completion. Both the location of the building and its decor proclaimed a new art of living at the French court. This small building provided relief from the formality and pomp of the château itself. Its decoration avoided the traditional dynastic glorification that had been the chief program at Versailles. In fact, the Petit Trianon was virtually a bare building—stark but pleasant outside, pleasing and restful to the eye indoors. Again Piranesi—and some of his English interpreters, such as William Chambers, whose *Treatise on Civil Architecture* of 1759 was well known in France—can be credited for this shift in taste. A discreet return to the antique began then, and it was followed by most architects, furniture designers, and decorators.

If architecture and decoration led the way toward a pared-down aesthetic, the same cannot be said of painting and sculpture. Before the creation of the stark and emblematic pictures, so rich in moralistic overtones, that characterize the short reign of Louis XVI and the last, revolutionary years of the century, many artists indulged in an exuberant style that has too often been seen as the last agonized shriek of the Rococo. Painting in France between 1760 and 1775 is particularly complex, combining many elements and strongly individualistic personalities. Robert, as we have seen, was one of those artists for whom the glorification of the past could not take place without an accompanying study of nature. The world of passion, pleasure, and delight expressed in the work of J. H. Fragonard (see Plates 14–16, 18), Robert's friend and traveling companion in Italy, is equally difficult to define. To be sure, he brought to its apex the galant world of his one-time teacher François Boucher, and certainly the influence of northern masters such as Rubens and Rembrandt partly explains his obvious delight in the materiality of paint. But most importantly, Fragonard must be understood in the context of Italy, although the lesson he learned there was not the customary one of his time: He was not responsive to the grandeur of antiquity, and his obligatory attempts at history painting (for the Prix de Rome and for his reception into the Academy) are competently theatrical and lack the conviction one finds in the work of born academicians. Fragonard mastered the technique of the Italian painters by making numerous copies, but he disregarded their often stilted officialism. What he did learn in Italy was drawn from the life and the landscape around him, and he never adopted the orthodox rhetoric of his more conventional peers. Instead, he created a world closer to nature and to the bucolic works of Virgil and the erotic poems of Ovid.

In a century prone to extol the individual, Fragonard was first and foremost an individualistic painter. When an official

career was still considered highly desirable and could be achieved by submitting oneself to strict rules, Fragonard did not bother to comply. He exhibited only once at the Salon, in 1767; he never became a full-fledged Academician. His paintings are often small, like Watteau's (which he must have admired), intimate like the still lifes of Chardin (under whom he was briefly apprenticed), and are intended more for private contemplation than for public display. Their discreet humor and unabashed frankness are equaled only in eighteenth-century literature—in the personal tone, for instance, of the letters that compose Laclos's *Liaisons dangereuses*. This may seem far from Italy, but the gently subversive art of Fragonard can be rooted only in the informality absorbed in that country by a sensitive and responsive artist. Fragonard's early studies, particularly those executed under the patronage of the Abbé de Saint-Non at Tivoli in 1760, show an immediacy of response to nature that would not be seen again in French painting until late in the nineteenth century. Fragonard applied this directness and sincerity to all his creations, from copies of Italian masterpieces to spirited portraits, atmospheric landscapes, and genre scenes.

It is only superficially paradoxical that in 1766—when the European sensibility was shifting toward a dignified vision of antiquity—Catherine II of Russia, one of the most enlightened monarchs of the time and one deeply influenced in her aesthetic choices by the stern recommendations of Diderot and Frederic Melchior Grimm, tried to attract to her court one of the least apparently Neoclassical sculptors of the time, Claude Michel Clodion. At the time he was established in Rome and enjoying success. Clodion's works lacked the diversity of Fragonard, his contemporary to whom he is often compared. But like Fragonard, his vision of antiquity—the source for all art of the period—derived from a pagan dream, and he expressed it in tantalizing terra-cotta sculptures of lustful satyrs and willing nymphs. The medium of these works was itself rife with archaeological overtones, and they were an immediate and resounding success. Like Fragonard, Clodion celebrates the Dionysiac aspect of life and love, and he does so with an equal humor and lack of pretention. And as with Fragonard, Clodion's reference to the antique is less to its legacy of images (although representations on so-called Etruscan vases may have been a direct source for the sculptor) than to its spirit and its youthful exuberance, real or imagined. A sense of that primal energy is, in fact, a trademark of Clodion who, alone among the sculptors of his century, knew how to kindle that incandescence even in his rare portraits.

When Clodion treated a subject that is both allegorical and historical—such as the invention of the hot-air balloon by the Montgolfier brothers (Plate 32)—he did so without the seriousness expected of official commissions: Cherubs cling to the ascending balloon as if attempting to ground it with their feathery presence. In brief, the qualities that set his work apart from the production of his contemporaries are humor, movement, a swiftness of execution that does not preclude the most exacting rendition of detail, and above all, a spirited vision of an imaginary ancient world.

No sculptor could be more different from Clodion than Jean Antoine Houdon. Diderot, whose portrait Houdon

exhibited at the Salon of 1771 (Plate 26), wrote about it succinctly and aptly: "Très resemblant." Houdon's studies after life, such as his famous *écorché* (the figure of a man whose removed skin reveals all of his carefully detailed muscles), constitute the basis of his work. Life and death masks helped him to render the likenesses of his sitters with a stark realism reminiscent both of Jean Goujon's startling *gisants* at Saint-Denis and of Republican Roman portraiture. He was perhaps less interested in the psychological traits of his sitters than he was almost morbidly fascinated by their bare physicality: Bone structure, sagging flesh, hair, pitted skin are all mercilessly rendered. Houdon astonishes us today as much as he did his contemporaries—his style seems so at odds with our received image of the eighteenth century.

Louis Claude Vassé (see Plate 13) or Pierre Julien (see Plate 31) fit more properly into their own century, perhaps because they lack the originality of a Clodion or the merciless eye of a Houdon. Theirs are decorative works, simple and pure, intended to enhance the elegant architecture and delicate interiors popular at the end of the century. Julien's work in particular is so much a mirror of its time, with its combination of measured classicism and post-Baroque elegance that, were it not for its gracefulness and quality of execution, it might be considered parodic, or at best a mere object of fashion.

Thus with varying degrees of success French sculptors of the transitional period between the reigns of Louis XV and Louis XVI created works that, based upon their Roman experiences, expressed their own particular interpretations of antiquity rather than slavishly following given models. It was Antonio Canova who created a body of work that in the eyes of his contemporaries actually equaled the greatness of antiquity and yet, by taking into account the lessons of the greatest Baroque sculptors—Bernini in particular—was resolutely modern. Like Piranesi, Canova was from the Veneto but achieved his fame in Rome where he enjoyed papal patronage. An overnight celebrity and arguably the most famous artist in Europe by the turn of the century, Canova went far beyond the hopes of the rigorous Winckelmann: Not only are his sculptures "correct" by the standards of the German historian, but their virtuoso brilliance of conception and execution puts them on a par with the most inspired sculptures of the past. Canova at once applied the rules and transcended them: This originality is often hard to see in the face of the work of his followers who, awed by the masterly technique of their model, forgot—or were simply unable to achieve—the variety and freedom of invention of the great sculptor. All embued with the "calm grandeur" so dear to Winckelmann, Canova's compositions nevertheless offer a multiplicity of original solutions to traditional sculptural problems: His *Perseus* (Plate 10) is an image of heroic triumph: Its spirit is classical but its execution is unmistakably Canova's invention.

Canova's revolutionary approach to sculpture can be compared only to David's equally radical transformation of painting. It should be noted, however, that even before David's complete reformulation of painting, significant changes had affected the visual arts of the late eighteenth

century in France. Duly commented upon by such constant scrutinizers as Diderot, the biennial Salons held at the Louvre gave artists their only real opportunity to present their latest creations to a large, interested public. In the late 1760s and 1770s these Salons had been the scene of spectacular and often somewhat awkward juxtapositions. The late compositions of the aging and almost blind Boucher, for instance, were ridiculed by the likes of Diderot, who equated the loose brushstrokes and unceasing use of light mythological subject matter with a decadence of style and moral values.

To this style the "modern" critics opposed the independent work of Jean Baptiste Greuze. A painter of portraits and of genre scenes, he introduced a concern for sentiment close to the fashionable ideas expressed at the time in the literary works of Jean Jacques Rousseau. Greuze's trip to Italy in 1755 has until recently been judged irrelevant to the development of his career, yet his work reveals a deeply original interpretation of antique themes and motifs. His narrative paintings are, in fact, allegories in disguise. His elegantly clad peasants often affect the postures of Hellenistic sculptures or, as in the *Broken Eggs* (Plate 11), are shown playing with the attributes usually reserved for mythological figures. The little boy on the right, for instance, is attempting to repair a broken bow and arrow, the traditional emblem of Cupid. It is not incidental that this painting was executed in Rome at a time when the artist was traveling with his patron, the enlightened Abbé Gougenot. Greuze's resounding success with such narrative paintings led him to try his hand at history painting, and in 1769 he presented to the Academy as his reception piece *Septimus Severus and Caracalla,* his only foray into history paining. He was not admitted to the Academy among the history painters, but rather among the genre painters, and severing his ties with the art establishment and no longer showing at the Salon, he followed an independent career and returned to the kind of dignified genre scenes that had established his reputation. His style, which had contributed so much to the formulation of ideas crucial to modern painting, did not survive Diderot's attacks, and Greuze's later years were marked by an unjust oblivion.

The link between the decisive shift in French painting of the 1760s and 1770s and the enlightened ideas of the *philosophes*, eventually culminating in the French Revolution of 1789, has often been noted. Indeed, the subject matter of most paintings of that prerevolutionary period glorifies moral virtues and offers the exemplary conduct of the ancients as a model for contemporary life. Their austere style, shunning the vaporous world of the Rococo, bespeaks the seriousness of the painters' ambition. Even in the decoration of private homes, the lingering amorous subjects of the late Rococo suddenly appear out of place. Typical of this change in taste was the decision, in 1773, by Madame du Barry—the king's former mistress—to refuse Fragonard's splendid *Progress of Love* (New York, Frick Collection) decorations for her residence at Louveciennes in favor of the more serious scheme devised by the little-known Vien, one of the exponents of the severe style of the 1770s.

The search for and adoption of a new style did not imply agreement with the new ideas on the part of artists. Most of the virtuous and patriotic subjects that constitute the basis of their works were imposed by their traditional patron, the king (or rather by his superintendent of buildings, the official who was in charge of distributing commissions). Many decisively "modern" artists were in fact staunch supporters of the monarchy. Paradoxically perhaps, Fragonard's wife was among the artists' spouses who, in an ostentatious demonstration of patriotism, offered their jewels to the National Assembly less than two months after the Bastille had been captured by the people of Paris.

Elisabeth Vigée Le Brun, however, always sided with the crown, a choice that eventually drove her into exile. Yet her portraits—an impressive tableau of French, and later, European aristocracy—are anything but backward-looking. She was particularly close to the court and to Queen Marie Antoinette in particular, yet her portraits of the royal family avoid the kind of official formality that had characterized royal portraiture until then. Portraits of the queen and her children show the royal consort as a dignified mother proud of her children. Given the unpopularity of the queen, these portraits are political propaganda at its best: They stress the human qualities of the sitter behind the mask imposed upon her by her rank. In these as in her less official portraits, Vigée Le Brun adopts an engaging naturalism. If there is no intense psychological depth in her depictions, there is still something that goes beyond the merely fashionable: Her palette and her application of paint occasionally reveal an unexpectedly advanced artist. As such, her work provides a significant link between the formalism of eighteenth-century portraiture and the more direct approach to it characteristic of the nineteenth century.

It is perhaps more than a coincidence that the period that so prized such "masculine" virtues as honor and patriotism also saw a proliferation of women painters. Among the most gifted was Adélaïde Labille-Guiard, often seen as the rival of Vigée Le Brun. Although they exhibited together at the same Salon, Labille-Guiard rallied to the new regime during the Revolution. In an egalitarian gesture, Jacques Louis David was one of the first painters to accept women as pupils, among them the wife of the scientist and *fermier-général* Antoine Laurent Lavoisier.

By the time he exhibited the portrait of Lavoisier and his wife (Plate 38), David had become one of the most controversial figures in Western art. His early works, still influenced by Boucher (a relative under whom he had briefly studied), had rapidly given way to a series of landmark paintings that radically transformed the course of art. David's entry in the 1785 Salon, *The Oath of the Horatii* (Paris, Louvre), painted in 1784, is radical in its paring down of emotional elements. Anecdotal detail is totally eliminated; each component—figure, movement, expression, even the austere architecture—acquires a symbolic significance. Commissioned by d'Angiviller for the crown, the painting was not intended as a statement of revolutionary faith but more broadly as an example of high virtue. It depicted total dedication to an elevated cause: the triumph of reason over passion. As the French Revolution progressed, the radical style of the painting (which had startled those admitted to its preview in David's studio in 1784) became a metaphor

for the implacability of the new regime. David's own support of the revolutionary cause reinforced the prophetic quality of the painting.

His *Death of Socrates* (Plate 37) was conceived in the same spirit of archaeological concern and moral rectitude. Completed in 1787 and shown at the Salon the same year, the painting had been commissioned by Charles Michel Trudaine de la Sablière, then only twenty years old. It was hardly intended as a revolutionary statement, yet the very story of the Greek philosopher condemned to death by the injustice of the state was typical of the subjects David was ready to depict with cool, even brutal, sincerity. It was painted at a time when the established order was being severely criticized, and it is hard to avoid seeing in this stark picture a subject imbued with burning topicality. Indeed, the painting acquired considerable notoriety during the Revolution: It was exhibited a second time at the Salon of 1791, and in 1795 it was engraved with a decisively political intention. Ironically, it was then intended as a protest against the brutality of Robespierre's Terror, a movement that David had wholeheartedly supported.

David's scrupulous archaeological concern, which led him, for instance, to request the help of prominent historians while painting the *Death of Socrates,* can be viewed as a way of giving his compositions a veracity otherwise unknown among the works of his contemporaries. This can also be seen in his portraits, the best of which are neither emblematic nor realistic in the traditional sense of the term. Their evolution in his oeuvre follows roughly that of his other paintings. The double Lavoisier portrait is a study in relative asceticism. The elegantly bare room that the couple occupies and the proliferation of scientific instruments on the table and floor, far from distracting or cluttering the composition, in fact give it its meaning and underlie its seriousness of tone.

Among the many artists who admired the *Death of Socrates* was the aging Sir Joshua Reynolds. At the time of the exhibition of David's picture, Reynolds was the most established artist in England. One of the cofounders and the first president of the Royal Academy, in 1768, Reynolds was also a persuasive theoretician. His *Discourses,* translated into many languages and read throughout Europe—most notably in France—constitute one of the pillars of Neoclassical theory. David's *Death of Socrates* is worlds apart from Reynolds's contemporary portraits, yet both artists shared a belief in the exacting demands of art. For Reynolds, beauty was an ideal the artist could not fully achieve but toward which he had to strive. This Neoplatonic idea reveals the august sources of Reynolds's theories, nurtured as they were in the classical tradition. In Rome in the early 1750s he witnessed the immense success of Mengs and Batoni but, as already noted, disdained their works. Rightly or wrongly, he thought that the slick manner of these modern masters—too often compared with Raphael himself—was simply a superficial parody of the Umbrian master. His own art, more robust and ambitious, does not draw from the antique as directly as does French Neoclassical painting. Reynolds's relationship to the classical tradition was intellectual. His ambition was to create an art that would, quite simply, be as beautiful as that of the ancients. This could only be achieved by a thorough assimilation of the history and means of the painters of the past. Raphael—but also Tintoretto, Titian, and Rubens—were his sources. His technique, a combination of the recipes of the Old Masters and inventive new formulas, was intended to give his compositions an Old Master quality.

Unfortunately for Reynolds, the English did not have a tradition of history painting as had the Italians and the French. This was the genre in which Reynolds should naturally have chosen to express his elevated ideas. Being limited by his British patrons to portraiture, Reynolds contrived to elevate the genre to truly heroic stature. For the gallery at Northumberland House, decorated with copies after Raphael and the Bolognese (some of which had been executed by Mengs and Batoni), Reynolds furnished full-size portraits of the duke and duchess, thus setting his own original compositions beside those of the famous masters of the past. Rather than show his sitters in the fashionable clothing of the day, he preferred to depict them garbed in vaguely classical outfits and engaged in activities recalling ancient allegory. These portraits combine a traditional sense of timelessness with a modern interest in psychological expressiveness.

Reynolds and his rival in portraiture, Thomas Gainsborough, occasionally shared the same sitters, but the lofty portraits of Reynolds could not be more foreign to the elegant informality of those by Gainsborough. Although the latter's career coincided largely with Reynolds's and therefore with the triumph of Neoclassical aesthetics, his portraits and landscapes belong fully to the Rococo. Unlike the French painters of that era to whom his works bear affinities, Gainsborough does not create a world of mythological fantasy. Born a rural gentleman, Gainsborough remained throughout his career a painter of lesser ambition than Reynolds and was hardly a theoretician. Eccentric and unorthodox, his working methods and his entire approach to the goals of portraiture could not have been more different from Reynolds's didacticism. One was a learned painter, the other a *peintre-né,* whose portraits, despite their spirited execution, retain an earthbound quality. Nature, rather than art, was the guiding principle for Gainsborough. His sitters are believable and have an immediate presence that betrays the sympathy they so often clearly aroused in the artist. Landscapes were accorded the same sense of immediacy and enthusiasm, although he painted fewer of them than portraits, which being much in demand, consumed more and more of his time. If a portrait includes a landscape component, it is always more than a mere backdrop. For all his naturalism, though, Gainsborough was also a painter who drew upon the works of others. His studies under the French engraver Gravelot may have attuned him to Watteau's *Fêtes Champêtres,* although he rejects the artifice of the genre to concentrate on scenes of a more immediate reality. Rubens, both because of his light sketch technique and of his astonishing landscapes, seems also to be a constant reference in Gainsborough's work—but again, brought down to a more accessible level.

Less inspired than either Reynolds or Gainsborough, George Romney carried the tradition of portraiture into the nineteenth-century. Like Reynolds, his ambition was to give portrait painting in England the dignity of classical art. He admired Le Sueur on a visit to Paris, discovered Raphael in

Rome and Titian in Venice, and drew also from the antique. Yet his portraits are more notable for their immediacy, ingenuity of composition, and lack of pretention than for their overt or covert references to the antique. His extraordinarily large output can be explained by his ambition, his affordable prices, and an easily accessible style that made him the most fashionable painter of his day.

The debut of Thomas Lawrence as a child prodigy led many to see in him the new hope of British painting. His subsequent fame among his contemporaries was, in fact, at least equal to that of Reynolds in his own time. Yet the brief interval of time between Reynolds's production and the mature work of Lawrence shows a considerable shift in English taste during the last years of the eighteenth century. Lawrence's patrons did not expect from him the classical references Reynolds believed to be important, nor was the painter interested in masquerading his subjects in semiantique costumes. In 1818 Lawrence stunned Roman critics with portraits whose rich tonalities were compared to those of Titian. He was very much a man of his time, reflecting and indeed effecting a new sensibility, and his portraits reveal a range of emotion unknown to his predecessors.

European art between 1760 and 1800 is especially difficult to define because of the astonishing and virtually simultaneous occurrence of seemingly unrelated, if not contradictory, styles often even within the work of a single artist. Romney's portraits make the more unexpected his original compositions based on classical or Shakespearean subjects. In Rome, the awesome austerity of David's *Oath of the Horatii* had stunned artists, resident and itinerant, who were at that time working in a very different and highly emotional style that stressed the darker side of human psychology. David's belligerent manner threatened to eclipse their work, especially since it, along with modified versions of the Empire style, was spreading across Europe in the wake of Napoleon's armies. But the threat was shortlived; their work flourished as the Romantic movement took hold. Indeed, it seems paradoxical that Rome, whose past had provided Europe with a basis for a Neoclassical grammar, would also become the cradle of the Romantic movement.

The artists responsible for articulating this original formal vocabulary, as well as for demonstrating a special taste for erudite subject matter, were centered around the Swiss-born artist Henry Fuseli, who had rapidly emerged as a major figure in the art world of London where he was virtually permanently settled. Literature—especially Homer, Dante, Shakespeare, Milton, and the Nordic sagas—provided the sources for Fuseli's often recherché subjects. It was, however, his contact with antiquity and Italian art (Michelangelo and Baccio Bandinelli, for instance) that helped him formulate a highly idiosyncratic idiom in which the distorted gestures and dramatically exaggerated expressions of the figures are rendered in a highly graphic style and in which the illusion of depth is, as in Greek vase painting, almost entirely absent. The fantastic and irrational world of Fuseli's painting, often charged with sexual overtones, became a trademark of English and northern European painters in the last years of the eighteenth century. If nothing else, these paintings offered a refreshing stock of new images.

Often associated with Fuseli's entourage, the young William Blake was an artist of very different ambition. A true visionary, Blake may have borrowed some of his stylistic characteristics from Fuseli, whom he befriended. The expressiveness of Blake's drawings is, like Fuseli's, contained within the limits of a strict, yet original, graphism. But Blake, unlike Fuseli, does not illustrate scenes from literature calculated to fire the imagination. Instead, his illustrations are totally individualistic comments, part of an ambitious cosmological and personal philosophy that was also expressed in his own literary works. At their most original, Blake's compositions—usually small watercolors—are self-contained expressions of a mystical vision, and they bear little relationship to contemporary aesthetic or philosophical concerns. The seriousness and conviction of the artist set him well apart from all his contemporaries, who could only really appreciate his work as an engraver. Yet the haunting presence of Blake's work looms over European art as a sign of things to come. In this respect, he can be compared to his contemporary, Francisco Goya.

Goya's realm, however, was not intellectual or mystical speculation. On the contrary, it was one of flesh and blood, of radiant sunshine and opaque darkness, of extraordinary humanity and compassion, of pessimism and despair. Like David, his exact contemporary, he lived through the political upheavals of his time, yet the lesson he drew from them was not one of stoicism. Witnessing the brutalities perpetrated by the Napoleonic armies during their occupation of Spain and the senseless cycle of violence that followed, he cried out against the absurdity of human nature. Yet Goya never forgot the candid joyfulness of the scenes he had depicted in the 1770s as cartoons for tapestries, and he knew that these images, too, were real.

Beginning as a painter of genre scenes that have a veracity unlike those of his French counterparts, Goya must have rapidly realized that direct observation and the unadorned recording of his subject could easily replace elaborate theories. His art, which often provokes a chill much like that of David's, nevertheless achieves this effect through very different means. His portraits of the Spanish royal family or members of the aristocracy are as much icons of their time as they are indictments of a regime. Contrary to what is often said, Goya's eye is not cruel or even critical, although his ability to record and to express the personalities of his sitters through such details as minute physical imperfections or particularly telling accessories eventually succeeds in penetrating the deepest layers of the sitters' personalities. The wide range of Goya's portraits, and the variety of their style —from the dashing portraits of swaggering gentlemen and got-up ladies to the more introspective studies painted with obsessive candor—are guided above all by a profound honesty of vision. If in David's portraits humans are painted as heroes, in Goya's, traditional heroic figures such as kings and queens are given a chance to appear as normal, sometimes even pathetic, humans. Goya removed the masks of composed elegance that characterized eighteenth-century portraiture and offered us instead a gallery of raw personalities. By giving his sitters the same presence and accessi-

bility once reserved for self-portraits, Goya sounded the death knell of the formal portrait. It is perhaps first in the literature of the nineteenth century that one would have to look to find such a radical approach to the depiction of human nature. Goya's portraits announce the age of the antihero as exemplified by Balzac's display of human types or Flaubert's unflinching depictions of his characters.

It is hard to understand in retrospect how such blatant exposure of human nature could have been acceptable to the sitters who commissioned these portraits. Yet Goya was in fact the most famous, and most fashionable, portrait painter in late eighteenth-century Spain and the official artist of the court. Although portraits continued to occupy him until the end of his life, which was spent in self-imposed exile in Bordeaux, an important shift can be sensed in his works in the period after the political events that ravaged Spain at the turn of the eighteenth century. Goya's work became then more publicly available through his readoption of the medium of etching (used earlier in his 1798 series *Los Caprichos*). The *Disasters of War* (executed in 1810, but released only in 1863, long after the artist's death and the events it depicted), the *Bullfights* (1816), and the *Follies* series broadened the artist's visibility as well as his repertoire of images. On the other hand, he followed his large representation of the execution of Spanish patriots, *The 3rd of May 1808*, (Madrid, Prado), a cry of horror at the reality of war, with several paintings depicting a world of private fantasy. To a certain extent these develop the themes and subjects of *Los Caprichos* as well as of many small paintings Goya had executed since the late 1780s. Particularly revealing of this late manner are the so-called "black paintings" made for his own house outside Madrid. Not intended for public exhibition, these paintings, executed in a rough technique and somber harmonies, are the artist's ultimate statement. Their meaning defies precise analysis, and they are often described as antecedents of the Symbolism and Surrealism of a much later era. As he had invited us to witness in his portraits the reality of the human condition, so Goya invites us to consider the reality of an apocalyptic world in his fantastic works.

Much had happened in France since David's *Oath of the Horatii* had marked the dawn of a new era in painting. The French Revolution had been a period of upheaval for the arts. Some artists, like Vigée Le Brun, compromised by their former ties with the monarchy, or following their own convictions, had emigrated along with a part of the aristocracy; others, Fragonard, for example, had survived the events without difficulties; and some, like Hubert Robert, had on occasion been imprisoned and under threat of death. David alone rode the crest of the Revolution not only as the most prominent painter of his time but as the recognized genius best able to dramatize and immortalize its events. He also served as its unofficial designer-in-residence and de facto "minister of the arts." Seen by many young politicians as a reenactment of ancient history, the Revolution needed an artist to give it its image, and David filled the bill to perfection.

Under the reign of Louis XVI the decor of daily life had already witnessed a return to simple, elegant forms thought to derive from antique prototypes. The process was accentuated during the Revolution: The seats for members of the Comité de Salut Publique, for example, were direct adaptations of antique models designed by David. As the Revolution progressed and a new world of elegance replaced the roughness of the high revolutionary period, customs and costumes continued to reflect the taste for antiquity. Napoleon, the heir—or usurper—of the French Revolution, quite naturally continued the tradition, as he saw himself the reincarnation of both Alexander the Great and Julius Caesar. Without apparent hesitation or conflict, David had transformed his earlier revolutionary fervor into unconditional adulation of the new monarch and himself established the link between Napoleon and his ancient predecessors by inscribing his *Bonaparte at the St. Bernard Pass* (1800, Versailles) with the names of Hannibal and of Carolus Magnus. After Napoleon proclaimed himself emperor (the title itself a reference to antiquity), a new style was introduced at his court. It was important for Napoleon to establish his credibility with his own entourage and with the other European courts, which had grudgingly to recognize him. To do this, he set out to surpass in splendor the memory of the past monarchy by imposing a style that would be unquestionably his own—and the old buildings of Paris quickly saw his monogrammed *N* replaced the *L* of the Bourbon kings.

The lack of a truly great "high art" during the Napoleonic period can be accounted for by the huge political propaganda effort into which the nation's creative energies were entirely funneled. But the applied arts did indeed flourish and even the most politically pointed efforts were imbued with aesthetic qualities of a high level. French decorative objects were dispatched throughout Europe as diplomatic presents or to furnish the residences taken over by Napoleon's relations or generals, now briskly declared monarchs themselves. Silversmiths and goldsmiths such as Thomire, furniture designers such as Jacob or Bennais can be considered among the greatest artists of their time. Their designs, usually based on classical prototypes or, after the conquest of Egypt by Bonaparte, Egyptian motifs, are striking in their elegance, originality, and the high quality of their craftsmanship.

Despite David's attempt during the Revolution to abolish the system established under the *ancien régime* for the training of artists, officials of the Napoleonic administration kept it alive. During Bonaparte's reign artists were taught as they had been for centuries: The highest prize for a young artist was still the Prix de Rome that would allow him to spend a few years perfecting his skills through the study and copy of antique models and the Old Masters. The system had its advantages: At worst, it produced perfectly competent, if wholly unoriginal, artists; at best, it incited gifted painters to exceed the limits imposed upon them. It is perhaps symptomatic of the democratic aspect of the arts under Napoleon that two of his favorite painters, Gros and Gérard—both made barons in recognition of their merit—did not have a chance or failed to win the Prix de Rome. Their bland styles, geared in Gros's case to the glorification of the emperor's military triumphs and in Gérard's to a fashionable portrait style, are typical of the sort of art most appreciated under Napoleon: pleasant, decorative, even imposing—but

a far cry from the spare purity of David's early compositions. David himself was not always supportive of their works, especially if they departed in the slightest from the norms he had established.

Girodet is an example of a gifted painter who, though brought up in the classical tradition, can be credited with introducing Romantic themes into French painting. He was the first artist in France to use themes derived from Ossian, the alleged author of "Nordic" poetry that was of tremendous influence on artists at the turn of the century, even though it was quickly revealed that these sagas were adroit modern pastiches. David avowed not to understand what his former pupil was doing. Such unorthodoxy was for him wholly out of place, and it must have been with relief that he welcomed the majestic image of Napoleon (Paris, Musée de l'Armée) executed in 1806 by another of his pupils, J. A. D. Ingres, in which the ruler is represented as a seated Zeus, wearing the emblems of his power.

Justly regarded as David's most gifted pupil, Ingres can be considered the most important painter of the first half of the nineteenth century in France. Through his own teachings, a long and busy career, and the dedication of his pupils to the principles he laid down, his work became a point of reference for his contemporaries as well as for many later artists. By strict Davidian standards, Ingres's art is unorthodox. Attracted at an early age by the perfection of Raphael's drawing and by the sweetness of the Umbrian master's compositions, the young painter abandoned antique sculpture and even classical themes as basis of his art. The drawings of John Flaxman, the British illustrator, and the decorations of Greek vases upon which those drawings were based, provided Ingres a further incentive to explore the expressive power of line drawing.

Ingres arrived in Rome in 1806, the year he painted the impressive official image of Napoleon. Yet, unlike David —whose career seemed to advance like an unwavering arrow —Ingres's sensibility moved during these early years in several directions. Official portraits, as the one he did of Napoleon, could have been his life's work. But in Rome he perfected a type of private portrait, both in drawing and painting (see Plates 46–49) that can be seen as the culmination of the traditional "Grand Tour portrait." His sitters, like Batoni's, are often posed before views of Italy (the inclusion of such keenly observed natural views and atmospheric effects bespeaks Ingres's repressed talent for landscape). Yet there is nothing rigid in the way the subjects greet the spectator. Superb likenesses, a masterly rendering of textures, and a rare perfection of surface lend an immediacy to these portraits, which occupied Ingres throughout his career. It was an academic art, but it transcended the narrow limits of the genre.

Ingres's independence from David can be witnessed in many aspects of his work: in the small compositions with medieval or Renaissance subjects, a genre favored by certain Romantic painters; in his rare landscapes; and in a personal and sophisticated reformulation of genre painting. Ingres's original style has its antecedents in French painting: David, of course, but also Poussin are at the roots of his art. In fact, for many visitors to the 1824 Salon the juxtaposition of Ingres's *Vow of Louis XIII* with Delacroix's *Massacre at Chios* must have appeared as a strangely updated reenactment of the century-old dispute between the "Poussinistes" and the "Rubénistes"—between the tenets of a cool and classical style and those of an art based on the expressiveness of color. The old dispute was intensified by the personalities of the two painters, so at odds with one another. In the heated atmosphere of a period that had not forgotten the triumphs of Napoleon and was about to enter an age of revolutionary upheavals, the two paintings were almost political statements. One, representing the dedication of France to the Virgin by Louis XIII, could only be seen as a celebration of the traditional values of the Bourbon restoration. And the other, the brutal description of a contemporary event, stirred "modern" Panhellenic feelings and expressed sympathy for a struggle of national liberation.

If Delacroix's statement was blatant, it was certainly not the first attempt to paint in a manner contrary to academic tradition. In 1818–19 Théodore Géricault had painted his masterpiece, *The Raft of the Medusa,* depicting a horrendous contemporary event. Its unorthodox execution achieved a dignity and heroism comparable only to the greatest compositions of David. Delacroix had known and admired Géricault and had even served as a model for one of the figures in *The Raft.* Delacroix, who was to become the standard-bearer for the Romantic movement in France, had a background totally different from that of Ingres. Although he had been apprenticed for a brief time to Pierre Guérin, a pupil of David's, it was his study of the Old Masters and the works of some of his contemporaries that shaped his style. Unlike Ingres, it was not toward Raphael or the other masters of drawing that he turned but rather to the more ebullient world of Rubens and the Venetians. Rubens was rarely proposed as an example to young painters of the time even though Paris was the repository of some of his most grandiose compositions. Delacroix also admired Goya and, like Géricault, the artists of the British school. He himself was a friend of Richard Parkes Bonington and learned the technique of watercolor, so much a trademark of that school. He also favored a new type of subject matter: tales generally drawn from such writers as Dante and Shakespeare, as well as from his contemporaries, Sir Walter Scott, Lord Byron, and Alexandre Dumas. For this he was often criticized by some of the more conservative upholders of the classical tradition. Delacroix's compositions were increasingly accepted by the public despite—or perhaps because of —their originality. The sheer brilliance of his palette—enhanced by a trip to Morocco during which he made many life studies—and his fresh approach to history painting were seen by many (notably writers such as Théophile Gautier and Charles Baudelaire) as the only hope for liberating French painting from the restraints of the moribund academic tradition.

Among the foreign artists exhibiting at the 1824 Salon were many British watercolorists. Constable was represented by *The Hay Wain* (1821, London, National Gallery), a picture that retains on a large scale the fresh and direct observation of nature usually reserved for sketches. The impact of such an unexpected approach to painting was felt immediately

by many French artists who found in the achievements of the British school another welcome alternative to the academic discipline.

England had provided a fertile ground for the Neoclassical movement, particularly in architecture and the design of interiors and furniture. The porcelain production of the Wedgwood factory, which employed designs by John Flaxman, had popularized this style throughout the British Isles. Sculpture, which could better imitate antique models than other artistic mediums, continued the tradition of Canova well into the nineteenth century. Nollekens (see Plate 67) or Francis Chantrey, the latter with increasing realism, offer brilliant examples of such adaptations. Painting was, however, less dogmatic. Reynolds's interpretation of the antique had been most original, as had been Fuseli's. Concepts in garden design formulated in the early part of the eighteenth century by Richard Boyle led to a wholly new and refreshing way of contemplating nature. This new relationship of man to nature had a very real impact on the British landscape painters. For them, nature was not to be reorganized on the canvas according to intellectual rules, instead it was to provide a wealth of emotion, from peaceful contemplation to awe-inspired admiration. Two major artists represent the poles between which British landscape painters mediated: J. M. W. Turner and John Constable.

Starting out as a painter of topographical views, Turner, in the early years of the nineteenth century, was one of the first artists actually to paint an entire picture wholly on the site. By 1812 he had created pictures of such magnitude as *Snow Storm: Hannibal Crossing the Alps* (London, Tate Gallery), a work that combines direct observation of nature with a manipulation of light learned from Claude and, above all, total confidence in the suggestive power of pure paint. Yet this feeling for the sublime was not Turner's only mode. His visits to Italy produced works such as *Venice, the Grand Canal* (Plate 84), in which changing atmospheric effects are particularly deftly suggested. Turner's innovations as a colorist are immense. Constable referred to paintings such as *Venice* as a "golden vision." Indeed, the coherence of the painting is not achieved through a solid composition (although the view is rather firmly framed by the buildings on either side of the canal) so much as by the radiance of the predominating pole and the yellow hues that dissolve sky, water, and buildings into a unified painterly space. Later, the Impressionists would clearly learn from this and similar examples.

Compared to Turner's compositions, Constable's appear extraordinarily focused, as if the painter had tried to express his profound attachment to his native Suffolk without any further need to explore the mysteries of nature. Sketches were particularly important to Constable; they constituted the prime notations of atmospheric effects and, in the case of cloud studies, helped the artist to determine his color harmonies. For all its lack of pretense and attachment to reality and craftsmanship, Constable's art is anything but simple-minded. His paintings reveal not only sophisticated compositions but also a realism achieved through imaginative and painstaking reflection on nature and the value of color.

Constable's immediate influence on French painting is ele-gantly revealed by the fact that Delacroix, upon seeing Constable's paintings before the opening of the 1824 Salon, felt the urge to alter the background of his own *Massacre at Chios*. French painters had indeed much to learn from the British landscapists. The genre itself had made a timid entry into the official world of the Academy as late as 1817 when a special Prix de Rome for landscape painting was instituted. The entries, however, were historical landscapes since pure landscapes were still considered—as they had been since the seventeenth century—of a lower order.

It is thus not surprising that the best French landscapes—in the modern sense of the term—were done at the time by individualistic painters who cared little for the grand tradition and relied almost exclusively on their sense of observation and ability to transcribe their impressions. Jean Baptiste Corot is perhaps one of the most unusual painters of the French school. Trained under Achille Etna Michallon and Jean Victor Bertin—two Neoclassical landscape painters—he was also influenced by Bonington, who inspired him to adopt a more direct approach. Some of his early works, those done in Italy for instance, have a freshness of conception that is surprising in the pictorial context of their time. It is hard to tell whether Corot considered them fully achieved works or elaborate cartoons, for next to these delightful studies in light and composition he submitted more elaborate historical landscapes to the Paris Salons (see Pates 98, 99). Although his later work was indeed admired by some of the young Impressionists, his misty, atmospheric effects only superficially relate to their efforts. Corot's aim was above all to transmute direct observation of nature into a delicate poetry, something he was also able to achieve in the elusive mood of his genre scenes (see Plate 100).

Direct observation of nature became increasingly important among French landscape painters such as Théodore Rousseau or Charles François Daubigny. By strict nineteenth-century standards, they may even be considered amateur painters, having had little or none of the training considered professionally necessary at the time. The example of the slightly older Corot and their own association with kindred artists seeking an alternative to studio painting were enough to transform these innovators into the welcome rejuvenators of French landscape painting.

Referred to as painters of the Barbizon School because of their predilection for working in that area of the forest near Fontainebleau, they were by no means limited to that locale. In fact, their works reflect a profound sympathy for the particular qualities of the many places they painted. Rousseau's works done in the Auvergne, for instance, affect a rough and rustic quality, while his views of the Vendée reveal an artist sensitive to the more atmospheric qualities of nature. Especially fascinated by trees and the light flickering through their branches, Rousseau reached in his most ambitious and successful canvases a type of overall painting of surprising modernity (see Plate 103). Such "intellectual" reconstructions—the paintings were often done from memory—were to be of decisive importance for the Impressionists. Further, the effect of those majestic canvases counted significantly in the later development of Symbolism.

The vibrant surfaces in Rousseau's paintings in fact suggest an almost pantheistic conception of the universe.

For these artists, who were witnesses to growing technological and social changes, nature was a last refuge from reality, and for an artist such as J. F. Millet leaving Paris was anything but escapism. Educated in a rural milieu, Millet devoted his talent to the representation of peasant life. He moved to Barbizon from Paris (where he had lived unhappily for ten years and where his paintings were at first poorly received) not merely to join a sympathetic community of artists but also to return to his origins.

It is hardly surprising that in a society that welcomed Rosa Bonheur's *Horse Fair* (Plate 110) as a great masterpiece, Millet's images of peasants did not fare well. His vision of nature is not a happy one: The loveliest sunset only promises a tomorrow of hard work, and the vastness of his fields are but a reminder of the strenuous pain of their cultivation. At a time when the novelist George Sand presented peasants in idyllic, saccharine novels, Millet shockingly exposed them on the walls of the Salon in tattered shoes and worn-out clothes, bent under the weight of their shouldered loads. From his youth he must have remembered the arduous life of peasants, and their miserable and hopeless condition. Yet Millet's images are not pious laments over such realities, and they transcend the ordinary genre scenes and the narrow limits of social realism. It is hard to know exactly how Millet felt about his subjects: His political tendencies may have been republican or may have been tainted with the kind of patronizing socialism in favor at the time. But whatever his politics, he was able to make the social message of his paintings even more poignant by lending his subjects a religious gravity and dignity uncommon in the representations of rural life. Dignified, even heroic, Millet's peasants are the icons of a society that has ignored them.

Eschewing the limitations of narrative painting, Millet painted without models or recourse to nature studies. His understanding of the nuances of nature was, however, so profound that, like Rousseau, he could execute from his own imagination compositions both convincing in their realism and mystical in overtone. *Haystacks—Autumn* (Plate 106) is a particularly relevant example. The towering haystacks dominate the composition in an almost apocalyptic landscape, as if Rembrandt's three crosses had been suddenly transformed into masses of hay. The lonely, reduced figure of the shepherdess, the herd whose formation accentuates the deep perspective of the landscape enhance the tragic mood of the picture and remove it from the limits of traditional realism.

Millet was not the only painter to describe the human condition in such compassionate terms. Honoré Daumier befriended Millet and was to some extent influenced by him. He, too, painted the lower classes with a poignancy made more acute by the urban environment in which they are portrayed. Millet represented his peasants in a complete communion with the land on which they toiled; Daumier painted the uprooted characters who in his day were a highly visible segment of Parisian society, which was itself in a state of change. The astonishing incongruity of Daumier's most powerful paintings comes from his transplanting, so to speak,

Millet's figures from their rural background into the harshly inhuman world of the newly industrialized city. His most famous composition, *The Third-Class Carriage* (Plate 107), may be just that: the journey by train to Paris of an uprooted peasant family. One may wonder if the women sitting uncomfortably on the wooden bench will be met at the station by the man of the family, so conspicuously absent, and if they have left their traditional world behind them in order to seek their fortune in the city. But the narrative elements, which in literature might have furnished the subject for a novel by Balzac or Maupassant, are purposely missing. As a young man Daumier had admired and copied Goya, and one finds in his compositions the same impassible compassion in the description of human types and miseries. Daumier's work as a caricaturist (see Plate 108) had taught him to load his images with a punch. In his painted works he achieves a similar intensity but strives toward a more elevated representation of the human condition.

The 1848 Revolution had for many artists marked the end of an era. The atrocious killings that had taken place on the streets of Paris—so horrifyingly recorded by Jean Louis Ernest Meissonier—and the clash of social and political values they represented put in question the whole moral value and social relevance of art. Nature and the idealization of work had provided for artists as different as Rousseau or Millet an alternative to their existential quest.

An answer of a more brutal nature was brought to the same deliberations by a slightly younger artist, Gustave Courbet. Raised like Millet in a rural environment (the region of the Jura mountains), Courbet considered Paris to be the very symbol of corruption, blatantly evidenced in the kind of socially irrelevant, emasculated art that was shown in the Salons. Yet his belligerent nature led him to fight the battle on the very turf of the art establishment: By presenting his works to the jury of the Salon, he sought not so much acceptance as public confrontation.

Courbet decided at an early age to become an artist and was apprenticed briefly to two academic painters in Paris. Announcing a trend common to many progressive painters of the late nineteenth-century, his frequent visits to the Louvre or to the short-lived Galerie Espagnole (a museum of Spanish art set up by Louis Philippe) proved to be of greater importance in the shaping of his taste and personality than his academic studies. The use of color by the Spanish masters —notably Velázquez and Murillo—and their sharp realism, combined with the powerful brushstrokes of Frans Hals, provided Courbet with a viable alternative to the smooth finish and slick surfaces of the French academicians. He also saw in their examples an honesty and truthfulness to the model he found severely lacking in the art of his time.

His conviction that art should only concern itself with the representation of reality and his belief that it was his mission to reform painting along these lines resulted in a series of ground-breaking works executed in 1849. Among them, the *Burial at Ornans* (Paris, Louvre) was perhaps the most startling. Acclaimed by the avant-garde critics, including the poet Charles Baudelaire, these pictures caused a scandal that Courbet, with his sense for publicity, was quick to use in

promoting himself as the leader of the Realist movement.

Young Ladies from the Village (Plate 114), shown at the Salon of 1852, reiterated the themes and style that had scandalized the public a few years earlier. The picture is indeed still puzzling. Its skewed perspective and awkward integration of the figures into the landscape are hardly more acceptable today than they were when they were ridiculed by the critics in 1852. The picture also contains an element of sharp social criticism: The three *demoiselles* are not just charitable ladies distributing alms to a poor cowherd; overdressed and haughty, they are obviously "parvenues," typical of the new breed of social climbers who rid themselves of social guilt by giving a few *sous* to the poor. The comment is not just social—although traditional Christian charity was often attacked by nineteenth-century socialists as an easy alternative to true justice—it is also aesthetic: The painting ridicules the kind of idyllic peasant-life subjects that were then in favor with those academic painters who were the misguided heirs to a tradition harking back to Boucher and Greuze. In order to describe these painted relatives of Flaubert's Madame Bovary, who daydreamed about the sophistication of the capital, Courbet chose a deceptively naive and vulgar style that lent force to the topicality of the subject.

Continuously commented upon, acclaimed, and rejected at the time, Courbet's works continued to scandalize the public. Although some of his paintings were admitted to the Salon, in a gesture of defiance to the art establishment he preferred to organize (in 1855 and 1867) his own exhibitions in specially rented spaces. The novelty of this approach lent him an even greater visibility. By the time of Courbet's later exhibition, however, many of his paintings no longer dealt with social issues. But if their subjects were no longer controversial, their style continued to be so. Landscapes such as *The Source of the Loue* (Plate 113) or *The Calm Sea* (Plate 118) were still unacceptable to many critics because of their raw realism, extensive use of the palette knife in applying pigment, and simply because of their audacious originality. It is perhaps more than a coincidence that the unadorned here-and-now quality of these landscapes finds a counterpart only in the explorations of artists working with the then-new medium of photography (see Plate 117).

Courbet's treatment by the art establishment casts an interesting light on the politics of art under the Second Empire. *Young Ladies from the Village* was first bought by the emperor's half-brother. Although discreet, semiofficial patronage of the most advanced painters often took place in those days, Courbet's nude, the *Woman with a Parrot* (Plate 115), shocked the prudish Empress Eugénie, and its promised purchase by the state never took place.

Under the Second Empire the arts enjoyed a revival. Public commissions, an ambitious building program, and the official support of many artists had once again turned the eyes of the world toward Paris as the artistic capital *sans pareil*. The disasterous politics of Napoleon III were ameliorated to a certain extent by his desire to reestablish the tradition of arts partonage that his uncle, Napoleon I (and before him the Bourbons), had so successfully carried out. Typically, many of the artists particularly in favor with Napoleon III, his court, and the art establishment were those content to do little but give old formulas, as it were, a fresh coat of paint. Alexandre Cabanel, the emperor's favorite painter, was entrusted with the decoration of many buildings as well as commissions for easel paintings. He somehow managed to reconcile the allegorical world of Boucher with the cold technique of an uninspired pupil of Ingres. In portrait painting, despite much original work going on among more advanced artists, the favorite of the court was F. X. Winterhalter. An artist of German origin but of truly cosmopolitan career and upbringing, he reformulated in his many portraits of Empress Eugénie (see Plate 120), for instance, the grace and spirited animation, which, a century earlier, had established the success of the Rococo painters. The obsession of Second Empire society with the eighteenth century bespoke a desire to avoid facing the harsh social realities of the time. The fashionably huge crinolines, so flagrantly impractical for those using the new public transportation, and the proliferation of Sèvres porcelain painted in the manner of the eighteenth century are only two examples of this need to live in an illusion of the past.

In the best instances, however, the revival of earlier styles could result in works of great originality, for example, the sculpture of J. B. Carpeaux, whose *Ugolino* (Plate 109) embodied in the eyes of its contemporaries a spirit and masterly technique worthy of Michelangelo and launched the artist's career. Important commissions were subsequently given to him, such as the famous group *Dance* for the façade of the new Paris Opera or official portraits of the emperor (Plate 122), works that betray the artist's sympathy for Baroque sculpture (Bernini's in particular) and yet offer a wholly new spirit and energy.

It was not just the eighteenth century that captivated the spirit and imagination of this society on its way to industrialization and technological progress. For many artists the world of the Renaissance or of medieval times exerted an equally strong fascination. In France an architect like Viollet-le-Duc painstakingly restored medieval castles and churches. In England William Morris and the Arts and Crafts Movement revived the centuries-old traditions of the craft guilds in a desperate effort to resist the encroachment of modern industrialization (see Plates 88, 89), while the pallid medieval evocations of Sir Edward Burne-Jones (see Plate 90) conjured up the images and values of a chivalric world at odds with the soot and squalor of England's burgeoning industrial centers.

Two mysterious images of startling originality may well serve as a kind of epilogue to the age. The first is the *Oedipus and the Sphinx* of Gustave Moreau (Plate 112): Instead of finding in antiquity the heroic clarity that had so often helped his comrades define a new language, Moreau can offer only an image of unyielding interrogation and impenetrable riddle. The other is a photograph by the Mayer and Pierson firm of the Countess Castiglione (Plate 121), who casts a cryptic glance at us from behind a mask she holds to her eye, a gaze as enigmatic as the period in which she lived.

J. Patrice Marandel

17

1 *Ancient Rome*, 1757
Giovanni Paolo Pannini
Italian (Rome), 1691–1765
Oil on canvas; 67¾ x 90½ in.
(172.1 x 229.9 cm.)
Gwynne Andrews Fund, 1952
(52.63.1)

GIOVANNI PAOLO PANNINI
Ancient Rome and *Modern Rome*

By the beginning of the eighteenth century serial views of famous monuments or landscapes had become a staple of the interior decoration of Continental palaces and English country houses. A number of artists, primarily in Italy, maintained large studios with many assistants in order to meet the demand for picturesque views. Canaletto, his nephew Bernardo Bellotto, and Francesco Guardi, all based in Venice, are the best known of the view painters, but in *capricci* —fantastic renderings of imaginary scenes—they were surpassed by their Roman contemporaries Giovanni Battista Piranesi and Giovanni Paolo Pannini.

These two paintings, executed at the high point of Pannini's career, are among the artist's most brilliant inventions, illustrating the great monuments of imperial and papal Rome with a unique formula. Combining the Flemish tradition of picture-gallery scenes with the Italian tradition of architectural views, Pannini depicts Rome in a series of paint-

2 *Modern Rome*, 1757
Giovanni Paolo Pannini
Italian (Rome), 1691–1765
Oil on canvas; 67¾ x 91¾ in.
(172.1 x 233 cm.)
Gwynne Andrews Fund, 1952
(52.63.2)

ings arranged on the walls of an imaginary, sumptuous, nave-
like space. They were commissioned by the artist's friend
and patron, the comte de Stainville, later duc de Choiseul,
who stands with a book and walking stick before Pannini's
copy of the *Aldobrandini Wedding* in *Ancient Rome* (Plate 1).
De Stainville was in many ways the quintessential eighteenth-
century nobleman: well traveled, well read, clever in his busi-
ness affairs, an able courtier and diplomat who indulged in
voracious collecting of painting, sculpture, and art objects.

Among the celebrated monuments shown in *Ancient Rome*
are the Pantheon, the Colosseum, and Trajan's Column, as
well as the *Farnese Hercules* and the *Laocoön.* In the center of
Modern Rome (Plate 2) is Michelangelo's *Moses;* on the walls
are views primarily of the work of Bernini: the square of
Saint Peter's, the Piazza Navona, and many of his fountains;
while the marbles of *David* and *Apollo and Daphne* are framed
by the colonnade at the rear.

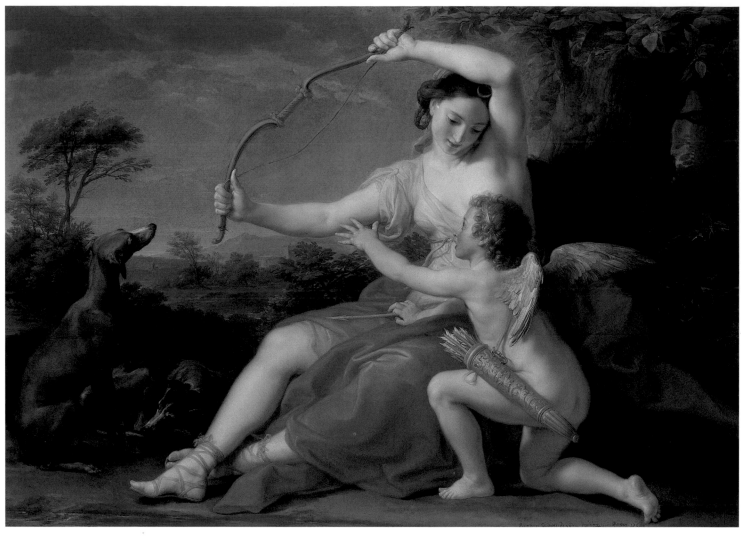

3 *Diana and Cupid*, 1761
Pompeo Girolamo Batoni
Italian (Rome), 1708–87
Oil on canvas; 49 x 68 in. (124.5 x 172.7 cm.)
Purchase, The Charles Engelhard Foundation, Robert Lehman
Foundation, Inc., Mrs. Haebler Frantz, April R. Axton,
L.H.P. Klotz and David Mortimer Gifts; and Gifts of Mr. and
Mrs. Charles Wrightsman, George Blumenthal and J. Pierpont
Morgan, Bequests of Millie Bruhl Fredrick and Mary Clark
Thompson and Rogers Fund, by exchange, 1982 (1982.438)

Opposite: detail

POMPEO GIROLAMO BATONI
Diana and Cupid

The son of a goldsmith, Pompeo Batoni demonstrated in his early paintings a love of polish and precision that became the hallmark of his mature style. Coupled with a genuine taste for antiquity and a facility for elegant draftsmanship, Batoni's natural gifts and acquired skills propelled him to the position of preeminent Neoclassical painter in Rome. By the third quarter of the eighteenth century, Batoni was widely considered the greatest living painter in Italy, and this picture was regarded by the circle of his patrons in Rome —wealthy English dilettantes—as "the best picture [the artist] ever made."

Diana and Cupid in many ways epitomizes the Italian Neoclassical style: It makes a learned reference to antiquity, both in the pose of Diana, which Batoni derived from a marble statue of Ariadne in the Vatican collection, and in the scene he depicts, which he took from Ovid's *Metamorphoses;* it is conceived in a sweet and felicitous color scheme; and it is executed with a suave, smoothly articulated vocabulary of forms.

GAETANO GANDOLFI
Alexander Presenting Campaspe to Apelles

Ubaldo Gandolfi, his younger brother, Gaetano, and the latter's son, Mauro, represent the last flowering of a glorious tradition in Bolognese figurative painting that was begun in the last years of the sixteenth century by the members of another distinguished family of artists, the Carracci. Gaetano, the most celebrated of the Gandolfi, enjoyed an international reputation and painted not only for Italian patrons but also for clients in Austria, England, and Russia.

This softly modeled black-chalk drawing by Gaetano—a late sheet done in 1797—is classical in both subject matter and composition. It reflects a growing Neoclassicism that began to appear in his work during the last decade of his life.

4 Alexander Presenting Campaspe to Apelles, 1797
Gaetano Gandolfi
Italian (Bologna), 1734–1802
Black chalk, heightened with white, on brownish
paper; 12 1/16 x 16 7/8 in. (30.6 x 42.9 cm.)
Rogers Fund, 1962 (62.132.3)

5 *Johann Joachim Winckelmann (1717–68)*
Anton Raphael Mengs
German, 1728–79
Oil on canvas; 25 x 19⅜ in.
(63.5 x 49.2 cm.)
Harris Brisbane Dick Fund, 1948 (48.141)

ANTON RAPHAEL MENGS
Johann Joachim Winckelmann

Anton Raphael Mengs, who was extremely active during the middle of the eighteenth century in a number of European cities, including Dresden, Rome, and Madrid, is remembered as much for his association with the historian Johann Joachim Winckelmann as for his easel paintings or the grand decorative cycles on which he worked. Mengs met Winckelmann in Rome in 1755. They worked together on a catalogue of the ancient sculpture in the Belvedere court at the Vatican and struck a deep friendship. The year before, Winckelmann had published his first treatise, *Thoughts on the Imitation of Greek Works in Painting and Sculpture*, and in 1760–61 Mengs painted the first full exposition of the work: the *Parnassus* for Cardinal Albani. This programmatic

painting embodied precisely the ideals that Winckelmann had promulgated: "For us," he wrote, "the only way to become great and, if possible, inimitable is by imitation of the ancients."

Through Winckelmann's eyes, Mengs developed an appreciation of antiquity sufficient to establish himself as one of the chief proponents, after Jacques Louis David, of the Neoclassical style in Europe. In his portraits, however, he retained a Baroque incisiveness, evident here. Mengs rendered with great sensitivity Winckelmann's fine features, posing him casually, as if he had been interrupted while reading Homer's *Iliad*. The portrait probably was painted around 1761.

GIOVANNI BATTISTA PIRANESI
Prisoners on a Projecting Platform

Giovanni Battista Piranesi was a native of Venice, but he went to Rome at twenty and—except for one short trip and one two-year stay back in Venice—lived the rest of his life in the ancient city that was to be the inspiration for and subject of most of his more than one thousand etchings.

Piranesi studied architecture, engineering, and stage design, and his first plans for buildings reveal this background combined with the tremendous impact of classical Roman architecture. The fourteen plates depicting prisons, probably Piranesi's best-known series, were described on the title page as "capricious inventions" when they were first published in 1749–50. These structures, their immensity emphasized by the low viewpoint, derive from stage prisons rather than real ones—real prisons of Piranesi's day in Italy were tiny dungeons—and in fact the image shown here is the only one of the set that shows prisoners. But where are they? On a projecting platform that has no logical reason for being and that is attached, in ways that are unclear, to

giant pilings. A ghostly figure seems to be watching them from the lower left. Such anomalies, and the many spatial ambiguities, are deliberate and are characteristic of the series. By calling the images "invented prisons," Piranesi was free to depict massive unadorned blocks that would express the vastness and strength he experienced in contemplating Roman architecture. The prints probably also carry echoes of Piranesi's boyhood experience of watching men build the great seawalls of Venice.

Piranesi was one of just a few great printmakers who were not also great painters. Giuseppe Vasi, an etcher of Roman views who was, briefly, Piranesi's teacher, said that Piranesi was "too much a painter to be an etcher." But, as the eminent Piranesi scholar Andrew Robinson wrote in connection with this remark: "To the contrary, Piranesi was so much a 'painter'—concerned with grandeur of form, light, tone, space, and mass and able to create these effects swiftly and directly —that he was a truly exciting printmaker."

6 *Prisoners on a Projecting Platform*,
Plate X of *Carceri*, 1749–60
Giovanni Battista Piranesi
Italian, 1720–78
Etching with engraving, sulphur tint or open bite,
burnishings; 16½ x 21¾ in. (41.7 x 55.3 cm.)
Harris Brisbane Dick Fund, 1937 (37.45.3 [33])

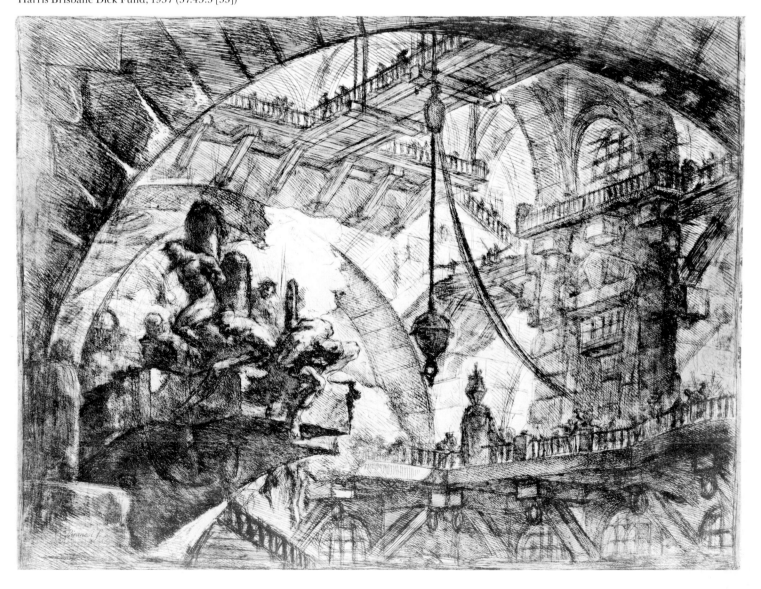

GIOVANNI BATTISTA PIRANESI
The Arch of Constantine and the Colosseum

Piranesi's *Vedute di Roma* (*Views of Rome*) were not produced as a finite set but rather were made over a period of some thirty years, from 1748 until the artist's death. They were sold as souvenirs for the lay public to take home from the Grand Tour, serving also as advertisements for the splendors of Rome. For some visitors, they fulfilled the latter function all too well: Goethe, for example, was disappointed when he got to Rome; the buildings did not look nearly so grand as Piranesi's etchings had led him to expect. The *Vedute* are not "inventions," like the *Prisons*, but are accurate renditions of the ancient Rome to which, in a sense, Piranesi's life was dedicated. His love of the Roman buildings was that of an archaeologist, and his less well-known works include detailed and exact renditions of the great utilitarian structures that made it possible for the Roman Empire to function. In the words of A. Hyatt Mayor:

He went at Rome's weedy lumps of ruin like an anatomist at a cadaver, stripping, sectioning, sawing until he had established the structure in all its layers and functions. Sometimes he removed accretions from columns embedded in the slums of Rome until he laid them bare like bones in a loneliness of sand. His method is the method of autopsy, and his books rank with the great books of anatomy, for he was the first, and remains the most dramatic, dissector of ruin.

Here the artist shows the Colosseum in a view from the Palatine Hill, in which, because of the accidents of destruction, the complexities of its structures are revealed. Yet Piranesi's scientific sense was matched by his aesthetic one, and the balance and liveliness of the composition, as well as the shimmer of light created by the parallel squiggles of etched lines, give the print an effect that completely transcends the documentary.

7 *The Arch of Constantine and the Colosseum*, 1750s
Giovanni Battista Piranesi
Italian, 1720–78
Etching; 15⅞ x 21⅜ in. (40.4 x 54.5 cm.)
Harris Brisbane Dick Fund, 1937 (37.45.3 [65])

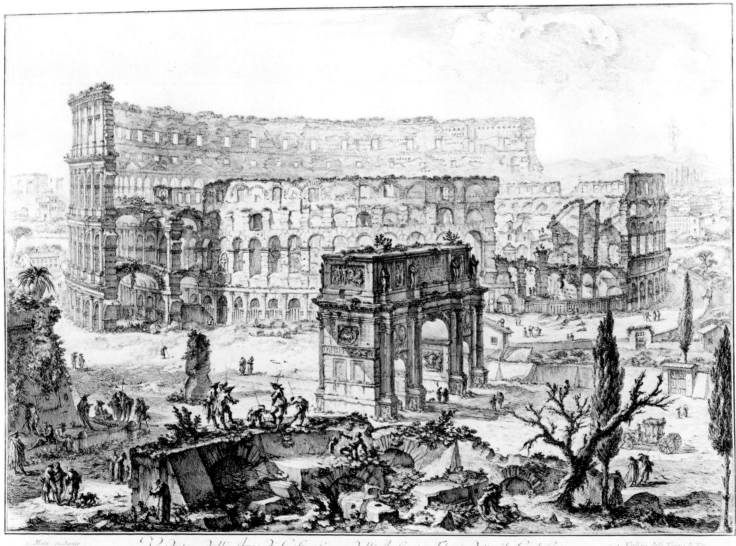

8 *Console Table*, ca. 1782–92
Attrib. to Giuseppe Maria Bonzanigo
Italian, 1745–1820
Painted and gilded poplar, marble top;
36½ x 57 x 25½ in. (92.7 x 144.8 x 64.8 cm.)
Rogers Fund, by exchange, 1970 (1970.4)

Above: detail

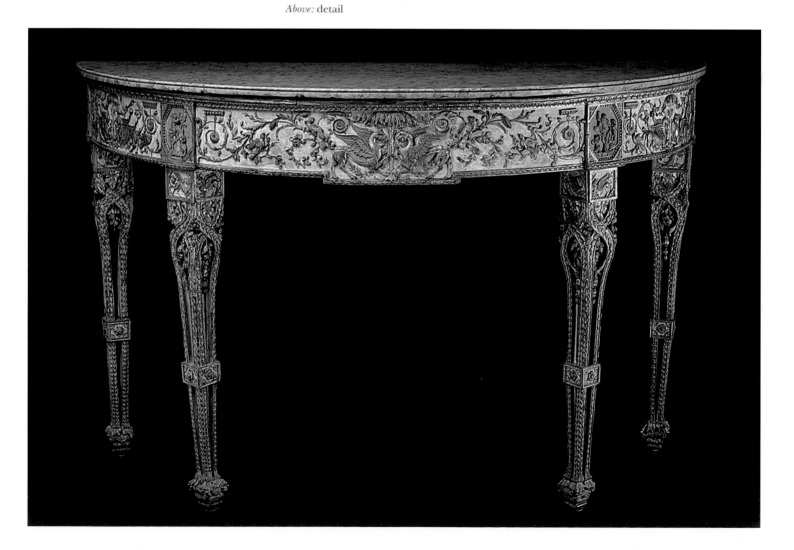

GIUSEPPE MARIA BONZANIGO
Console Table

This magnificent semicircular console table, displaying elaborate carving, is likely to have been executed by sculptor and furniture maker Giuseppe Maria Bonzanigo. It may have been made as a royal commission, since Bonzanigo was extensively employed by Victor Amadeus III of Savoy. Comparable pieces by Bonzanigo are found in the Palazzo Reale in Turin and in the royal hunting lodge in Stupinigi, just outside that city. The table's gilded decoration consists of foliated scrolls, birds, griffins, sphinxes, and other fantastic animals as well as mythological figures in hexagonal medallions. Its Neoclassical ornament, based largely on engravings by Michelangelo Pergolesi, and the elegant openwork legs are exquisitely refined in design and execution.

9 Fan with Scenes of Vesuvius and Pompeii
Italian, 1786
Painted parchment leaf, sticks and guards of tortoise
shell with gilt-metal decoration, glass stud;
L. 10⅝ in. (27 cm.), W. 20 in. (50.8 cm.)
Gift of Mrs. William Randolph Hearst, 1963 (63.90.26)

FAN WITH SCENES OF VESUVIUS AND POMPEII

The Grand Tour, or extended travel on the European continent, began in the seventeenth century as an educational experience for the ruling classes, but by the later eighteenth century it had become de rigueur for well-bred English and American gentlemen. Of the many places on the Continent visited, Italy held greatest importance, particularly the cities and environs Rome, Venice, Florence, and Naples. The latter became even more important following the 1748 excavation of Pompeii and the increasingly frequent eruptions of Vesuvius.

In lieu of picture postcards, fans—or just the painted leaf—with depictions of the major sites (identified, lest one forget) could be purchased. Typically, the leaf would show three scenes. In this example the center, dated 1786, depicts a nocturnal view of activity at Vesuvius. To either side are views of Pompeii. At the left the scene is identified as "Avanti colonnata del quartiere de' Soldati di Pompei," or the soldiers' quarters. In reality what is shown are several of the seventy-four Doric columns that formed a portico around the square connecting two theaters. The misnomer dates from 1766, when excavations in the area produced greaves, helmets, and weapons. The "Porta del Pompei" shown at right is rendered in sufficient detail to identify it as the Herculaneum Gate. Classical motifs used in the decorations at Pompeii inspired the designs that fill the interstitial spaces on the front leaf as well as the grotesques on the back.

Antonio Canova
Perseus with the Head of Medusa

The Venetian Antonio Canova was the preeminent sculptor of the age of Neoclassicism and a prodigiously talented carver of marble. This medium was quintessentially suited to the taste of the age, and in Canova's hands it yielded brilliant effects, at once pristine and sensual, that fulfilled the notions of a classical past embraced by his contemporaries.

Here Perseus stands coolly triumphant, holding aloft the severed head of the snake-haired gorgon Medusa, the sight of which will turn into stone anybody gazing upon it. His pose and demeanor vividly recall that of the *Apollo Belvedere*, the work of antiquity most admired in Canova's era. But the extended sweep of Perseus's cloak endows the figure with a buoyant élan quite unlike its self-contained classical forerunner, and the sleek majesty and streamlined lyricism mark this unmistakably as the work of its own age.

Although Canova was the sculptor associated more than any other with the Napoleonic era, he was content to work for patrons of varying political convictions. The first version of the Perseus had, in fact, been acquired by Pope Pius VII as a replacement for the *Apollo Belvedere* itself, one of the Greek sculptures that Napoleon had removed from the Vatican and shipped to the Louvre upon his conquest of Italy.

The understudy succeeded so handsomely that when the Congress of Vienna compelled the restitution of the Napoleonic booty, the Vatican retained Canova's composition as a companion to the returned *Apollo*. This second, slightly revised version of the composition was acquired by a young Polish couple, Count and Countess Tarnowski, who had seen it in Canova's studio on their Grand Tour visit to Rome.

10 Perseus with the Head of Medusa,
1804–06
Antonio Canova
Italian, 1757–1822
Marble; H. 86⅝ in. (217 cm.)
Fletcher Fund, 1967 (67.110.1)

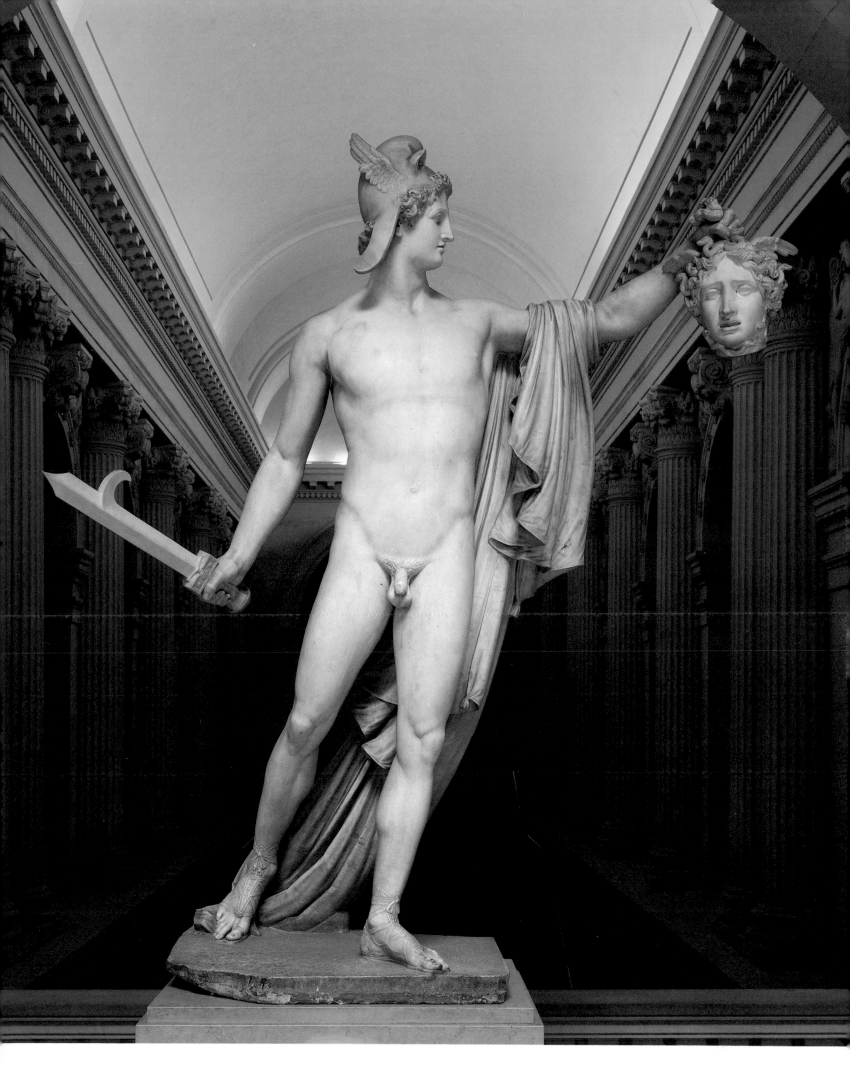

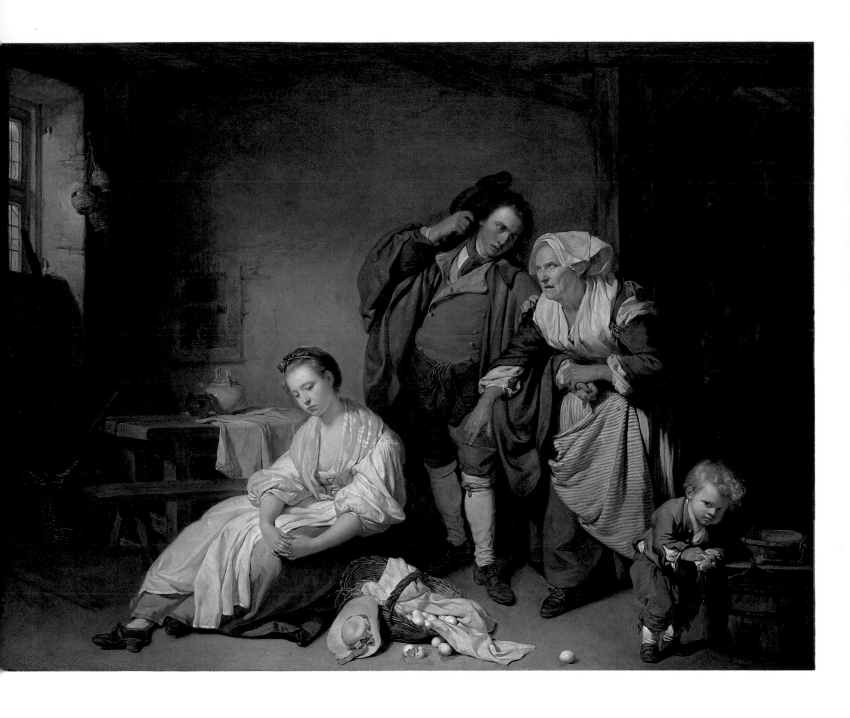

Jean Baptiste Greuze
Broken Eggs

Jean Baptiste Greuze, extolled by Denis Diderot as one of the greatest painters of his day, was a principal proponent of the shift in emphasis in French painting from scenes of pleasurable pursuits, in the manner of Jean Antoine Watteau and François Boucher, to objects of moral instruction, in the manner of Jacques Louis David. From the beginning of his career Greuze demonstrated a predilection for genre scenes, and through engravings of these pictures, as well as through public prompting by critics like Diderot, his pictures of moments of awakening conscience in the lives of ordinary people exerted considerable influence on contemporary painting.

Greuze painted *Broken Eggs* (Plate 11) in Rome in 1756,

soon after his arrival there for study. When it was exhibited in Paris the following year, it bore a long title that specified its moralizing tone: *A Mother Scolding a Young Man for Having Upset a Basket of Eggs that the Servant Girl Brought from the Market; A Child Attempts to Put an Egg Back Together*. Even to the unsophisticated observer, the broken eggs would have been understood as a symbol for lost virginity; fortunately, in this instance we have an explanation of the picture by the well-versed critic of contemporary mores, the abbé J. J. Barthélémy:

A girl had a basket of eggs; a young man toyed with her, the basket fell, and the eggs were broken. The girl's mother ar-

11 *Broken Eggs*, 1756
Jean Baptiste Greuze
French, 1725–1805
Oil on canvas; 28¾ x 37 in. (73 x 94 cm.)
Bequest of William K. Vanderbilt, 1920
(20.155.8)

*Bi. Mel—
Thank you for
all you've
done—
Nancy E. McCool
'96*

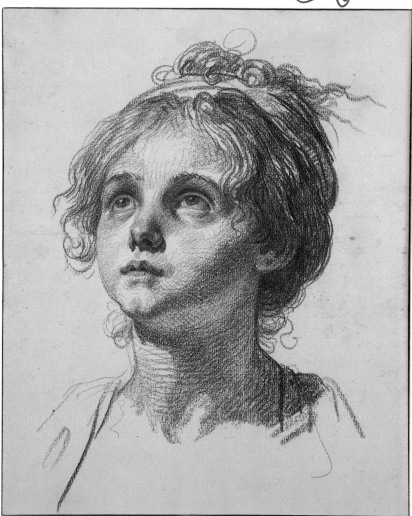

12 *Head of a Girl Looking Up*
Jean Baptiste Greuze
French, 1725–1805
Red chalk; 13⅞ x 11⅛ in.
(35.3 x 28.4 cm.)
Rogers Fund, 1949 (49.131.2)

rives, seizes the young man by the arm and demands compensation for the eggs; the bewildered girl is seated on the floor; the embarrassed young man makes the worst excuses in the world, and the old woman is in a fury; a child thrown into the corner of the picture takes one of the broken eggs and tries to repair it . . . the figure of the girl has a pose so noble that she could embellish a history painting.

Naturally, virginity cannot be restored once lost, any more than an egg can be repaired once broken, thus the uncomprehending determination of the young boy throws into greater relief the agitation of the girl's mother. This painting, along with its pendant, *The Neapolitan Gesture* (Hartford, Connecticut, Wadsworth Atheneum), was engraved;

the prints were sold together and they were circulated widely.

Greuze paid particular attention to the facial expressions and gestures of the figures in his compositions in order to convey with the greatest possible clarity the emotion and drama of the scene.

The beautiful drawing of a young girl (Plate 12) is a fine example of Greuze's consummate ability as a draftsman and typical of his many large-scale head studies, which, executed in chalk, were not always drawn with specific paintings in mind but, like them, were sometimes later engraved for prints. Although not connected with a specific painting, *Head of a Girl Looking Up*, was engraved in reverse by Pierre Charles Ingouf the elder.

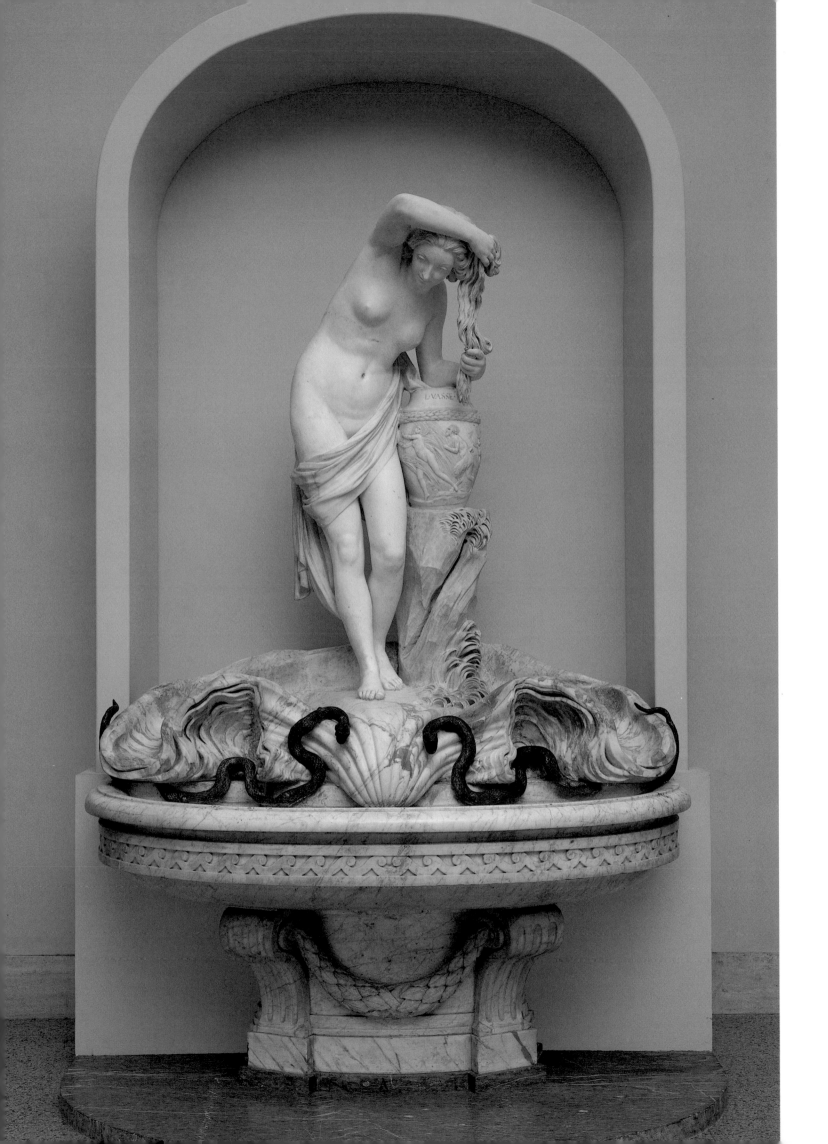

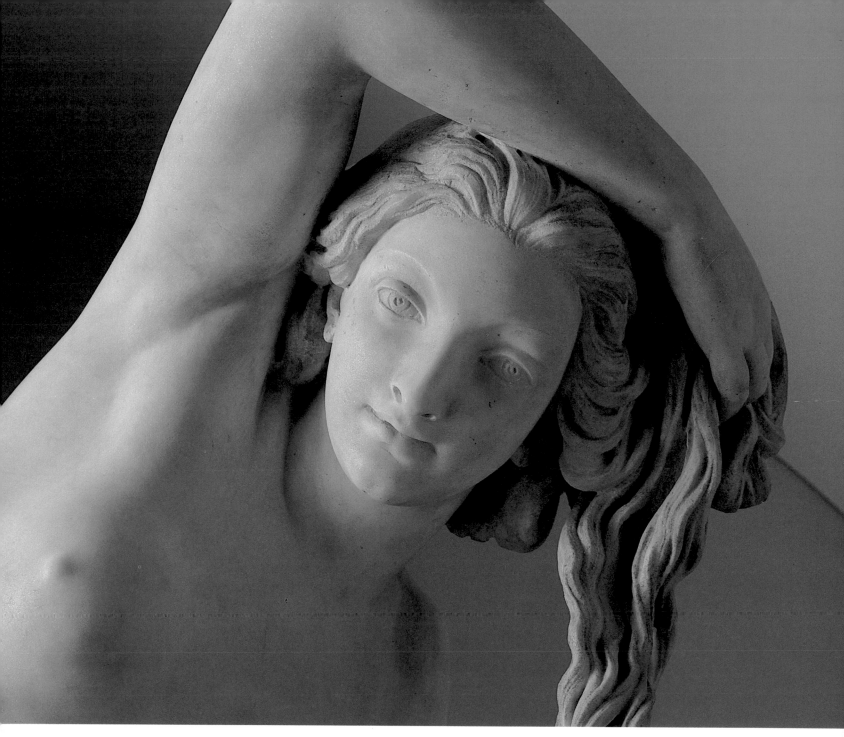

13 *Wall Fountain with a Nymph Drying Her Hair*, 1763
Louis Claude Vassé
French, 1716–72
Marble; H. of figure 59 in. (149.9 cm.) Purchase,
Josephine Bay Paul and C. Michael Paul Foundation,
Inc. and Charles Ulrick and Josephine Bay Foundation,
Inc. Gifts and Rogers Fund, 1971 (1971.205)

Above: detail

LOUIS CLAUDE VASSE

Wall Fountain with a Nymph Drying Her Hair

This fountain adorned the vestibule of the Château de Dampierre. It was carved for the duc de Chevreuse, of the Luynes family in whose keeping it descended until this century.

Water filled the basin through the jaws of the snakes beneath the curves of the outsize shell. While the sight and the sound of water must have done much to enliven the composition, it is the nymph herself that most successfully carries the aquatic imagery. She stands as if transported from a river's edge, squeezing moisture from her soaked tresses. The urn at her side bears a relief of Pan pursuing Syrinx,

a nymph who escaped from Pan's amorous assault by being transformed into a water reed.

There is manifest delight in the control of the nymph's pose, her arm hooked above and framing her head with its look of delicious surprise. Vassé also shows his range in the selection of ornament, encompassing both the rough supporting shell and the chaste "Vitruvian" scrollwork pattern below the basin's rim. In sum as in its parts, the composition encapsulates the classicism of the later Louis XV period at its most relaxed and assured.

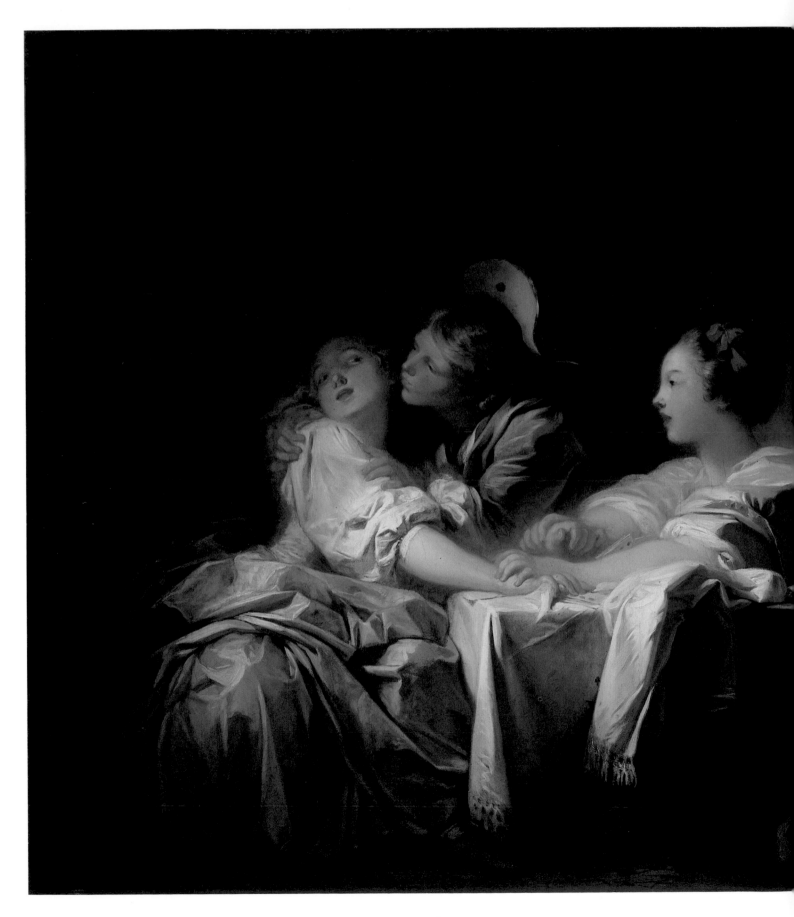

14 The Stolen Kiss
Jean Honoré Fragonard
French, 1732–1806
Oil on canvas; 19 x 25 in. (48.3 x 63.5 cm.)
Gift of Jessie Woolworth Donahue, 1956
(56.100.1)

JEAN HONORE FRAGONARD
The Stolen Kiss

Almost four years after winning the coveted Prix de Rome in 1752 with a large historical painting, *Jeroboam Sacrificing to the Idols* (Paris, Ecole des Beaux-Arts), Jean Honoré Fragonard left Paris for Italy. Under the directorship of Charles Joseph Natoire at the French Academy in Rome, Fragonard followed a course of study that progressed from copying the Italian Baroque painters Pietro da Cortona, Guido Reni, and the Carracci, to working from nature in the Roman Campagna. His study of the Italians, with their rich color harmonies and dramatic lighting, had an immediate impact on his art. Indeed, the composition and bold play of chiaroscuro in *The Stolen Kiss,* painted during Fragonard's Italian sojourn, arguably owe some debt to Pietro da Cortona's example. While the palette and atmospheric effects of this picture anticipate Fragonard's style of the mid-1760s, his treatment of the figures—especially at left and in the background—nevertheless reminds us that Fragonard was trained under François Boucher.

JEAN HONORE FRAGONARD
Le Dessinateur

The grace, elegance, and seemingly effortless competence of his draftsmanship have long made Jean Honoré Fragonard a favorite with drawing collectors. As early as 1765, when a group of Italian landscape drawings by the artist was exhibited in the Salon, Pierre Jean Mariette—one of history's greatest connoisseurs—had nothing but praise for Frago-nard's abilities. The use of black chalk in the garden scene reproduced here is somewhat unusual for Fragonard: More often than not, he chose red chalk for his drawn landscape compositions. *Le Dessinateur* is one of three fine drawings by Fragonard that came to the Metropolitan Museum with the Robert Lehman Collection.

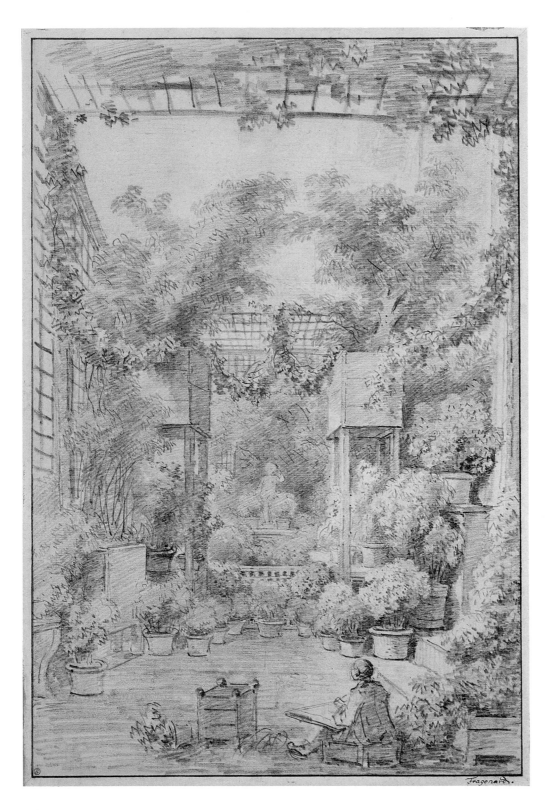

15 Le Dessinateur
Jean Honoré Fragonard
French, 1732–1806
Black chalk; 13⅝ x 9½ in.
(34.6 x 24.2 cm.)
Robert Lehman Collection,
1975 (1975.1.626)

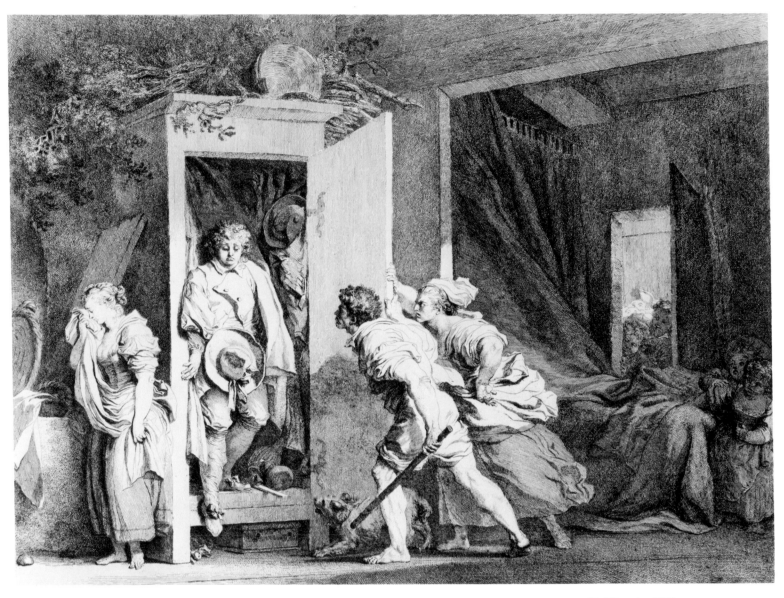

16 L'Armoire, 1778
Jean Honoré Fragonard
French, 1732–1806
Etching; 16½ x 21⅞ in. (42 x 51.3 cm.)
Purchase, Roland L. Redmond Gift,
Louis V. Bell and Rogers Funds, 1972
(1972.539.2)

JEAN HONORE FRAGONARD
L'Armoire

Fragonard made, in addition to his paintings and drawings, thirty etchings, including some original landscapes inspired by a trip to Italy and plates after paintings by Italian masters. Most of these were made in 1763–64. He then did no more etching until 1778, when he produced *L'Armoire*, his largest and most complex print. The story is clear: The amorous encounter of the young couple, evidenced by the rumpled bedclothes, was interrupted; the young man quickly hid in the closet but was discovered by the irate older couple, probably the girl's parents. The young man steps out shamefacedly, holding his hat over his groin, while the young woman wipes her eyes on her apron. The children standing at the foot of the bed seem anxious about the outcome of the drama; the others, in the doorway, are amused by it.

This kind of theatrical situation with a moral component, in which the viewer's emotions were meant to be engaged, was often represented in French art of this period, most notably in that of Jean Baptiste Greuze. In addition, the hat, which calls attention to the young man's sexual arousal at the same time it hides it, would put the print in the category of *estampes galantes*, prints showing erotic subjects, which were sought after by certain collectors of the day.

18 The Love Letter
Jean Honoré Fragonard
French, 1732–1806
Oil on canvas;
32¾ x 26⅜ in. (83.2 x 67 cm.)
The Jules Bache Collection,
1949 (49.7.49)

JEAN FREMIN
Snuffbox

Although introduced into Europe from America as a medicinal aid, the practice of taking snuff became a fashionable social custom by the late seventeenth century. The powdered tobacco was carried in small boxes with hinged lids called *tabatières*, or snuffboxes.

Snuffboxes in precious or exotic materials were popular luxury items and were often presented as gifts. All surfaces of the exquisitely crafted *objets*, including the bottom, were decorated because they were not meant to be displayed but to be handled and carried on the person or in a purse. Among the Paris goldsmiths who excelled in the production of gold boxes was Jean Frémin. This example from his workshop exhibits a layering of abstract patterns and naturalistic motifs that is characteristic of Rococo design and that recalls textiles of the period. Like water stirred by crosscurrents of wind, engraved *rocaille* scrolls and meandering ribbons of gold enliven the surfaces of the oval box. Individual leaves and flowers, enameled *en plein* (directly onto the surface of the snuffbox), seem to emerge from the engraved and chased surfaces as though floating among shimmering waves of gold. The delicate charm of *en plein* enameling belies the technical virtuosity required, as each color is fired at a different temperature. It is likely that an enameler specializing in snuffboxes collaborated with Frémin.

17 Snuffbox, 1756–57
Jean Frémin
French, 1714–86
Gold, enamel, bloodstone, lapis lazuli,
and pearl; L. 3⅜ in. (8.6 cm.)
Gift of Mr. and Mrs. Charles Wrightsman,
1976 (1976.155.14)

JEAN HONORE FRAGONARD
The Love Letter

When Jean Honoré Fragonard failed to exhibit in the Salon of 1769, the press rumored that "the lure of profit and the interest in boudoirs and wardrobes [had] diverted the painter from striving after glory." It is true that after 1767 Fragonard had ceased to show in the Salon, abandoning historical and religious painting for piquant amorous scenes, rustic landscapes, and decorative panels that won him great favor among a select, private clientele. In the early 1770s, he was afforded the patronage of the wealthy connoisseur Bergeret de Grancourt, as well as the celebrated ballet dancer Mademoiselle Guimard; he had also gained entry as decorator for Madame du Barry, Madame de Pompadour, and Louis XV at Bellevue, Louveciennes, and Versailles, respectively.

Fragonard, who excelled in depicting the fashionably attired female, endowed his subjects with a charm, liveliness, and elegance that epitomized and catered to Rococo taste. *The Love Letter*, a characteristic work that probably dates to the 1770s, shows Fragonard's great technical facility—the spontaneity of his brush and his keen coloristic sense—as well as a gay imagination and joyful spirit that preclude from human passion any note of coarseness.

While the subject of this picture is perhaps easily deciphered by the twinkling gaze and mischievous half-smile of the sitter, who clutches a love note and bouquet of flowers, the inscription, which is only partly legible, has caused some debate as to the identity of the young woman dispatching the letter. The inscription may read simply, "to my cavalier," or it may say, "A Monsieur Cuvillier," identifying the recipient as the son-in-law of the painter François Boucher, and thus the model as Boucher's daughter, Marie Emilie, the widow of the painter Baudouin, who in 1773 married Charles Etienne Gabriel Cuvillier.

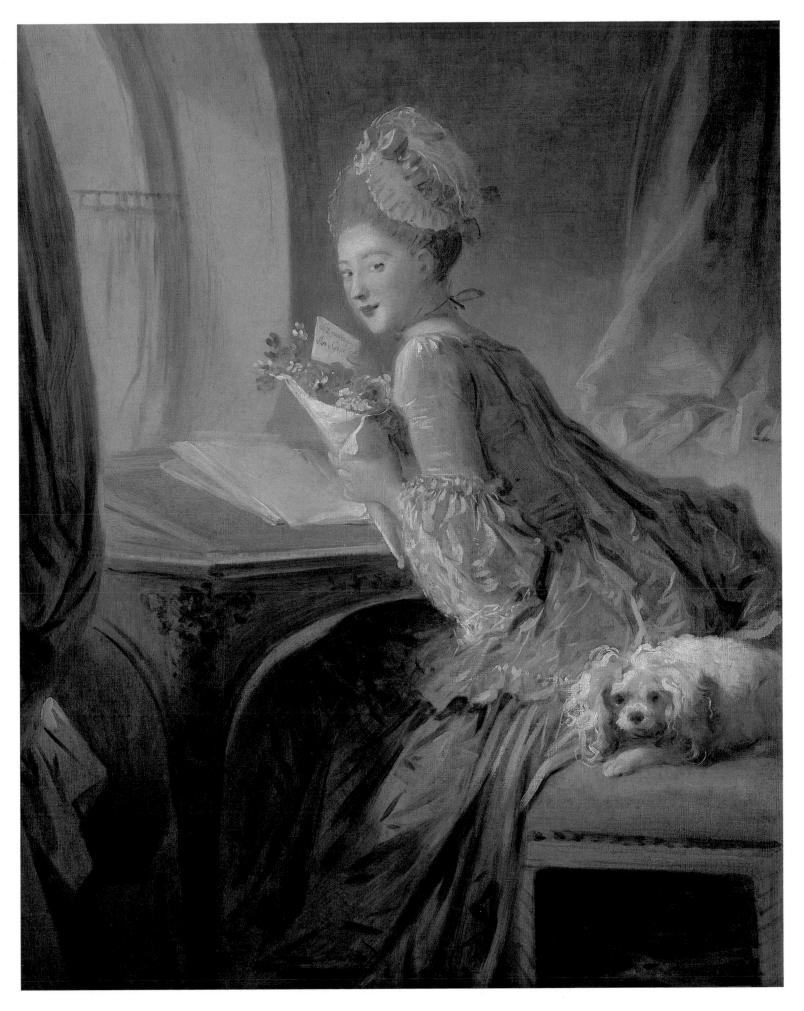

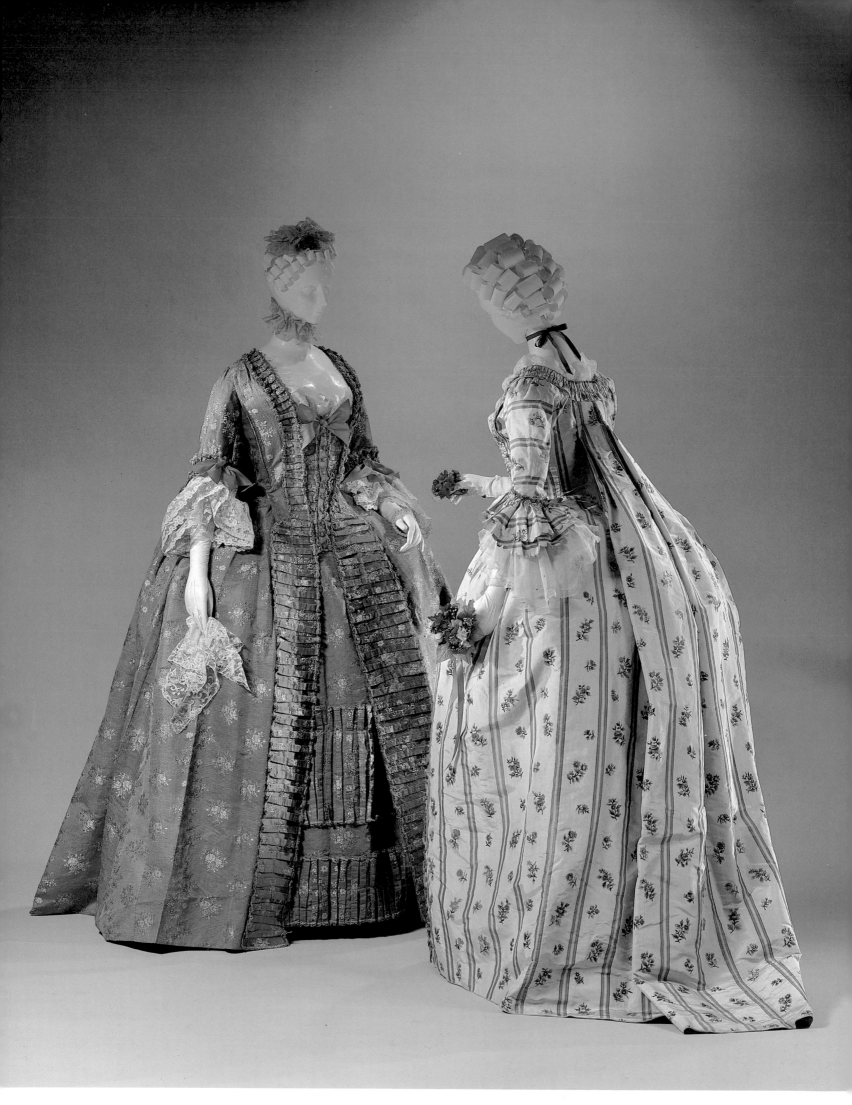

Two Silk Dresses

The costume silhouette represented in these two examples of the style known as the *robe à la française* is one of the most familiar from the eighteenth century. The flowing backs of these dresses, which identify the style, combine with the elliptical skirts to mirror the quality of line found in the other decorative arts of the 1770s. The colors and textures of the patterned silk textiles indicate a change from the complex intertwining spatial relationships of earlier motifs to one more separate and linear. The stripes that become particularly prominent in the last quarter of the century are implicit in the placement of the motifs in the earlier green dress but explicit in the rows of well-spaced painted flowers between woven stripes in the later white dress. The luxury of these silks would have made the dresses among the most valued possessions of the ladies who wore them.

19a Green silk dress (robe à la française)
French, ca. 1770
Silk, brocaded in polychrome floral
pattern on textured ground
Rogers Fund, 1932 (CI 32.35.2ab)

19b White silk dress (robe à la française)
French, ca. 1778
Silk, with green woven stripes and painted
floral patterns on taffeta ground
Purchase, Irene Lewishohn Bequest, 1954
(CI 54.70ab)

Melchior Rene Barre
Etui for Sealing Wax

This étui, of a form designed to hold sealing wax, lacks the personalized stamp of the owner normally found on the bottom of such a case. The repertoire of fine Neoclassical ornament that decorates the two-part cylinder is executed in a variety of metalworking techniques and in three tones of gold colored with copper and silver alloys. Trophies consisting of objects associated with pastoral and mythological romance are suspended from ribbons against the densely stippled ground; they are references to the exchange of messages of love in envelopes sealed by wax impressed with the sender's stamp.

20 *Etui for Sealing Wax*, 1775
Melchior René Barré
French, d. 1791
Gold; L. 4⅝ in. (11.8 cm.) Bequest of
Kate Reed Blacque in memory of her
husband, Valentine Alexander Blacque,
1938 (38.50.32a,b)

OVERLEAF:

Mantel Clock (Pages 42–43)

About the middle of the eighteenth century, the making of cases for French mantel clocks began to pass out of the province of the furniture maker and into the hands of the bronze founder, porcelain modeler, or marble cutter. French clock cases were often related to the sculpture and small decorative objects of the period. This fashion continued into the reign of King Louis XVI, when the carved forms, asymmetrical arrangements, and C scrolls that are the signature of the Rococo designer were superseded by more formal structures preferred by Neoclassical artists.

This clock represents a transition, being both more monumental and clearly structured than the Rococo and more playful and asymmetrical than a true Neoclassical design. A decorative marble base and gilt-bronze pedestal support the clock dial in the form of a copper sphere scattered with gilt-bronze stars and divided by separately revolving hour and minute rings of enamel and gilt bronze. The figure of the youthful Eros on the left points with his arrow to the hour. Above, a cherub holds a wreath of grapes and a floral swag, and at the right sits Father Time. These three bronzes match the sculptor Augustin Pajou's own description of part of a group that he modeled in 1775 for a clock for the prince de Condé from designs provided by the architect Claude Billard de Belisard. Together they represent the *Triumph of Love over Time*. Eros, especially, is very close in style to the relief figure of Apollo in the foyer of the Opéra at Versailles, commissioned from Pajou in 1770. Signed "Lepaute à Paris," the movement was supplied by the workshop of one of the most distinguished clockmaking establishments in eighteenth-century France.

21 Mantel Clock
French, ca. 1775–80
Modeled by Augustin Pajou, 1730–1809; after a design
by Claude Billard de Belisard, act. 1772–90; movement
by the Lepaute workshop: Jean Baptiste, 1750–1843;
Pierre Henry, 1745–1805; Pierre Basile, 1750–1843 Case
of gilt bronze, marble, and copper; H. 37 in. (94 cm.)
Gift of J. Pierpont Morgan, 1917 (17.190.2126)

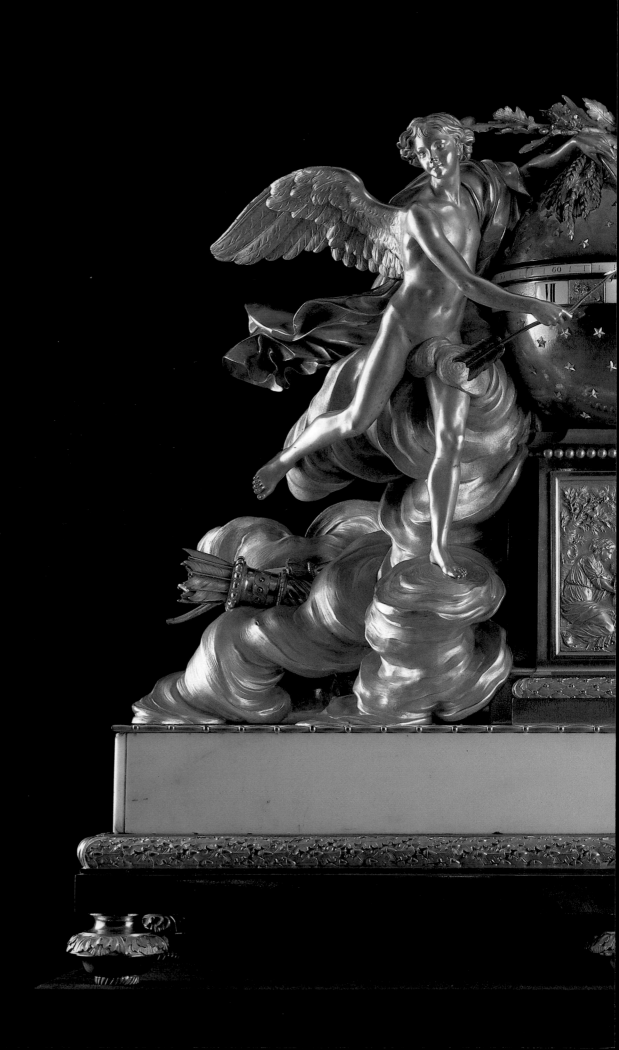

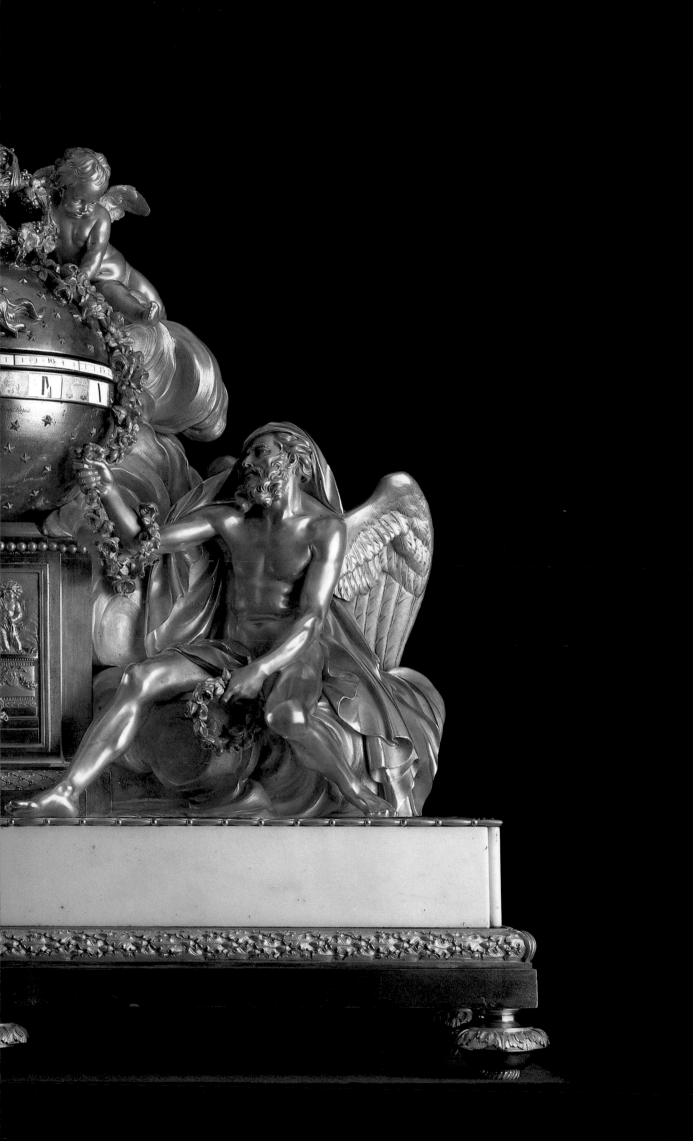

HUBERT ROBERT
Young Artists in the Studio

Hubert Robert was an exact contemporary of Jean Honoré Fragonard, whom he knew when they were both students at the French Academy in Rome. Robert's early interest in architecture and the ruins of classical antiquity was fostered during his years at the academy by his contact with the great Italian masters Giovanni Paolo Pannini and Giovanni Battista Piranesi. When he returned to France in 1765, Robert became a key figure in the development of Neoclassical French art.

To judge from the number of his surviving drawings, Robert was a tireless draftsman. *Young Artists in the Studio*—no doubt a work of the Roman period—is a particularly fine example of his red-chalk draftsmanship. Figural drawings like this one are far rarer in Robert's oeuvre than are architectural and landscape compositions.

22 Young Artists in the Studio
Hubert Robert
French, 1733–1808
Red chalk; 13¹³⁄₁₆ x 16¼ in. (35.2 x 41.2 cm.)
Bequest of Walter C. Baker, 1971 (1972.118.231)

HUBERT ROBERT
The Return of the Cattle

In 1754, two years after securing the patronage of the duc de Choiseul, one of the leading collectors of his day, and of the marquis de Ménars et de Marigny, minister of fine arts, Hubert Robert left under their auspices to study at the French Academy in Rome, where he would remain for the next eleven years. Upon his return to Paris in 1765, the numerous drawings made in Rome and at neighboring villas were used with endless variation in his paintings.

This picture and its pendant, also in the collection of the Museum, were exhibited in the Paris Salon of 1775 as *The Return of the Cattle among the Ruins at Sunset* and *The Portico of a Country Mansion near Florence*. Indeed, the noble Roman ruins in *The Return of the Cattle* are evidently based upon drawings executed in Italy, most notably a sanguine called *Le retour du troupeau*, now in the Musée de Valence. The overall composition is the same, with only a few architectural elements changed: The door on the left surmounted by a pediment in the Valence drawing became in the painting a classical statue in a niche on the right-hand side of the arch, and the groin vault in the drawing has been exchanged for a coffered arch.

In this painting we see the alliance of classical Roman architecture with an everyday contemporary occurrence, the afternoon return of the cattle. It is this successful blend of archaeological reminiscence with French naturalism, worked in delicate tonality, that resulted in the great demand for the work of Hubert Robert during the eighteenth century.

23 The Return of the Cattle
Hubert Robert
French, 1733–1808
Oil on canvas;
80¾ x 48 in. (205.1 x 121.9 cm.)
Bequest of Lucy Work Hewitt,
1934 (35.40.1)

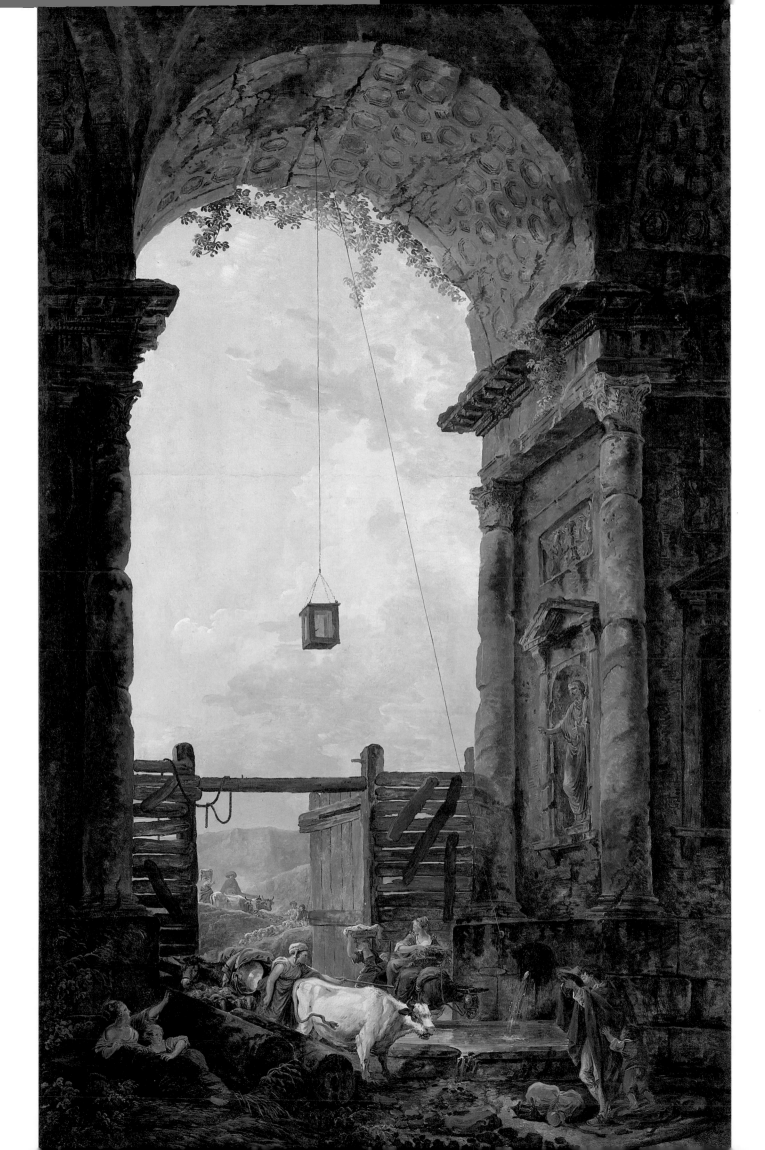

24 *Pair of Vases with Covers*
French (Sèvres), ca. 1763
Soft-paste porcelain;
H. 22½ and 22 ³/₁₆ in. (57.2 and 56.3 cm.)
Gift of R. Thornton Wilson, in memory of
Florence Ellsworth Wilson, 1956 (56.80.1,2)

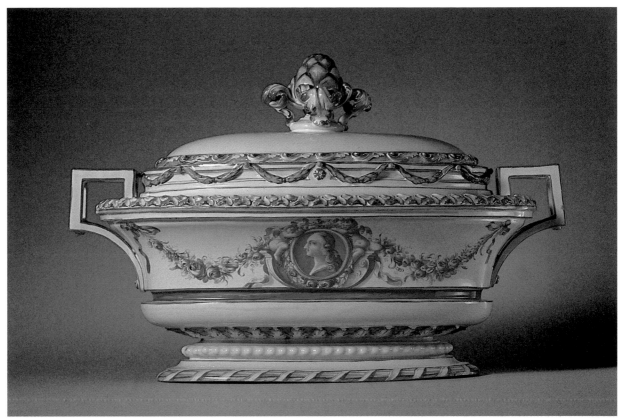

25 Tureen
French (Niderviller factory), ca. 1774–75
Tin-enameled earthenware; L. 15 in. (38 cm.)
The Charles E. Sampson Memorial Fund,
1977 (77.378ab)

PAIR OF SEVRES VASES

The move to new premises in 1756 marked the beginning of a period of great experimentation and invention at the Sèvres porcelain factory, when many new models exhibiting a more restrained Rococo or early Neoclassical style were developed. The model for these fragile covered vases is presumably that described in a 1763 inventory in the factory archives. Each vase is in the form of a tower with projecting cannon muzzles.

The walls are painted with trophies of war and crowns of laurel, both symbols of victory. They hang from alternate openings on ribbons interconnected and entwined with garlands of flowers, oak leaves, and acorns. In this view, the trophies consist of helmets, weapons, and shields that suggest classical and Turkish origins. Another pair of trophies includes plans used in the construction of fortifications, a map of the Kingdom of Naples with tools for measuring distances, a Roman fasces, and a porphyry vase overflowing with gold coins.

FAIENCE TUREEN

The profile portrait in the center of the bowl of this tureen is that of King Louis XV who died in 1774 and in whose memory this piece may have been made; he was a friend of the owner of the Niderviller factory, the comte de Custine. The clay used by the Niderviller factory was exceptionally fine grained and plastic and produced the most refined of all French faience. This example blends Rococo motifs —made orderly and symmetrical—with some of the more overt and easily assimilated features of the Neoclassical style, such as the square-angle handles and pine-cone finial.

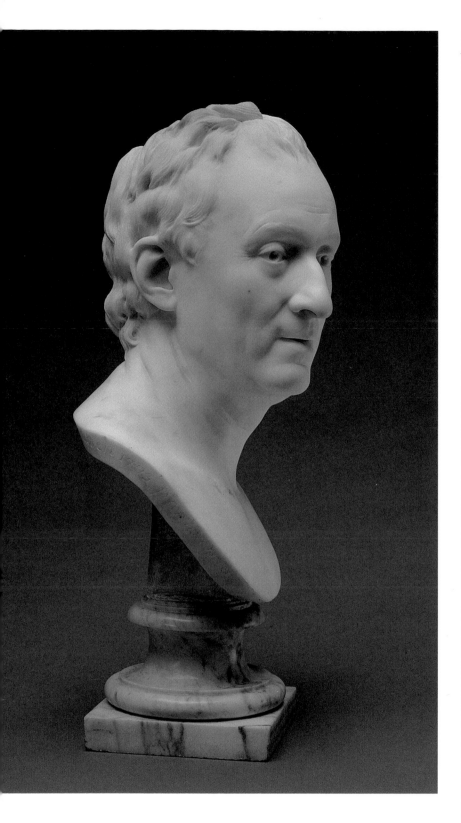

26 *Bust of Denis Diderot*, 1773
Jean Antoine Houdon
French, 1741–1828
Marble; H. 15¾ in. (40 cm.)
Gift of Mr. and Mrs. Charles
Wrightsman, 1974 (1974.291)

27 *Bust of Sabine Houdon*, 1788
Jean Antoine Houdon
French, 1741–1828
Marble; H. 10⅝ in. (27 cm.)
Bequest of Mary Stillman
Harkness, 1950 (50.145.66)

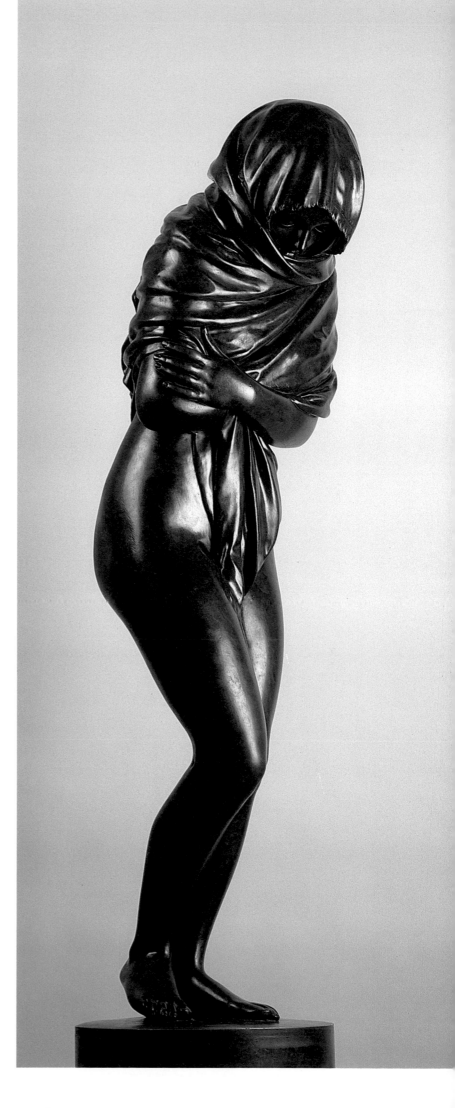

28 *La Frileuse*, 1787
Jean Antoine Houdon
French, 1741–1828
Bronze; H. 57 in. (144.8 cm.)
Bequest of Kate Trubee
Davison, 1962 (62.55)

JEAN ANTOINE HOUDON
Three Sculptures

Jean Antoine Houdon was the preeminent portraitist of the Enlightenment; in his work were sublimely realized the era's virtues of truth to nature, simplicity, and grace. Houdon's extraordinary ability to translate into marble not only his subject's personality, but also the vibrant essence of living flesh, ensured his lasting fame.

Houdon's bust of Denis Diderot (Plate 26), the pivotal figure of the French Enlightenment, was first modeled in terra-cotta in 1771 at the behest of Dmitri Galitzine, Russian ambassador to France and good friend of the sitter. Although Diderot's thoughts and writings paved the way for revolution, his incandescent wit, combined with an almost childlike enthusiasm, endeared him to intellectuals and aristocrats alike. This marble preserves the elusiveness of his quicksilver charm.

Houdon's canonical portraits of the *philosophes* (as well as of America's Founding Fathers) have contributed to his popularity in America. No less beloved are his depictions of children, of which the most beautiful may be the head of his own daughter Sabine (Plate 27). This profoundly individualized portrait is shaped with a classical purity whose severity renders all the more poignant the tender image within. The delicately naturalistic folds of flesh at the intersection of Sabine's chest and arms are carved with a melting softness that perfectly captures the limpid fragility of infant skin. Her alert, unsentimentalized features present a personality whose distinction transcends the category of children's portraits.

The sculpture known as *La Frileuse* (the word denotes a person susceptible to cold, as well as the head-shawl the girl wears) (Plate 28) was first modeled in 1781. In this composition Houdon departed decisively from the conventional allegorical treatment of Winter in order to communicate the most vivid possible impression of a creature suffering from cold. It was one of the most successful of his larger projects, and he produced several versions of it; but when a marble was submitted at the Salon of 1785, its boldness caused consternation. This yet later bronze variant, which the sculptor was particularly proud of having cast himself, was bought by the reprobate duc d'Orléans. The figure may be less shocking to modern eyes than when first created, but the abrupt contrast between the fully wrapped upper body and the bareness of flesh below is still very striking.

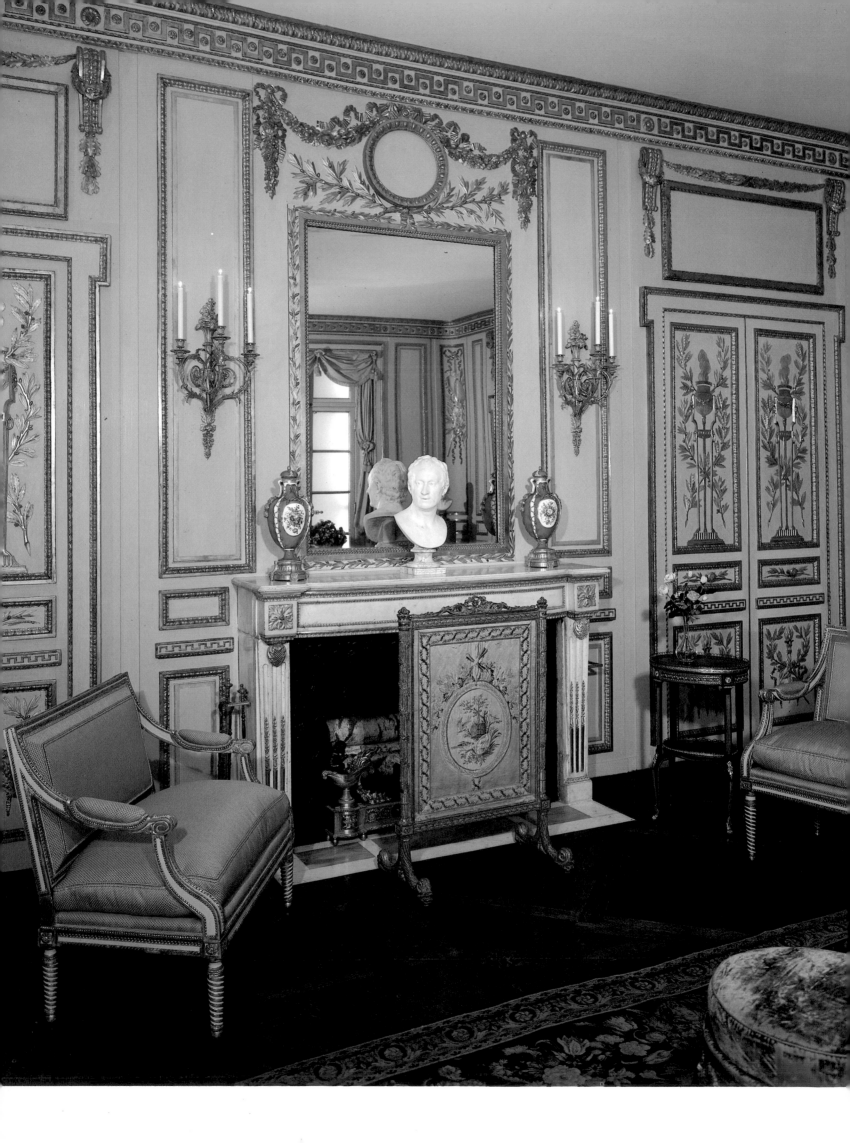

ROOM FROM THE HOTEL DE CABRIS

The Hôtel de Cabris in Grasse, based on designs of the little-known Milanese architect Giovanni Orello, was built between 1771 and 1774 for Jean Paul de Clapiers, marquis de Cabris. The exceptionally harmonious paneling, or *boiserie*, made, carved, and gilded in Paris around 1775–78, may not in fact have been installed until the first decade of the nineteenth century. A variety of crisply carved and gilded ornament, strongly Neoclassical in character, decorates the *boiserie*. The curved panels, originally intended as corners for the room, display trophies of musical instruments. Especially beautiful are the carvings on the four sets of double doors. Incense burners, or *cassolettes*, in the shape of an antique tripod, so fashionable in the later eighteenth century, are found on the upper panels of each door. The panels below are carved with flaming torches that, like the incense burners, are surrounded by crossed laurel and olive branches. The rectangular overdoor panels, as well as the circular frames above the mirrors, were intended for paintings that were never executed.

29 Room from the Hôtel de Cabris, Grasse
French, ca. 1775–78
Carved, painted, and gilded oak;
11 ft. 8½ in. x 13 ft. 5¾ in. x 25 ft. 6½ in.
(3.56 x 4.24 x 77.7 m.) Purchase,
Mr. and Mrs. Charles Wrightsman Gift,
1972 (1972.276.1,2)

JEAN HENRI RIESENER
Secrétaire

Jean Henri Riesener, one of the most important Parisian cabinetmakers working in the Louis XVI style, received many commissions from the court and the nobility. Between 1783 and 1787 he executed this resplendent secrétaire together with a commode *en suite* for Marie Antoinette, who placed both pieces in her apartment at the Château de Saint-Cloud. The presence of Saint-Cloud inventory marks and the stamp of the *Garde Meuble de la Reine*, the queen's personal furniture registry, underline the history of the secrétaire. Furthermore, Marie Antoinette's monogram appears among the gilt-bronze floral wreaths on the frieze. Black-and-gold lacquer panels are framed by gilt-bronze sculptured borders and elegantly suspended garlands of naturalistically rendered flowers. The apron is adorned with cornucopia-shaped mounts overflowing not only with the bounty of nature, but also with coins, crowns, and the Order of the Saint-Esprit, symbols of royal magnificence.

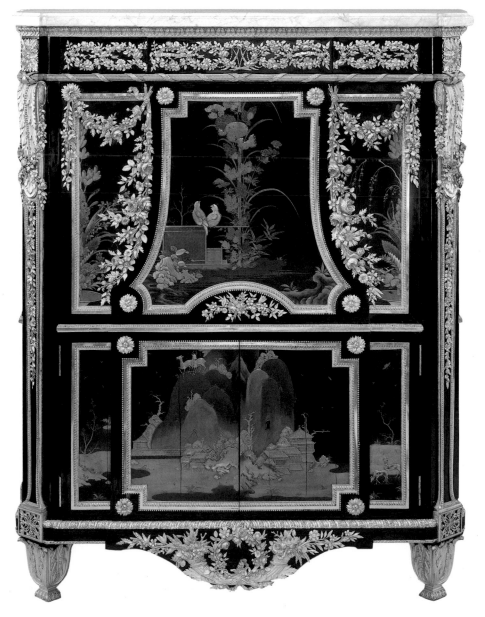

30 Upright Secrétaire, ca. 1783–87
Jean Henri Riesener
French, 1734–1806
Japanese lacquer and ebony veneered on oak,
white marble top, and gilt-bronze mounts;
57 x 43 x 16 in. (144.8 x 109.2 x 40.5 cm.)
Bequest of William K. Vanderbilt, 1920 (20.155.11)

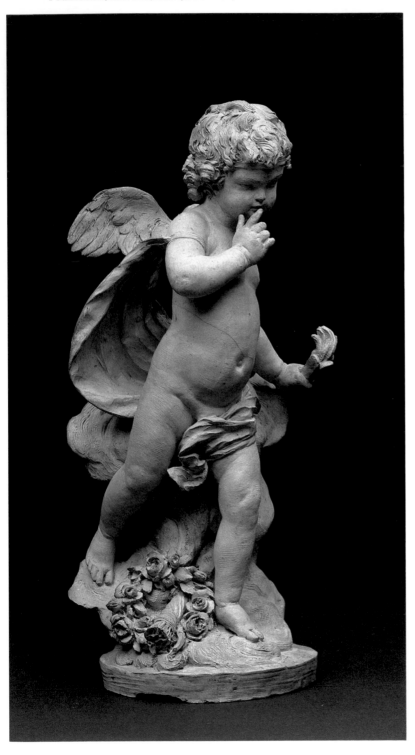

31 L'Amour Silencieux (The Soundless Cupid), 1785
Pierre Julien
French, 1731–1804
Terra-cotta; H. 15¼ in. (38.7 cm.)
Purchase Charles Ulrick and Josephine Bay
Foundation, Inc. Gift, 1975 (1975.312.1)

Pierre Julien
L'Amour Silencieux

From the seventeenth century on, terra-cotta models were increasingly prized by collectors as revelations of personal style. By the end of the eighteenth century, French sculptors often showed their most vivid clay sketches at the Salon alongside works in nobler mediums. Pierre Julien exhibited this stealthy Cupid, for instance, at the Salon of 1785. A sculptor whose scrupulous attention to surface finish surpassed that of any of his contemporaries, Julien lavished a wealth and variety of treatment upon his subject, stippling and scraping the wet clay all over. His fingerprints and even the imprints of thread from the wet cloth that covered the statuette between modeling sessions are also preserved. It is possible that Julien did not intend this as a model for a larger work but that it was destined for a connoisseur's cabinet from the start.

The *Amour Silencieux* stems from a rich vein of Greco-Roman subject matter, being based on the Alexandrian deity Harpocrates, always depicted as a naked boy commanding silence with his gesture of finger to lips. However, Julien's Cupid glides through the air with infinitely more urgency and alertness than any of his prototypes.

Clodion
Model for a Monument to Commemorate the Invention of the Balloon

Clodion is famous for his terra-cotta statuettes of satyrs and bacchantes, of which the Metropolitan Museum owns notable examples. This wholly uncharacteristic work (indeed, there is nothing like it anywhere) was made for a competition among the greatest French sculptors (including Houdon, Julien, and Pajou) for a monument to commemorate the first ascension of a manned hot-air balloon. This was achieved by the Montgolfier brothers in 1783. An alternative model by Clodion, known only through photographs, was a much tamer affair than this work. In this plan, Clodion pushes allegory to an extreme, swamping Fame and Zephyr in a dizzying flight of infants. His is an exceedingly bold essay at monumentalizing flight, the most ephemeral of subjects. Although the topic could not have been more fashionable, as balloons proliferated in the decoration of objects of all sorts, the project for a monument came to naught. For that matter, it is next to impossible to visualize Clodion's extravaganza in terms of marble statuary.

32 Model for a Monument to Commemorate the
Invention of the Balloon, 1784
Claude Michel (called Clodion)
Terra-cotta; H. 43½ in. (110.5 cm.)
Purchase, Rogers Fund and Anonymous
Gift, 1944 (44.21)

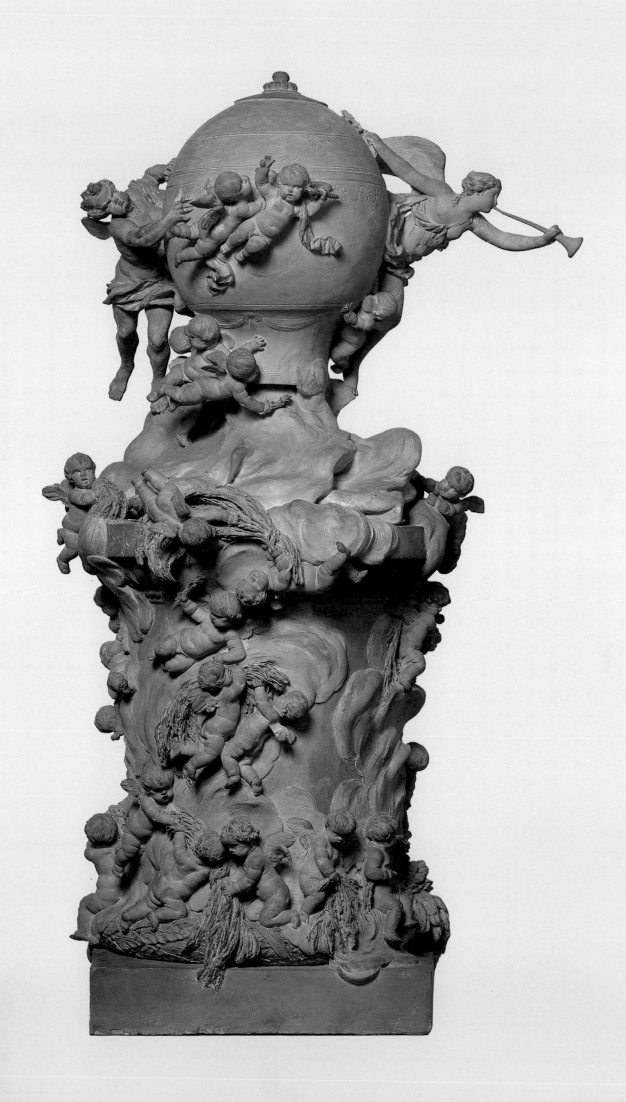

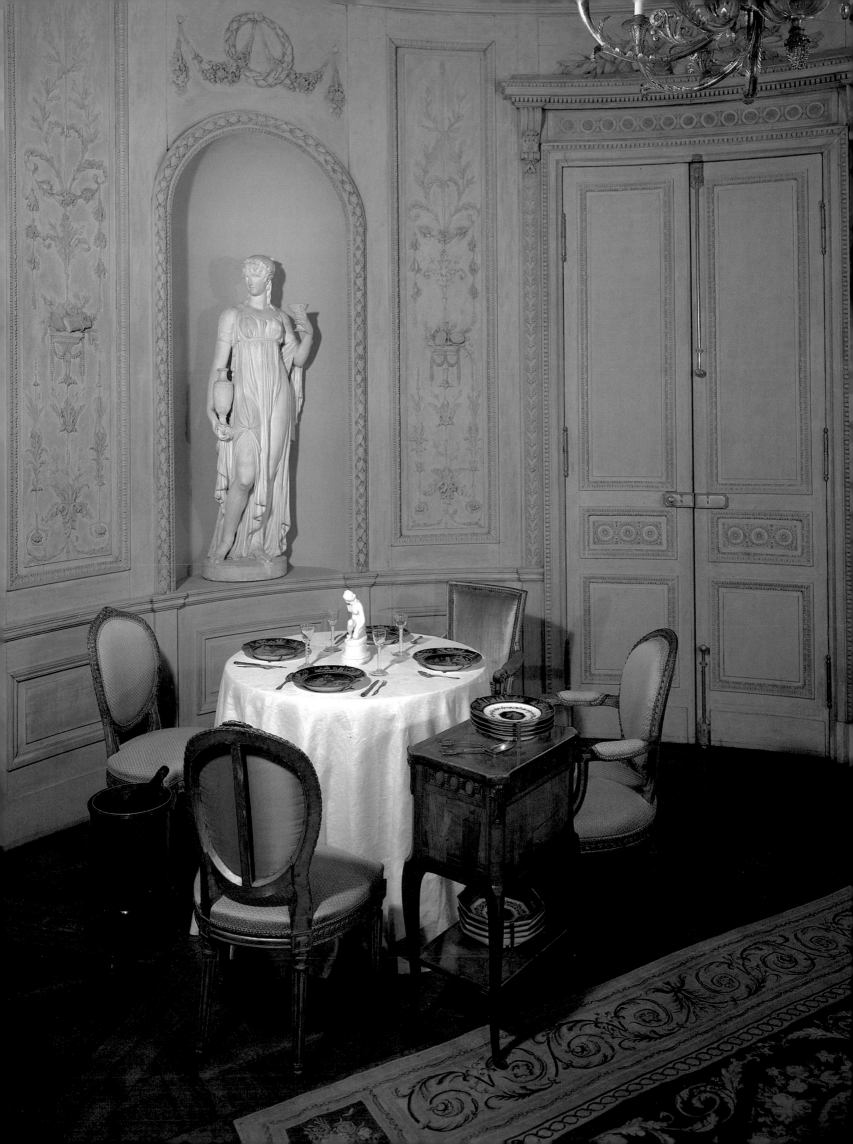

33 Room from Bordeaux
French, ca. 1785
Carved and painted pine;
oval, L. 18 ft. 1¾ in. (5.53 m.)
Gift of Mrs. Herbert N. Straus,
1943 (43.158.1)

34 Madame de Wailly, 1789
Augustin Pajou
French, 1730–1809
Marble; H. 24½ in. (62.2 cm.)
Fletcher Fund, 1956 (56.105)

ROOM FROM BORDEAUX

The delicate carving in low relief of the gray-green *boiserie* in this room is attributed to the sculptor and wood-carver Barthélemy Cabriol, who spent most of his working life in Bordeaux. This oval room, presently arranged to resemble the setting for a small supper party, may have come from the Hôtel de Saint-Marc, on the Cours d'Albret in Bordeaux. The finely carved decorations consist of laurel wreaths and floral garlands above the wall recesses and mirrors. Trophies in the so-called "classical candelabra style," representing music, arts, and agriculture, are found on the vertical panels. The door lintels are surmounted by trophies as well, one of which, symbolizing architecture, incorporates objects such as a compass, a ruler, and a basket overgrown with acanthus leaves, referring to the alleged origin of the Corinthian capital. Although contemporary with the room, the white marble chimneypiece does not come from it. An engraving from 1880 depicting this graceful room shows the original chimneypiece, as well as the radiating pattern of the wooden floor, now also replaced.

AUGUSTIN PAJOU
Madame de Wailly

The sitter was the wife of the sculptor's lifelong friend, Charles de Wailly, his companion from student days in Rome. De Wailly had built neighboring houses for Pajou and himself and Pajou made busts of the architect and his wife. The portrait of Madame de Wailly displays the artist's particular gifts to best advantage. In it the solidity that characterizes all his work is enlivened by an equally characteristic linearity to produce a brilliant eighteenth-century version of a Roman matron's portrait. Nonetheless, the sense of dignity does not suppress the spirit of humor and intelligence that radiates from Madame de Wailly's fully mature countenance. This maturity is echoed in Pajou's handling of her body, enhanced by the deliberately clinging cloth that half-confines and half-exposes her breast and comfortable shoulders. The sinuous and weighty curls that frame her face and cascade heavily over her shoulders are no longer concocted of evanescent froth (as in Houdon's portraits), but are deliberately and insistently sculptural, lending harmony and equilibrium to the whole.

55

35 *Comtesse de la Châtre (Marie Charlotte Louise Perrette Aglaé Bontemps, 1762–1848)*
Louise Elisabeth Vigée Le Brun
French, 1755–1842
Oil on canvas; 45 x 34½ in. (114.3 x 87.6 cm.)
Gift of Jessie Woolworth Donahue, 1954 (54.182)

36 *Self-Portrait with Two Pupils,
Mademoiselle Marie Gabrielle Capet
(1761–1818) and Mademoiselle
Carréaux de Rosemond (d. 1788), 1785*
Adélaïde Labille-Guiard
French, 1749–1803
Oil on canvas; 83 x 59½ in.
(210.8 x 151.1 cm.)
Gift of Julia A. Berwind, 1953
(53.225.5)

LOUISE ELISABETH VIGEE LE BRUN
Comtesse de la Châtre

In her light-spirited, casually elegant, and delicately nuanced portraits of aristocratic women of the late eighteenth century, no painter better captured the fleeting world of the *ancien régime* than Elisabeth Vigée Le Brun. The daughter of pastel portraitist Louis Vigée and a student of, among others, Joseph Vernet, Vigée embarked at age fifteen on an unremittingly successful career as a portrait painter that led her in the course of her long life to the courts at Versailles, Rome, Naples, Vienna, St. Petersburg, and London for commissions of some six hundred portraits. Her talents as an artist and her personal charm enabled Vigée to win the respect not only of her patrons but of fellow artists as well; despite the low status of women painters during her day, she was invited to join the academies of art in Paris, Rome, Parma, and Bologna.

The comtesse was twenty-seven when she sat for this portrait in 1789. She had married Claude Louis, comte de la Châtre, in 1778; later she divorced him and married François Annail, marquis and later comte de Jaucourt.

ADELAIDE LABILLE-GUIARD
Self-Portrait with Two Pupils

When this extraordinary triple portrait was shown in the Salon of 1785, it was immediately recognized by sympathetic minds to be a cogent plea for the improvement of the status of women artists in the Academy. One female reviewer wrote that she overheard some viewers claim that the painting was too vigorous and forceful to have been made by a woman, "as if my sex were eternally condemned to mediocrity and as if her works always had to carry the stamp of her weakness and ignorance."

When Adélaïde Labille-Guiard was admitted to the Academy in 1783, the same year as Elisabeth Vigée Le Brun, the number of female associates was limited to four. In this portrait she surrounded herself with two of her own pupils, Mademoiselle Capet and Mademoiselle Rosemond, and dressed in full and extravagant costume to assert her class and rank. Labille-Guiard limited herself almost exclusively to portraiture for the rest of her career. She married her instructor, François André Vincent, after obtaining a separation from her first husband in 1780.

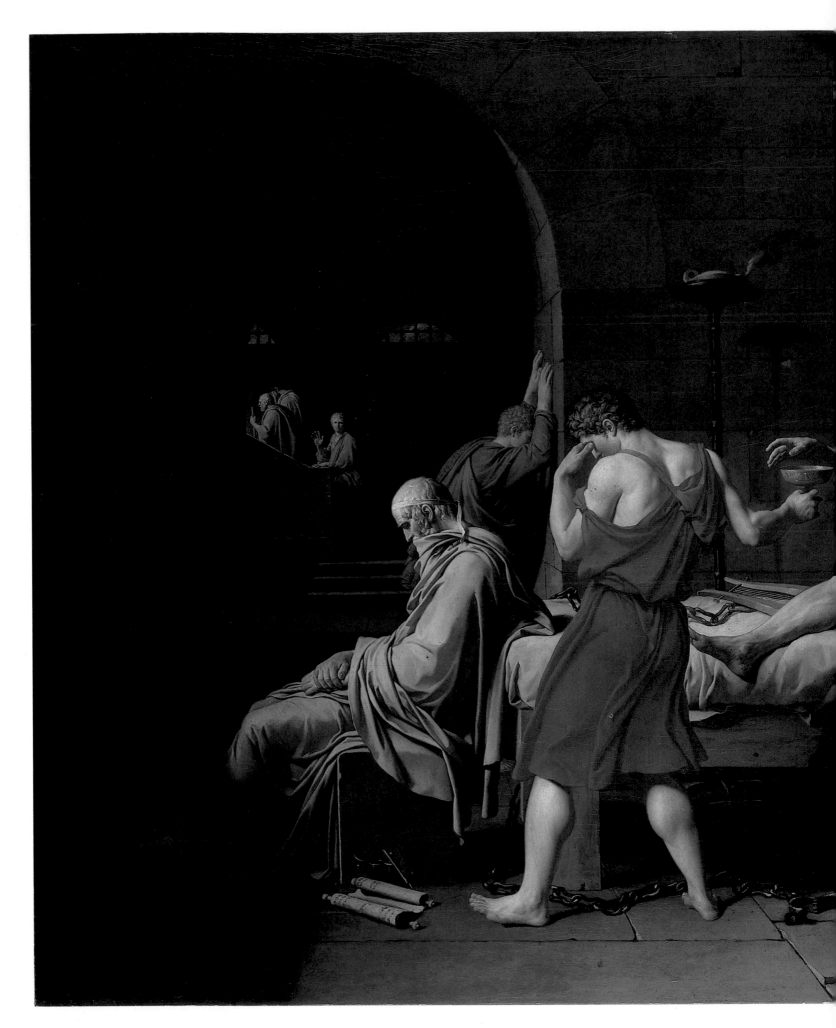

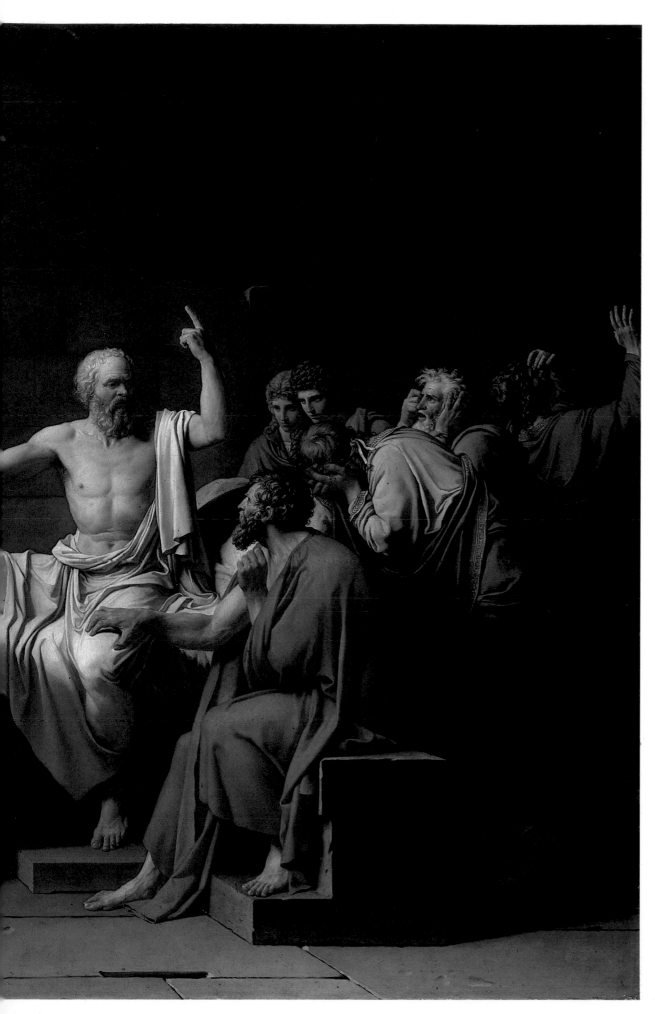

37 *The Death of Socrates*, 1787
Jacques Louis David
French, 1748–1825
Oil on canvas; 51 x 77¼ in.
(129.5 x 196.2 cm.)
Wolfe Fund, Catharine Lorillard
Wolfe Collection, 1931 (31.45)

Page 60: text

JACQUES LOUIS DAVID (Pages 58–59)
The Death of Socrates

At the approach of the French Revolution, when Greek and Roman civic virtues were extolled as salutary antidotes to the degeneracy of the old regime, David triumphed at the Salon with a succession of works—*The Oath of the Horatii* (1784) (Paris, Louvre), *The Death of Socrates* (1787), and the *Lictors Bringing Back to Brutus the Bodies of his Sons* (1789) (Paris, Louvre)—that gave clear expression to the moral and philosophical directives of his time. Like the subject of the three brothers Horatii, who bravely pledge their young lives to the defense of their honor, family, and country, or that of Brutus, whose sons have been sacrificed to the cause of liberty, David's tribute to Socrates' stringent social criticism and stoical self-sacrifice was easily interpreted as a symbol of revolutionary ideology, dedication, and protest. In fact, the picture, which was first shown at the Salon of 1787, was shown again during the Revolution, in the Salon of 1791. Four years later, it was engraved at the government's expense.

David's *Death of Socrates* was based loosely on Plato's *Phaedo* and on advice the artist had secured from the Greek scholar Jean Adry. Socrates, charged by the Athenian government with impiety and corrupting the young through his teachings, was offered the choice of renouncing his beliefs or being sentenced to death for treason. Faithful to his convictions and obedient to the law, Socrates chose to accept his sentence. David has portrayed him seated on his prison bed, calmly reaching for the cup of poisonous hemlock while he discourses on the immortality of the soul—a heroic gesture reputedly suggested to David by the poet André Chénier. In the interest of simplifying and unifying the composition, David chose to reduce the number of disciples present from the fifteen described by Plato to nine; they are shown in various attitudes of horror, grief, and admiration: Crito, seated on a stool, listens intently as he rests his hand on Socrates' knee; Plato, represented as an old man, is poised in deep meditation at the foot of the bed; and Apollodorus, who was described as the most grief-stricken, is presumably the figure at right, with both hands raised. The philosopher's wife, Xanthippe, appears in the background, escorted by the servants of Crito.

*38 Antoine Laurent Lavoisier (1743–94) and His Wife
(Marie Anne Pierrette Paulze, 1758–1836), 1788*
Jacques Louis David
French, 1748–1825
Oil on canvas; 102¼ x 76⅝ in. (259.7 x 194.6 cm.)
Purchase, Mr. and Mrs. Charles Wrightsman Gift,
1977 (1977.10)

JACQUES LOUIS DAVID
Antoine Laurent Lavoisier and His Wife

A key work in the development of Neoclassical portraiture and one of the milestones of Jacques Louis David's artistic career, this lifesize double portrait of 1788 depicts the celebrated statesman and chemist Antoine Laurent Lavoisier and his wife, Marie Anne Pierrette Paulze. Lavoisier, who is perhaps best known for his pioneering studies of oxygen, gunpowder, and the chemical composition of water, also developed and codified a reformed system of chemical nomenclature. In 1789 his theories were published in the *Traité élémentaire de chimie*, a volume for which Madame Lavoisier, who often assisted her husband and is said to have studied under David, prepared the illustrations. While the talents of Madame Lavoisier, here represented as a kind of muse inspiring her husband, are evoked by the portfolio of drawings that rests on an armchair behind her, Lavoisier's chemical experiments, including two relating to gunpowder and oxygen, are amply represented by the various scientific instruments on the table and floor. The manuscript from which he is distracted may be that of the *Traité*, on which he is known to have been working in 1788.

A man of diversified interests—from agriculture to weights and measures—Lavoisier proved himself to be a capable, albeit later unpopular, administrator. From 1769 he served as a farmer-general, or tax collector (a position that ultimately led him to the guillotine), and from 1771 as general director of the Administration of Gunpowder and Saltpeter. By 1787 he had already aroused public antipathy by the wall he had erected around Paris to collect custom dues, and in August 1789, as Commissioner of Gunpowder, he became the principal target of rioting when he ordered the transfer of some 10,000 pounds of low-grade gunpowder from storage in the arsenal in Paris to Essones, to be replaced by a much higher-grade powder. His implication in this scandal, just days before the Salon was to open, led to the withdrawal of the present picture from public exhibition.

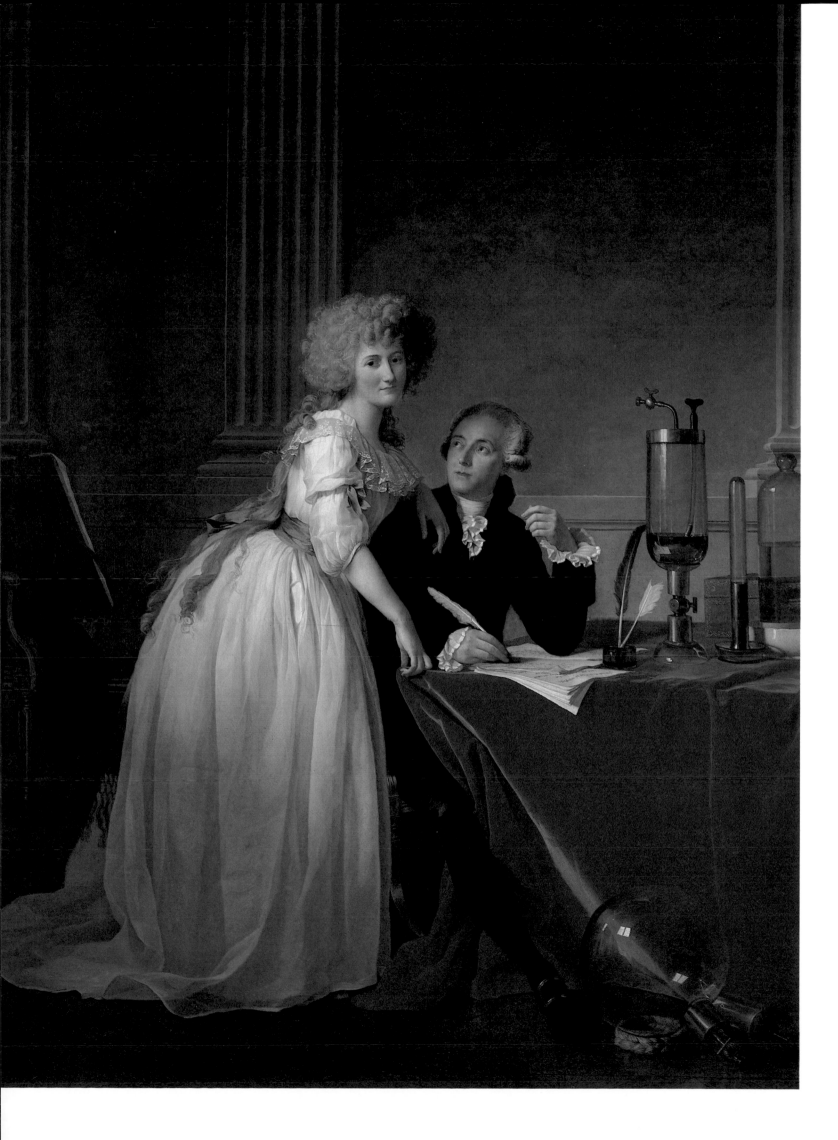

COIN CABINET

Originally part of a suite of furniture including a bed and a pair of armchairs, this exceptional coin cabinet was commissioned by Dominique Vivant Denon, tastemaker extraordinaire during the Consulate and Empire periods. Its design by Charles Percier was in fact inspired by a drawing by Denon. He had participated in Napoleon's Egyptian campaign of 1798–99, and his influential work of 1802, *Le voyage dans la basse et la haute Egypte*, contains an illustration of the pylon at Ghoos on which the overall shape of the cabinet and the decoration of its frieze are based. The front and back panels are inlaid with a scarab flanked by two uraei on lotus stalks. These silver decorations, as well as the winged disks on the frieze, were made by the noted silversmith Martin Guillaume Biennais. The interior is set with twenty-two coin drawers, graduated in size. On each drawer a silver bee is mounted with a hinged wing that serves as a pull. It is thought that Jacob Desmalter, who as *ébéniste de l'Empereur* supplied numerous fine pieces of Empire furniture to the Bonaparte family, was also responsible for the execution of this outstanding coin cabinet.

TAPESTRY WITH PORTRAIT OF NAPOLEON I

Napoleon's order of 1806 to have tapestry copies of two portraits of himself and one of Josephine woven at the Gobelins manufactory was only completed in 1813. This tapestry—the second piece woven—is after a copy by François Gérard, or one of his pupils, of his own painting.

The original portrait, which at the time belonged to Talleyrand, was based on Jean Baptiste Isabey's drawings of the coronation for the collection of engravings called the *Livre du Sacre*. The emperor, wearing the robes he wore for his coronation at Notre Dame on December 2, 1804, is depicted with his regalia.

All three tapestries were given as presents, this one to Jean Jacques Régis de Cambacérès, duc de Parme, prince and arch-chancellor of the Empire. Each tapestry was lined, mounted on a stretcher, put into a gilded frame, and provided with woolen curtains.

The ensemble of tapestry and frame work together, while the decorative motifs used to embellish costume, furnishings, and frame form a veritable lexicon of Napoleonic ornament.

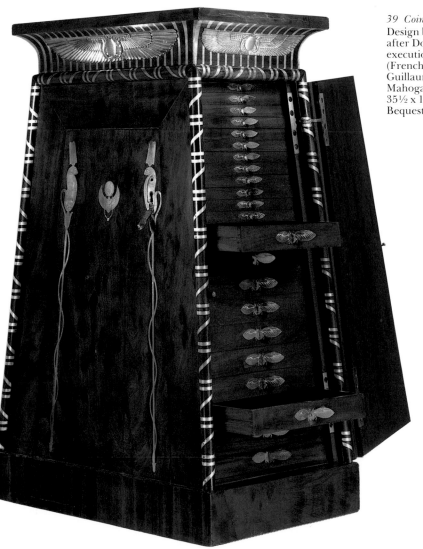

39 Coin Cabinet, ca. 1805
Design by Charles Percier (French, 1764–1838)
after Dominique Vivant Denon (French, 1747–1825),
execution attributed to François Honoré Desmalter
(French, 1770–1841), with silver mounts by Martin
Guillaume Biennais (French, active ca. 1796–1819)
Mahogany with silver inlay and silver mounts;
35½ x 19¾ x 14¾ in. (90.2 x 50.2 x 37.5 cm.)
Bequest of Collis P. Huntington, 1900 (26.168.77)

40 Portrait of Napoleon I, 1808–11
Designed by François Gérard (1770–1837) in 1805;
woven in the haute-lisse workshop of Michel Henri
Cozette (1744–1822) at the Gobelins manufactory by
Harland (prob. the Elder, act. 1790–ca. 1826), Abel
Nicolas Sollier (act. 1790–1815), Duruy the Younger
(prob. Charles Duruy, act. ca. 1805–1850), and five
other weavers Tapestry woven of wool, silk, and silver-
gilt thread; H. 87½ (222 cm.), W. 57½ in. (146 cm.)
Purchase, Joseph Pulitzer Bequest, 1943 (43.99)

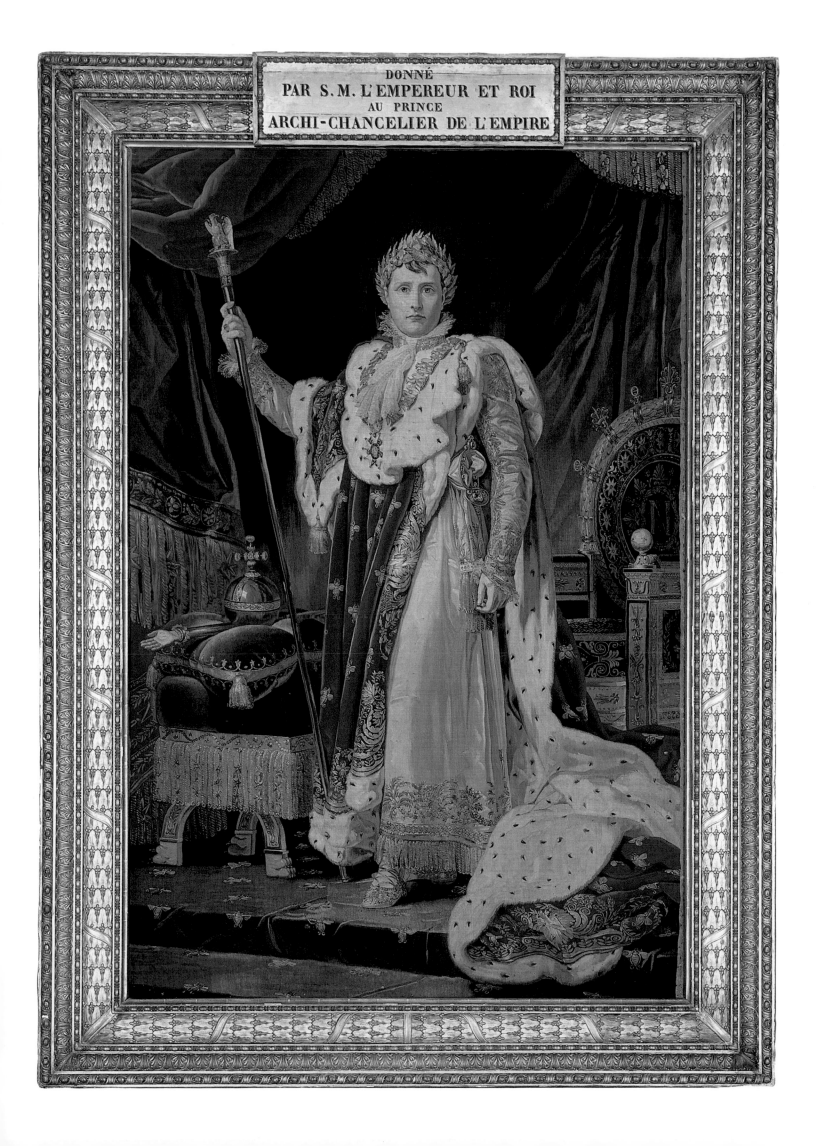

DONNÉ
PAR S. M. L'EMPEREUR ET ROI
AU PRINCE
ARCHI-CHANCELIER DE L'EMPIRE

41 General Etienne Maurice Gérard (1773–1852), Marshal of France, 1816
Jacques Louis David
French, 1748–1825
Oil on canvas; 77⅝ x 53⅝ in. (197.2 x 136.2 cm.)
Purchase, Rogers and Fletcher Funds, Bequest of
Mary Wetmore Shively, in memory of her husband,
Henry L. Shively, M.D., by exchange, 1965 (65.14.5)

JACQUES LOUIS DAVID
General Etienne Maurice Gérard, Marshal of France

An active figure in the aesthetic as well as political aspects of the French Revolution, Jacques Louis David, who had supported the execution of Louis XVI, was exiled to Belgium when the monarchy was restored after Napoleon's defeat at Waterloo in 1815. As a regicide, he spent the last nine years of his life, from 1816 to 1825, in exile in Brussels, where he continued to paint mythological subjects and portraits.

With this portrait of General Gérard, who was also banished from France in 1816, David initiated a series of monumental portraits that are striking in their clear, bright color and sharp realism. Noble and restrained in composition, betraying all the marks of an official commission in its ostentatious display of uniform and decorations, this portrait nonetheless reveals David's ability to evoke, through stance and visage, the character and psychology of the aging soldier.

Etienne Maurice, comte de Gérard, boasted a distinguished military career in the French army. He enlisted as a volunteer in 1791 and rose to the rank of *général de division* after the battle of Moscow, having masterminded a vital rear-action in the retreat from Russia. He was named count of the Empire in 1813, awarded the Legion of Honor and the Knighthood of Saint Louis in 1814, and named peer of France by Napoleon during the Hundred Days.

Pierre Paul Prud'hon

Andromache and Astyanax

Pierre Paul Prud'hon occupies an unusual position among French artists at the end of the eighteenth century. Superficially, he might appear to be one of the primary Neoclassical painters: His paintings are based on classical texts, the compositions reflect the design of antique reliefs, and his figural type is based on ancient prototypes. He was also an ardent supporter of the Revolution and an active member of David's leftist Club des Arts; under the direction of David, the Neoclassical style had been invested with a political and moral dimension. Yet Prud'hon's warm and sweet color harmonies have little to do with the cool tonality of David's paintings, and his preference for sentimental subjects is almost the opposite of David's espousal of heroic themes. In many ways, Prud'hon's work, rather than reflecting the stark Neoclassicism of his day, looked more toward the less strident, domesticated art of the Romantic painters at the beginning of the nineteenth century.

This painting, begun in 1815—late in Prud'hon's career

—and left unfinished at his death, represents a scene from Racine's play *Andromaque*. In it, the young boy Astyanax rushes to the arms of his mother, Andromache, who has been taken by Pyrrhus as spoils from Troy. Pyrrhus is infatuated with Andromache, and seeks to win her love by protecting her son; Andromache, for her part, despises Pyrrhus as the son of the man who killed Hector, her husband. Looking into the eyes of her son, Andromache sees his father:

"Hector," she'd cry, and clutched the boy again.
"Behold his eyes, his mouth, his brave young face;
'Tis he, 'tis you, dear husband, I embrace."

Prud'hon's subject may refer to the fate of the young king of Rome and his mother, the empress Marie Louise, after the fall of Napoleon: The emperor is reputed to have said after his abdication in 1814 that "the fate of Astyanax, prisoner of the Greeks, always seemed to me the saddest in history." Marie Louise commissioned this picture in 1814.

42 Andromache and Astyanax
Pierre Paul Prud'hon
French, 1758–1823
Completed by Charles Boulanger de Boisfremont
(French, 1773–1838)
Oil on canvas; 52 x 67⅛ in. (132.1 x 170.5 cm.)
Bequest of Collis P. Huntington, 1900 (25.110.14)

WOVEN BORDERS

Woven to size on one width, their pattern perpendicular to the length of the fabric, these two borders were intended to be cut and applied to other furnishings. They were made in Lyons, a preeminent weaving center that had fallen on hard times in the late eighteenth century but that was revitalized by Napoleon I through his many orders for fabrics for the refurbishing of the imperial palaces. Yards of these textiles were still in storage, unused, when the emperor went into exile in 1815. These borders were woven after the Bourbon Restoration—whether for Louis XVIII or Charles X is not certain—and the design is particularly fitting for the new monarchy: It consists of two lengths of intertwined foliage, called *rinceaux*—one of stylized leaves, the other of Bourbon lilies—executed in two types of metal thread and placed against a rich and regal blue satin ground.

43 Borders
French, 1815–30
Woven silk and metal threads;
41⅜ in. x 21⅞ in.
(105.2 x 55.6 cm.)
Rogers Fund, 1940 (40.134.20)

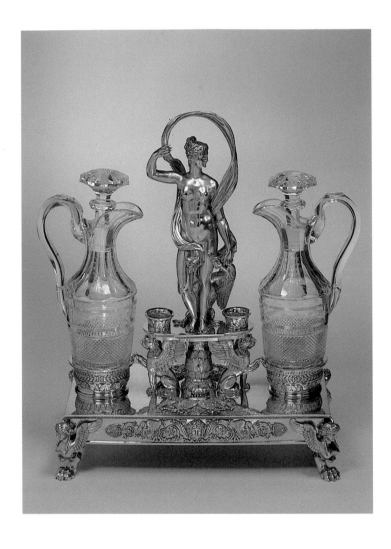

44 Cruet Frame, ca. 1817
Jean Baptiste Claude Odiot
French, 1763–1850
Silver; H. 15⅜ x 12 in. (30.5 x 39.1 cm.)
Gift of Audrey Love, in memory of
C. Ruxton Love, Jr., 1978 (1978.524.1)

THE DEMIDOFF VASE

Malachite, mined on lands belonging to the Demidoff family in Russia, became a favorite decorative material in the nineteenth century. When polished, the tiny arcs in the green stone interact to produce a superb field for ornament. For works of considerable size, such as this monumental vase, small, thin pieces of malachite were joined to make a sort of veneer. To furnish his Florentine palazzo and to advertise his family's wealth, Prince Nicholas Demidoff had several large malachite objects, including this vase, fitted with mounts by the leading French manufacturer of ornamental bronzes, Thomire. In this setting, Thomire's chief contribution was to keep the contrasts between stone and metal quite simple; as demonstrated here, French Empire ideals of spareness in design were to outlive the fall of the imperial regime for some years. Because of this restraint, the "handles," comprising figures of Fame holding trumpets, stand out all the more boldly.

The shape of this vase deliberately emulates those imposing, oversize marbles, the Borghese Vase (Paris, Louvre) and the Medici Vase (Florence, Uffizi), that were among the most admired furnishings to survive from classical antiquity. After the sale of Demidoff property in 1880, its sheer impressiveness won the Demidoff Vase a natural place in one of New York's grandest mansions, the Fifth Avenue house of William Henry Vanderbilt.

SILVER CRUET FRAME

The restoration of the Bourbon monarchy in 1815 did not bring an end to the Empire style, as designers and craftsmen who worked for Napoleon continued many aspects of that style under the patronage of Louis XVIII and his circle. The silversmith Jean Baptiste Claude Odiot, head of the family workshop from 1785 to 1827, survived the Revolution and the restoration of the monarchy, in each case by joining the army.

This cruet frame, one of a pair, is part of a 119-piece service produced by Odiot and billed to "M. de Demidoff," presumably Prince Nicholas Demidoff. The frames comprise ornamental friezes and three-dimensional elements cast separately and assembled using nuts and bolts, a method characteristic of Odiot's work. The focus of the composition is the statuette of a nude woman whose legs are embraced by a swan and whose encircling drapery serves as a handle. The figure could be interpreted as Venus, the swan being one of her attributes. The graceful swan had been the favorite motif of the empress Josephine, and was a regular feature in Empire design. It has also been used in the ornamental frieze at the front of the frame.

45 Demidoff Vase
French, 1819
Bronze mounts by Pierre Philippe Thomire
(French, 1753–1843)
Malachite and gilt bronze; H. (excl. pedestal)
67½ in. (171.5 cm.)
Purchase, Frederic R. Harris Gift, 1944 (44.152)

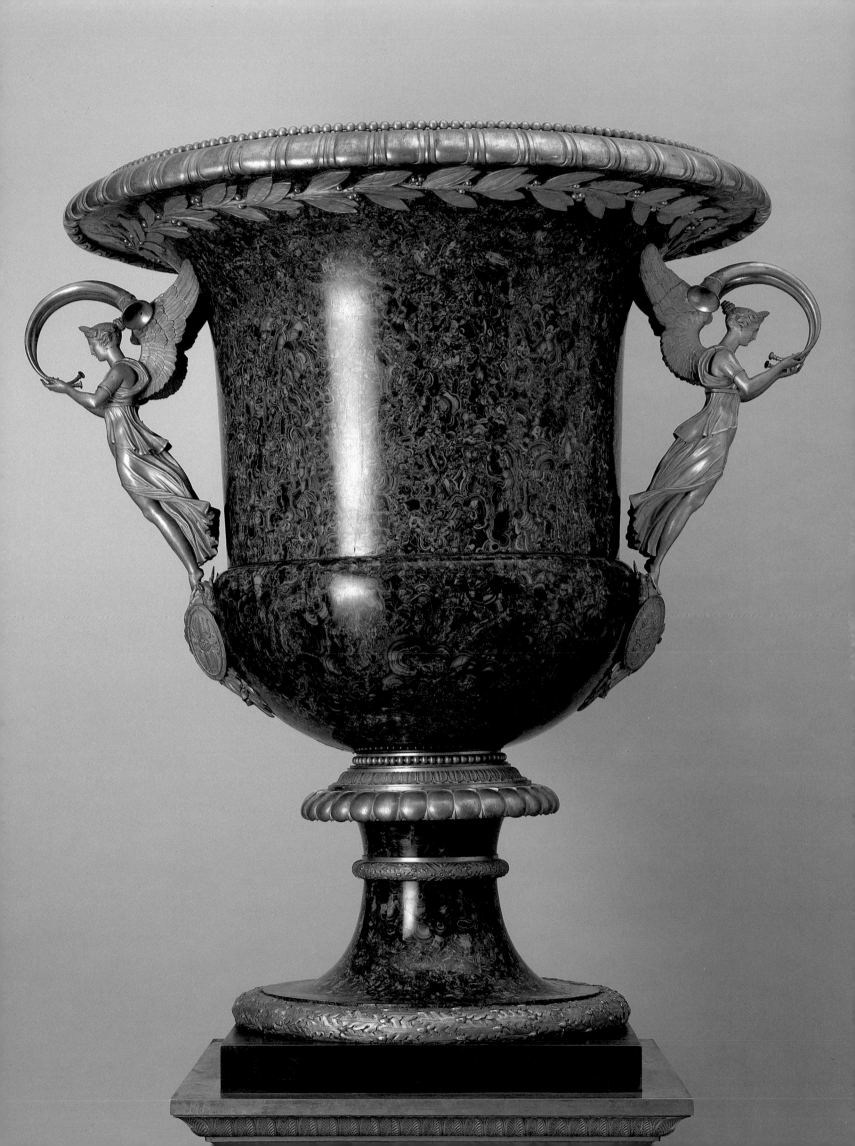

Jean Auguste Dominique Ingres
Three Studies of a Male Nude

J.A.D. Ingres was David's most celebrated pupil. Awarded the Prix de Rome in 1806, Ingres left Paris for Italy, where he stayed until 1824; ten years later he returned to Rome for seven more years as director of the French Academy. Ingres's classical style and his working procedure epitomized the academic tradition, which he defended vehemently against the French Romantic movement led by Delacroix.

The three depictions of a male nude on this sheet are studies for the dead body of Acron in the painting *Romulus Victorious over Acron, King of the Caeninenses, Carries the Spolia Opima to the Temple of Jupiter.* The picture was one of two commissioned by the French military governor of Rome for the Quirinale, then destined to be the Roman residence of Napoleon I. The painting was finished in 1812 and hung in the Quirinale until 1815. Napoleon never went to Rome, and the painting was moved to the Lateran Palace. In 1867, Pope Pius IX presented it to Napoleon II, and today it hangs in the Ecole des Beaux-Arts, Paris.

Jean Auguste Dominique Ingres
Madame Lethière and Her Daughter Letizia

After the fall of Napoleon in 1814, the French community in Rome dispersed and Ingres lost many of his patrons. Experiencing financial hardship, he turned to making on commission highly finished portrait drawings in graphite pencil. These drawn portraits became very popular, and a fascinating cross section of Ingres's world is preserved in more than four hundred fifty drawings of artists, architects, musicians, and members of society.

The sitters rendered here are Rosina Meli, the second wife of Alexandre Guillon Lethière, and their one-year-old daughter, Letizia. The sitter's father-in-law, Guillaume Guillon Lethière, had been a pupil of David's and in 1807 became the director of the French Academy in Rome, where Ingres first knew him. Ingres made several portrait drawings of Lethière and his family, including one of Rosina and Letizia together with Alexandre. That portrait was executed in the same year as the Metropolitan's drawing; it is now in the Museum of Fine Arts, Boston.

46 *Three Studies of a Male Nude*
Jean Auguste Dominique Ingres
French, 1780–1867
Graphite; 7¾ x 14³⁄₁₆ in.
(19.7 x 36.4 cm.)
Rogers Fund, 1919 (19.125.2)

47 *Madame Lethière and Her Daughter Letizia*,
ca. 1815
Jean Auguste Dominique Ingres
French, 1780–1867
Graphite; 11¹³⁄₁₆ x 8¾ in. (30 x 22.2 cm.)
Bequest of Grace Rainey Rogers, 1943 (43.85.7)

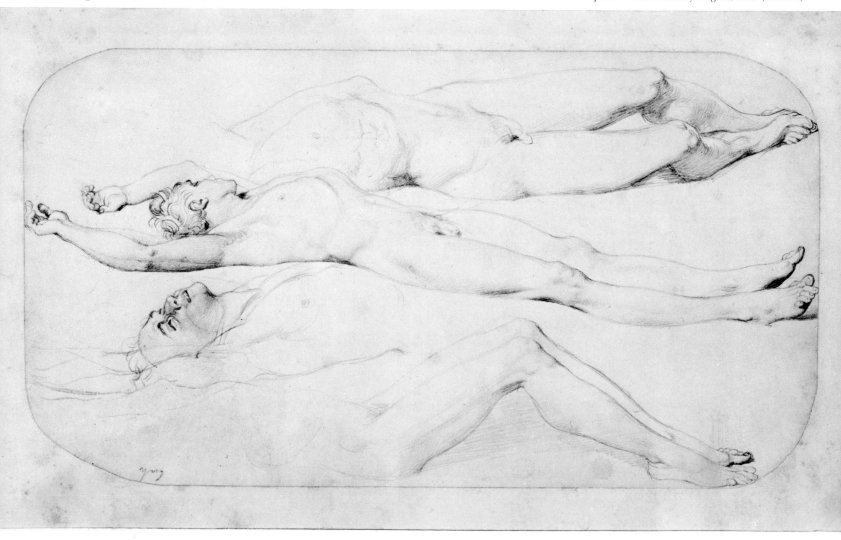

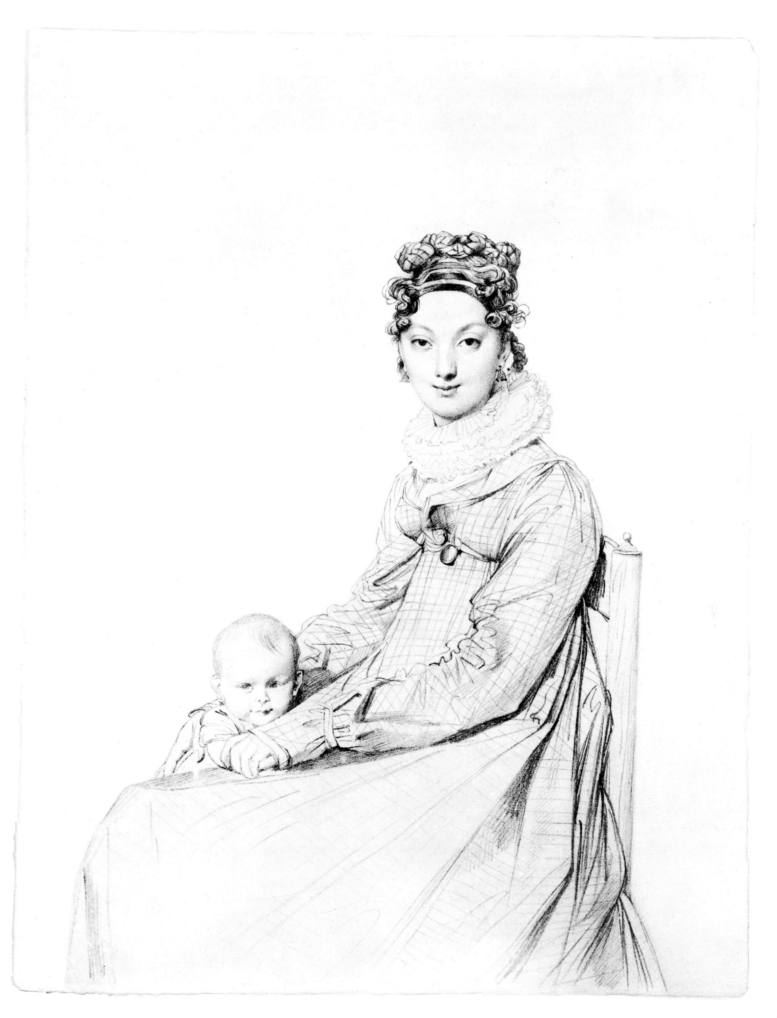

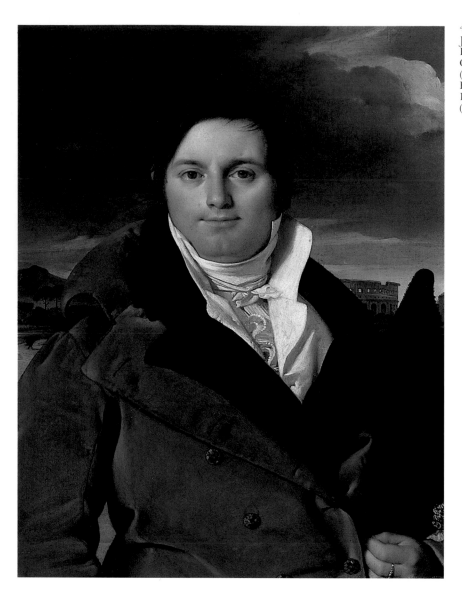

48 *Joseph Antoine Moltedo (b. 1775)*
Jean Auguste Dominique Ingres
French, 1780–1867
Oil on canvas; 29⅝ x 22⅞ in.
(75.3 x 58.1 cm.)
Bequest of Mrs. H.O. Havemeyer,
1929, H.O. Havemeyer Collection
(29.100.23)

49 *Pauline Eléonore de Galard de Brassac de Béarn
(1825–60), Princesse de Broglie*, 1853
Jean Auguste Dominique Ingres
French, 1780–1867
Oil on canvas; 47¾ x 35¾ in. (121.3 x 90.8 cm.)
Robert Lehman Collection, 1975 (1975.1.186)

JEAN AUGUSTE DOMINIQUE INGRES
Joseph Antoine Moltedo

Hostile critics referred to Ingres's early works as having an "archaic" or Gothic character, meaning that his paintings exhibited qualities reminiscent of fifteenth- or early sixteenth-century painting. In its unrelenting realism, exaggerated mathematical perspective, and rigorous local color, the portrait of Moltedo, a modern equivalent of a Holbein portrait, exemplifies Ingres's gothic or primitivizing early style. It belongs to a series of portraits of French officials in Napoleonic Rome painted between 1810 and 1814. These are distinguished by the inclusion of Roman views as backdrops for the sitters, as well as by stormy gray skies—a Romantic conceit that serves as a foil to the calm and secure expressions of the men portrayed.

Until the mid-1950s, this painting was known only as a portrait of a gentleman. Once it was discovered that the picture had been in the collection of the Moltedo family for most of the nineteenth century, the sitter was identified as Joseph Antoine Moltedo, a Corsican who served as director of the Roman post office from 1803 to 1814. An inventor of sorts, Moltedo designed a fire pump and a hemp-weaving machine, and ran a lead foundry at Tivoli.

JEAN AUGUSTE DOMINIQUE INGRES
The Princesse de Broglie

Ingres's portrait of the princesse de Broglie is his last commissioned portrait. Although the artist had supported himself almost exclusively on portraits as a young man, he hoped, once he returned to Paris in 1841 amid great acclaim, that he could renounce them: "Damn portraits," he complained in 1847, "they are so difficult to do that they prevent me from getting on with greater things that I could do more quickly." Nevertheless, he succumbed to pressure reluctantly between 1845 and 1853 and accepted commissions for five paintings—from the comtesse d'Haussonville, the baroness James de Rothschild, the princesse de Broglie, and two from his idol of beauty, Madame Moitessier—that together constitute the greatest achievements of his maturity.

In each of these portraits, the sitter is dressed for a ball and shown in her own house, either pausing before going out or engaged in conversation. And in each, the rich furnishings of the environments the women inhabit and the luxurious stuff of their clothes are brilliantly played against the absolute silence of the scene and the complete serenity of the sitters. The princesse de Broglie was twenty-eight when Ingres completed her portrait in 1853.

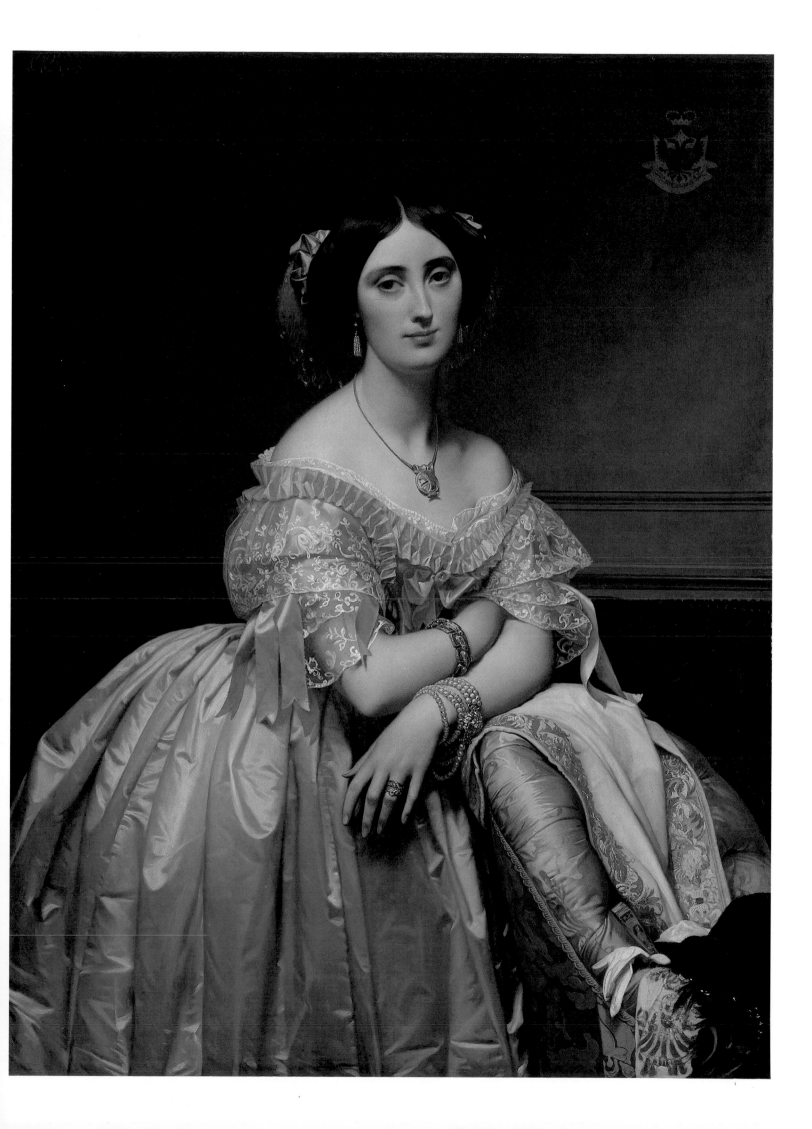

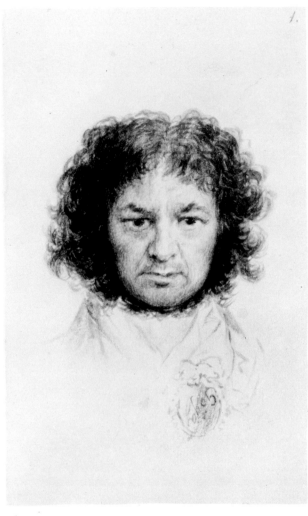

51 Don Manuel Osorio Manrique de Zuñiga
(b. 1784)
Francisco de Goya y Lucientes
Spanish, 1746–1828
Oil on canvas; 50 x 40 in. (127 x 101.6 cm.)
The Jules Bache Collection, 1949 (49.7.41)

50 Portrait of the Artist, ca. 1795
Francisco de Goya y Lucientes
Spanish, 1746–1828
Point of brush and gray wash;
6 x 3⁹⁄₁₆ in. (15.3 x 9.1 cm.)
Harris Brisbane Dick Fund, 1935
(35.103.1)

Francisco de Goya y Lucientes
Portrait of the Artist

Goya rendered this self-portrait around 1795, when he was forty-nine years old. The artist's intense stare suggests that the portrait is a mirror image. In the words of the Goya scholar Pierre Gassier, "This is the finest and most tragic of all the known self-portraits. Made a few years after the illness of 1792, which had left him deaf, it has a strange resemblance to his contemporary, Beethoven." After Goya's death, the drawing became the frontispiece to an album of fifty of his drawings, selected from different periods by his son and grandson, who, in financial need, sold the album to the Spanish painter Valentin Carderera. The Metropolitan Museum purchased the famous album in Paris in 1935. It is the largest single group of Goya drawings outside the Prado, Madrid.

Francisco de Goya y Lucientes
Don Manuel Osorio Manrique de Zuñiga

In the early 1780s, Goya was asked to paint six official portraits for the Bank of San Carlos (now the Bank of Spain). The sitters included such influential personages as Charles III of Spain, the conde de Altamira, and the conde de Cabárrus, founder of the bank. Indeed, this commission would prove to be a turning point in Goya's career, for not only did it occasion his first portrait of Charles III (later, in 1786, he was appointed Painter to the King), but also it was to bring him the patronage of the noble Altamira family. Goya painted another three portraits of the Altamira family over the next few years, including this picture of the conde de Altamira's youngest son, don Manuel.

Although this painting at first appears to be a conventional portrait of a child, on closer scrutiny it is seen to be a rather sinister and unsettling work. Don Manuel, depicted in luxurious costume, holds a magpie on a string, who in turn holds Goya's calling card in his beak. In the background three cats stare menacingly at the bird, ready to pounce. From the earliest days of Christian art, birds have been used to symbolize the soul, and in much Baroque painting, caged birds represent childhood. But rarely are birds so convincingly threatened as here: It would appear that Goya is illustrating the frail boundaries that separate a child's world from the ever-present forces of evil.

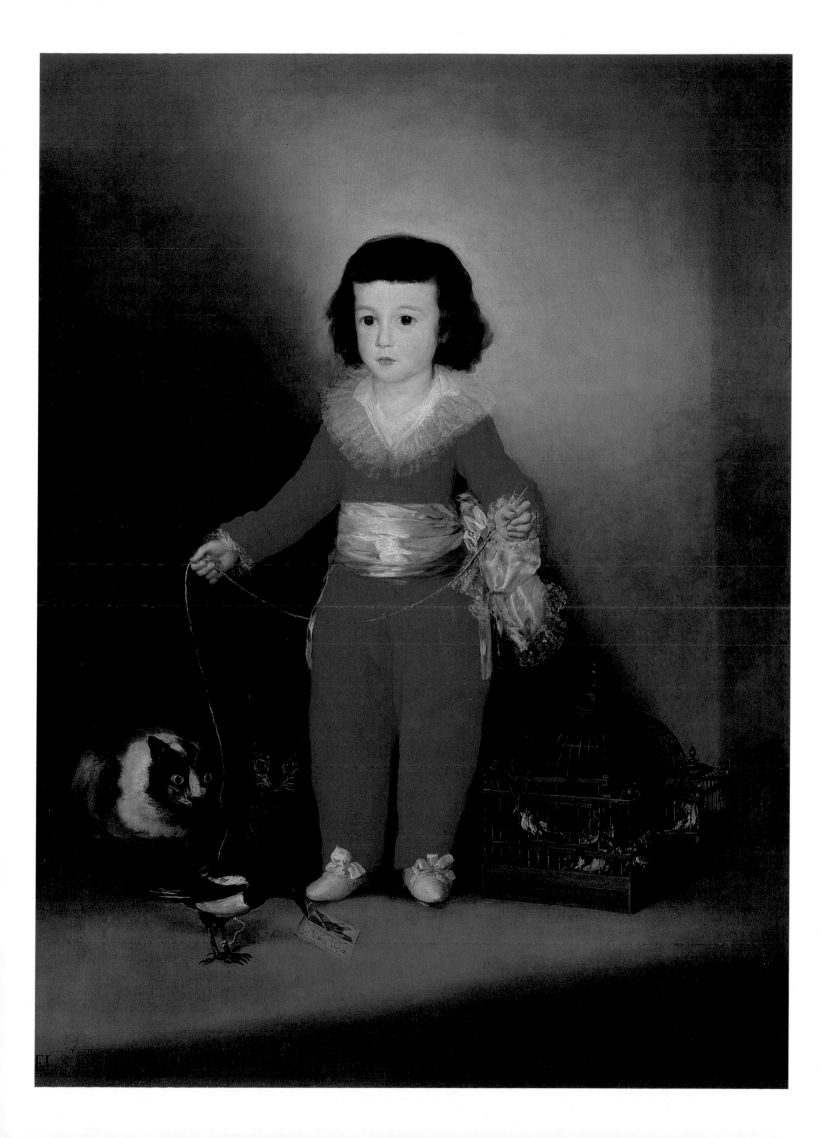

FRANCISCO DE GOYA Y LUCIENTES
He Wakes Up Kicking

Goya painted directly onto canvas without relying upon preparatory sketches. Yet he has come to be regarded as one of the greatest graphic artists of all time. At his death, Goya left more than one thousand drawings and nearly three hundred etchings and lithographs, representing his most innovative, personal, and disturbing work. From 1796 onward, Goya filled eight albums with drawings to amuse himself and his friends. They are commentaries on human existence—often satirical—ranging from the pleasures and folly

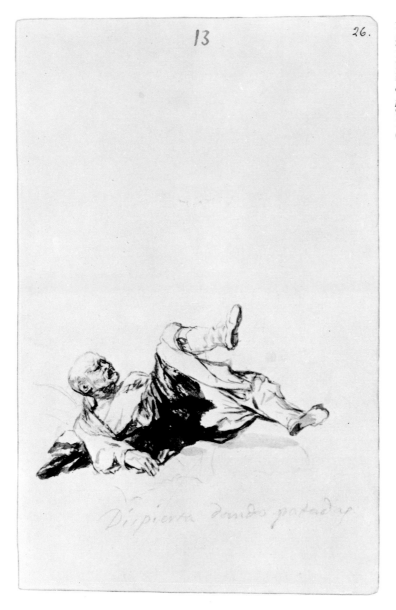

52 *He Wakes Up Kicking*, ca. 1801–03
Francisco de Goya y Lucientes
Spanish, 1746–1828
Point of brush and gray wash, heightened with black chalk; inscribed by the artist in black chalk below figure, *Dispierta dando patadas* [He Wakes Up Kicking], 9⅝₁₆ x 5¾ in. (23.6 x 14.6 cm.)
Harris Brisbane Dick Fund, 1935
(35.103.26)

of love to the anguish of human misery. The captions written casually above or below the drawings are Goya's own, added to explain the subject or to bemuse the spectator. This pathetic little figure is shown struggling with his anxieties as if in an existential vacuum. The drawing belongs to Goya's smallest album, dated 1801–03, of which only seventeen drawings are known. It is also one of the fifty sheets purchased by the Metropolitan in 1935.

Francisco de Goya y Lucientes
The Giant

Goya was a fashionable and successful painter of royal portraits and tapestry cartoons when in 1799, at the age of fifty-three, several years after suffering a nearly fatal illness that left him deaf, he published a set of eighty satirical etchings called *Los Caprichos,* now the best known of his prints. Goya went on to produce three other sets of etchings, the *Disasters of War,* the *Bullfights,* and the *Follies,* or *Proverbs,* and at the age of eighty, in Bordeaux, he took up the brand new medium of lithography and created some of the greatest works ever done in that medium. The nearly three hundred prints, even without his magnificent painted oeuvre, would place Goya among the major artists of his era.

The Giant stands alone among Goya's prints in several ways. He was technically innovative in both etching and lithography, and in this print he created the image by covering the plate with an allover tone of aquatint and then using a burnisher to scrape out the design. The method is thus similar to mezzotint—a technique brought to great heights in England in the eighteenth century—but the effect is stronger and freer. The plate was accidentally destroyed, and only six impressions of it are known, this and one other in the first state, and four others showing more burnishing to change the outline of the forearm and make more explicit the tiny villages on the plain.

The print is not part of any series, although it was done during the period of the *Disasters of War,* that is, between 1810 and 1820, while Spain was devastated first by the armies of Napoleon and then by famine and civil disorder. The image is similar to the painting called *The Colossus,* or *Panic,* now in the Prado, Madrid, made by 1812. In both works the colossal figure stands for the immense powers governing human destiny, over which we have no control.

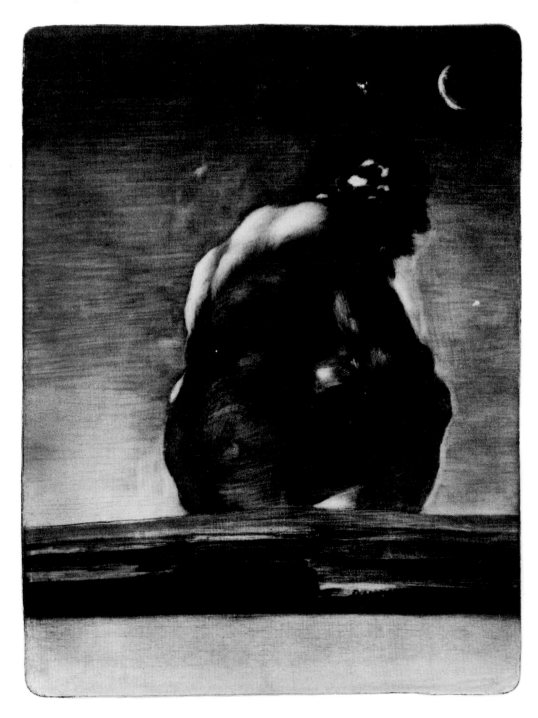

53 The Giant, 1818
Francisco de Goya y Lucientes
Spanish, 1746–1828
Aquatint with burnishing;
11½ x 8¼ in. (29.5 x 20.9 cm.)
Harris Brisbane Dick Fund, 1935
(35.42)

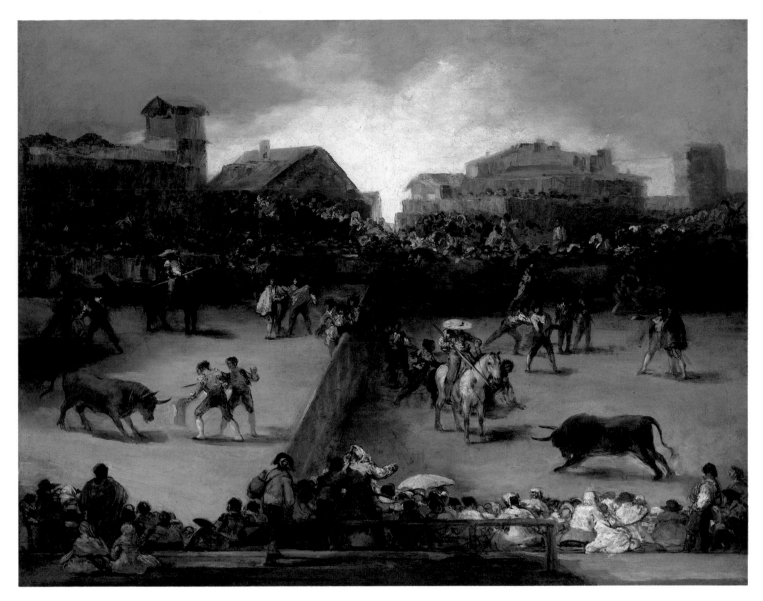

54 The Bullfight
Francisco de Goya y Lucientes
Spanish, 1746–1828
Oil on canvas; 38¾ x 49¾ in. (98.4 x 126.3)
Wolfe Fund, Catharine Lorillard Wolfe
Collection, 1922 (22.181)

Opposite: detail

Francisco de Goya y Lucientes

The Bullfight

Bullfighting is a subject intimately associated with the art of Goya, where it is perhaps best expressed in his series of etchings, the *Tauromaquia*. These thirty-three plates, worked by Goya in the course of 1815, were published the following year and constitute one of the few series of prints publicly sold by the artist during his life. They depict actual events that occurred in the Plaza de Madrid: dramatic scenes of heroism by brave toreadors as well as gruesome gorings of innocent bystanders. In their ennobling of everyday occurrences, the prints were sure to find a popular audience; but in publishing them, Goya traversed the opinion of many of Madrid's aristocrats that bullfighting was a base sport, appealing to the worst instincts of an uneducated mind. That Goya willingly proclaimed his identification with the ancient Spanish ritual is testimony not only to his particular love of bullfights but also to his identification with the proletariat and their pursuits.

This painting, well known and much discussed since the end of the nineteenth century, is somewhat anomalous in style and technique to the rest of Goya's oeuvre, and thus it has sometimes been regarded skeptically by authorities in the field. Some writers believe that it was included, although not named, in an 1812 inventory of Goya's studio; others believe that it figured in an 1828 inventory taken after his death. Almost certainly it was executed in the years before the publication of the *Tauromaquia*, and it shares with the prints a remarkable specificity and feeling of actuality. Yet the divided bullring has never been identified with certainty, and no known toreador's name has been associated with those depicted here. Nonetheless, the remarkable calligraphy of Goya's brush, seen in the jotted crowd of observers, and his brilliant inclusion of bright color within an otherwise restricted palette, can be found in a number of genre pictures executed during the Spanish War of Independence.

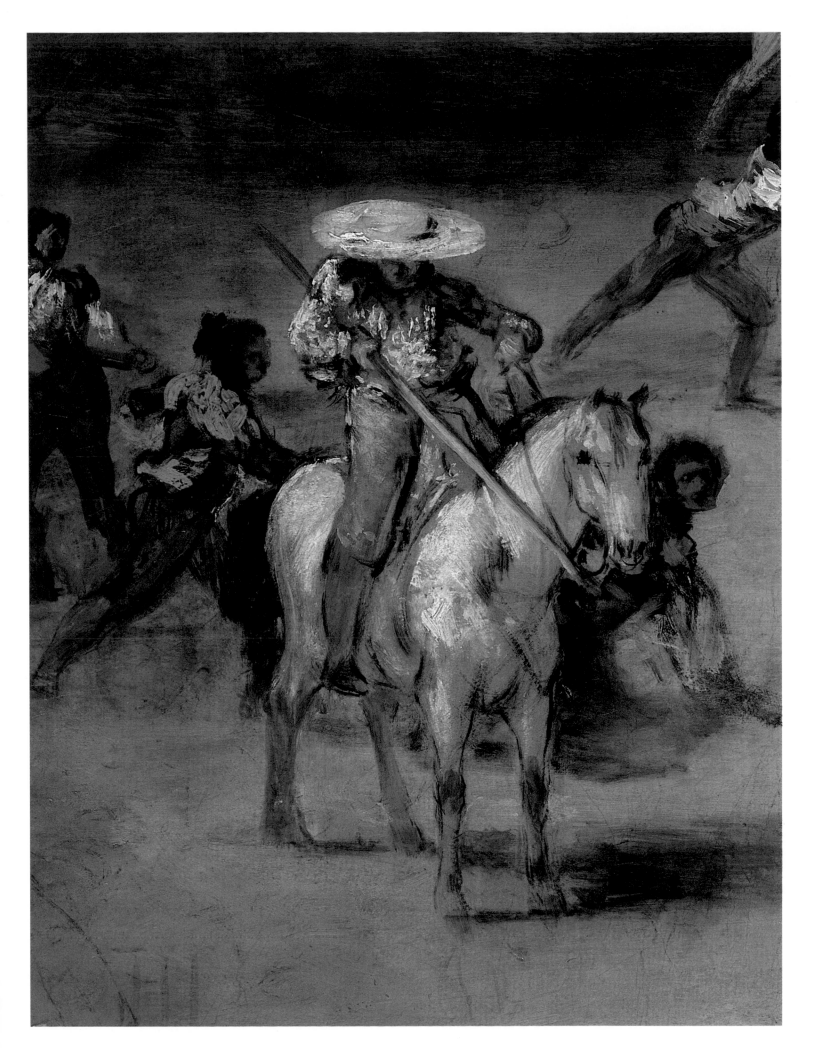

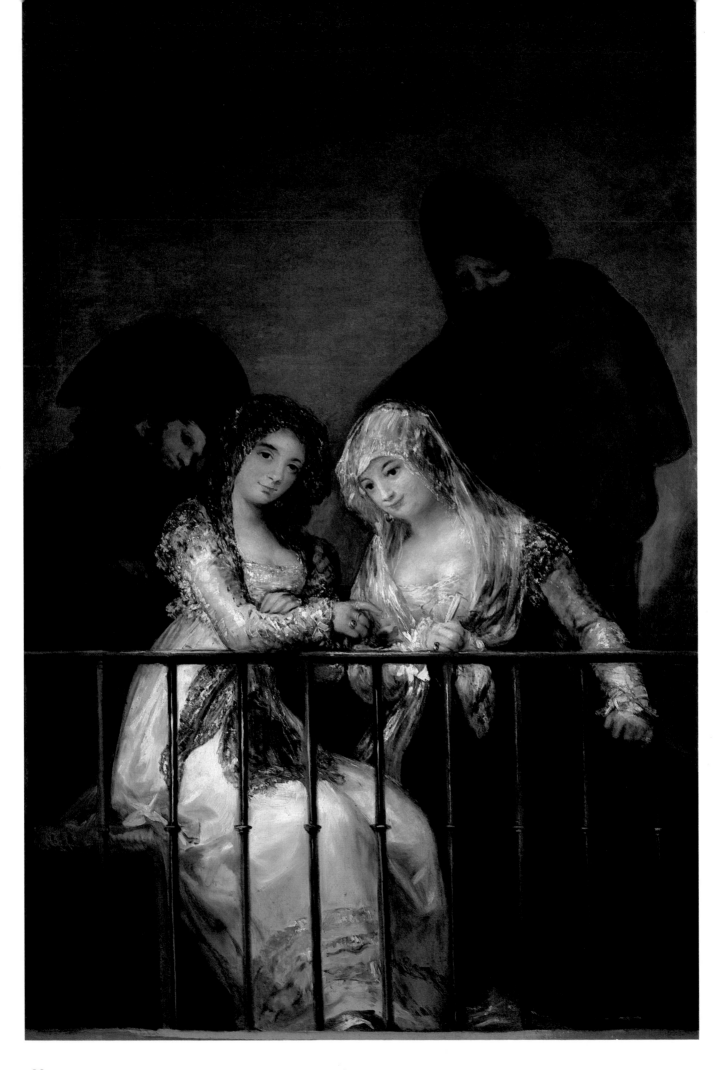

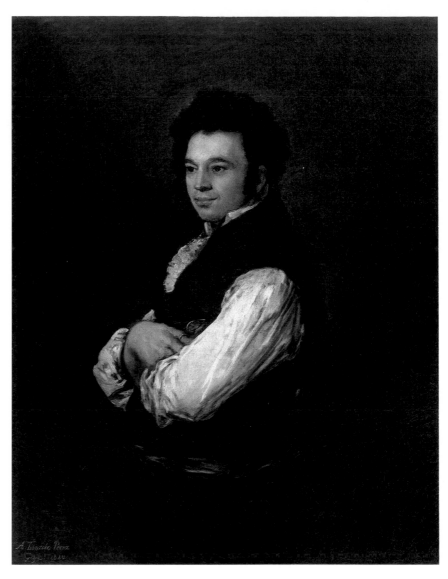

55 *Majas on a Balcony*
Copy after Francisco de Goya y Lucientes
Spanish, 1746–1828
Oil on canvas; 76¾ x 49½ in.
(194.8 x 125.7 cm.)
Bequest of Mrs. H.O. Havemeyer, 1929,
H.O. Havemeyer Collection (29.100.10)

56 *Don Tiburcio Pérez y Cuervo, the Architect*, 1820
Francisco de Goya y Lucientes
Spanish, 1746–1828
Oil on canvas; 40¼ x 32 in. (102.1 x 81.3 cm.)
Theodore M. Davis Collection, 1915,
Bequest of Theodore M. Davis (30.95.242)

COPY AFTER

FRANCISCO DE GOYA Y LUCIENTES
Majas on a Balcony

This painting is a copy, probably executed soon after the
artist's death, of a painting now in Geneva that is one of a
group of genre subjects that Goya painted during or shortly
after the Spanish War of Independence (1808–14), when
he received no commissions from the court. Here, he depicts
majos and *majas*, male and female members of the Spanish
working class who were easily recognized by their striking
attire and flamboyant behavior. The enthusiasm for *majismo*
was such that Goya's patrons sometimes chose to pose in
the guise of these dashing young Spaniards.

During the middle and second half of the nineteenth
century there was a marked interest in Spanish paintings,
especially those of Goya. Edouard Manet based the compo-
sition of his 1868 painting *The Balcony* (Paris, Musée d'Orsay)
on *Majas on a Balcony*. However, it is not known which of the
four versions of the painting he had seen.

FRANCISCO DE GOYA Y LUCIENTES
Don Tiburcio Pérez y Cuervo, the Architect

On February 27, 1819, Goya acquired a country property
of about twenty-five acres on the right bank of the river
Manzanares, just outside Madrid. He moved to the prop-
erty, called the "Quinta del Sordo," with Leocadia Weiss and
her daughter, Rosarito, and remained there until he left for
Bordeaux in June 1824. Not only was Spain sinking into
political and economic chaos at the time, but closer to home,
the Inquisition had reopened its files on Goya; thus the
Quinta was a double form of escape that enabled him to
work in peace and quiet. Goya spent this period mainly on
graphic works, a few ecclesiastic commissions, and murals
to decorate the Quinta: fourteen works known as "the black
paintings," now in the Prado, Madrid. He also executed a
few portraits, although, unlike earlier in his career, these
were confined to pictures of his friends, one of them, Don
Tiburcio Pérez y Cuervo.

Don Tiburcio, an architect, is known to have been quarrel-
some and to have enjoyed a reputation as a bullfighter, an
interest he shared with the artist. Goya's depiction of him in
an almost defiantly casual pose stands in direct opposition
to the formality of the artist's earlier portrait commissions.
The result is one of the most engaging of Goya's male portraits.

ENGLISH COIN CABINET

The cabinetmakers William Vile and John Cobb, partners since 1750, were appointed "Joint Upholsterers to his Majesty's Great Wardrobe" in 1761. In that same year, Vile submitted a bill for alteration work on George III's medal cabinet, work that had been supplied—probably by Vile—in 1758. The cabinet illustrated here, which may have had an open stand, is likely to have been an end section of that medal cabinet. The other, almost identical end-cabinet is in the Victoria and Albert Museum in London, and the whereabouts of the middle section are not known. Comprising three stages, the cabinet is richly decorated with superbly carved and applied ornament. The front of the pedimented top section is carved with the star of the Order of the Garter, set within acanthus foliage. Enclosed behind doors are 135 shallow drawers, intended to hold the king's extensive collection of medals.

LOUIS FRANÇOIS ROUBILIAC
The Sense of Sight

Louis François Roubiliac, a refugee Huguenot sculptor from France, arrived in England in the 1730s and immediately entered the supportive circle of other French Huguenots active in London. Although he based this porcelain figure on his terra-cotta of Ganymede, he has added a painted rainbow and a peacock feather around the eagle's neck so as to make the figure represent Sight, for a series of statuettes embodying the five senses. There is very little here of the conflicting and syncopated rhythms of the Rococo style that accounted for so much early porcelain art. Rather, the sculptural rhythms of Roubiliac's work are marked by broad diagonals, a characteristic of Baroque art.

57 Coin Cabinet, 1758–1761
Attrib. to William Vile
English, 1700–1767
Mahogany; 79 x 27 x 17¼ in.
(200.7 x 68.6 x 43.8 cm.)
Fletcher Fund, 1964 (64.79)

58 The Sense of Sight
London (Chelsea), ca. 1755
Modeled prob. by Louis François Roubiliac
(b. France, act. England, 1702/5–1762)
Soft-paste porcelain from a set of five;
H. 11⅛ in. (28.3 cm.) Bequest of
John L. Cadwalader, 1914 (14.58.117)

OVERLEAF:

ENGLISH TAPESTRY ROOM *(Pages 84–85)*

Even before his accession to the title in 1751, George William, sixth earl of Coventry, had begun to reconstruct his house and gardens at Croome Court in Worcestershire. In 1760 Robert Adam replaced Capability Brown as the earl's architect and interior decorator, and under Adam's direction the refined, elegant tapestry room was executed. Most of the elements in the room today, such as the oak floor, mahogany doors, and carved paneling by the carpenter John Hobcraft and the carver Sefferin Alken, are authentic. The decorative chimneypiece displays two kinds of marble as well as a lapis-lazuli tablet. The master plasterer Joseph Rose, who worked for Adam on a number of occasions, was responsible for the ceiling with its ornamented wheel molding, center rosette, and garlanded trophies. It is known that a number of leading London cabinetmakers and upholsterers supplied the furnishings for this room. The marquetry commode was purchased from Peter Langlois, a French cabinetmaker, in 1764, and the firm of Ince and Mayhew provided the set of carved and gilded seating, the pierglass, and the curtain cornices. Specially ordered in 1763, the crimson tapestries on the walls and seating are the chief glory of the room. They were woven in the workshop of Jacques Neilson at the Gobelins manufactory in Paris. The oval medallions, depicting mythological scenes symbolizing the elements, are based on designs by François Boucher. Upon its completion in 1771, this tapestry room must undoubtedly have been one of the grandest and most harmonious of all early Neoclassical interiors.

59 Tapestry Room from Croome Court, Worcestershire
English, 1760–71
Wood, plaster, tapestry, and marble; 13 ft. 10¾ in. x
27 ft. 1 in. x 22 ft. 8 in. (4.23 m. x 8.27 m. x 6.9 m.)
Gift of the Samuel H. Kress Foundation, 1958 (58.75.1a)

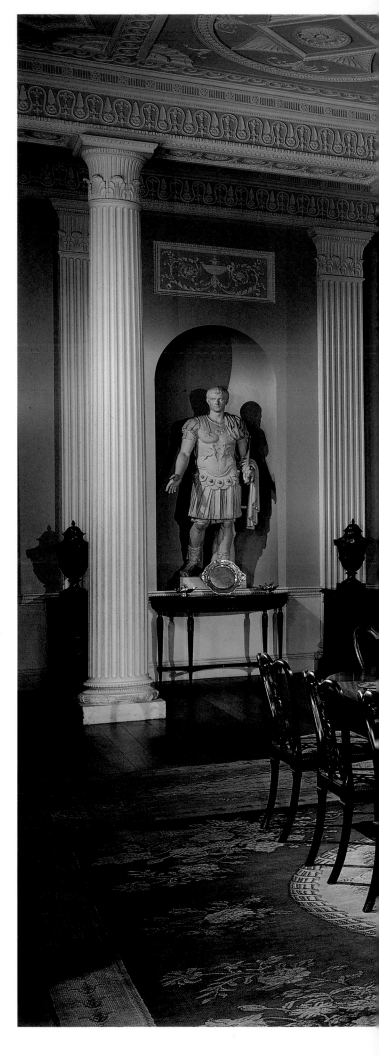

*60 Dining Room from
Lansdowne House, London*
English, 1765–68
Wood, plaster, and marble;
17 ft. 11 in. x 47 ft. x 24 ft. 6 in.
(5.46 m. x 14.31 m. x 7.47 m.)
Rogers Fund, 1931 (32.12)

DINING ROOM FROM THE LANSDOWNE HOUSE

In 1765 William Petty Fitzmaurice, second earl of Shelburne and the future marquis of Lansdowne, acquired a palatial residence on London's Berkeley Square. The mansion, built after designs of the Scottish architect Robert Adam, was only partially completed at the time. It was for Lord Shelburne that Adam designed this dining room, one of his most successful and sophisticated interiors. Preserved drawings and engravings for both the elevation of the walls and the complex geometrical ceiling show that the room was executed almost precisely as planned. The oak floor, the shutters, and the frames of doors and windows, carved by the sculptor John Gilbert, are original to the room, as is the marble chimneypiece, which has been attributed to Thomas Carter. The decorative columnar screen, creating a spatial effect of remarkable grandeur, is a feature recurring in several of Robert Adam's interiors. The glorious white plaster decorations of griffins, putti, Vitruvian scrolls, leaf garlands, and trophies, carried out by Joseph Rose, illustrate Adam's love for classical ornament. Plaster casts have replaced the antique statues from Lord Shelburne's collection that stood in the niches along the walls. Furniture from other sources complements this most splendidly proportioned room with its pleasing color scheme.

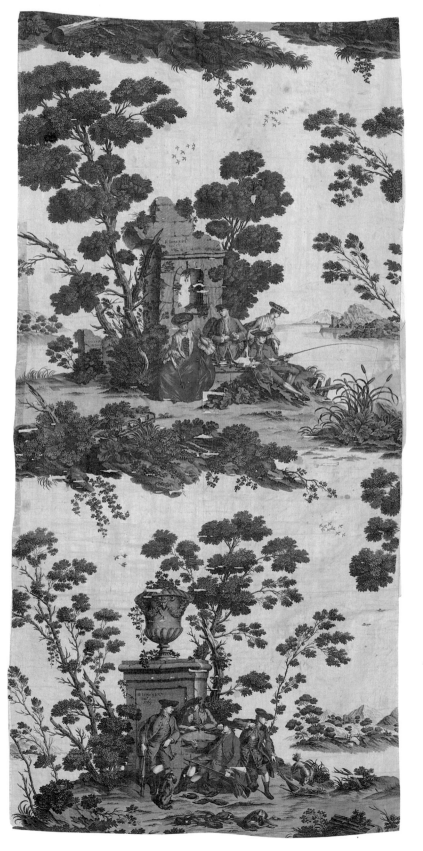

61 *Hunting and Fishing Scenes*
Robert Jones
English, act. 1761–80
Cotton and linen, copperplate
 and block printed with penciling;
81⅛ x 39 in. (206.1 x 99 cm.)
Rogers Fund, 1983 (1983.365)

ROBERT JONES
Hunting and Fishing Scenes

In 1752 Francis Nixon of Drumcondra, Ireland, discovered the process of colorfast copperplate printing on textiles. This technique utilized only one color but allowed larger and more detailed compositions, rendered with finer modeling, than could be achieved with traditional woodblock printing. The subjects and scenes used to decorate furnishing fabrics produced by this new method often parallel closely those found in contemporary paintings and prints. This is particularly evident in *Hunting and Fishing Scenes,* which depicts fashionably attired ladies and gentlemen pursuing the sporting pastimes of the gentry amid romantic ruins and landscape.

The inscription tells us that this was printed in 1769 by Robert Jones and Co. at Old Ford, a manufactory that Jones had founded at least eight years earlier in the East End of London. The painterly quality of the designs was achieved by combining different printing methods. First, the principal elements of the composition were copperplate printed —one plate for each of the two major scenes—in aubergine. Additional colors were then added by woodblock printing—a process involving great skill and time to ensure that all impressions register properly. Finally, blue was added by penciling.

GEORGE STUBBS

A Favorite Hunter of John Frederick Sackville, Later Third Duke of Dorset

George Stubbs was one of the rare artists of the eighteenth century who developed an important oeuvre with virtually no formal training. He became famous in his day as a painter of "sporting pictures," but he could render human physiognomy or a picturesque landscape with the same sensitivity and precision that he brought to his beloved horses. Stubbs was the son of a currier and leather seller, and although he began drawing at an early age, his experience in his father's shop seemed to have inculcated the passion for horses, for equestrian anatomy and movement, that gave birth to the series of investigations that led to the central achievement of the artist's life: the publication in 1766 of his engraved *Anatomy of the Horse*. It was this treatise, still useful today, that secured Stubbs's reputation and ensured sufficient commissions to support a comfortable life.

This canvas, probably commissioned by John Sackville, was executed at the height of Stubbs's career: a moment when his landscapes reached a pre-Romantic poetry and his painting of figures was confident and persuasive. As always, the portrait of the bay hunter is superbly executed. The small inconsistencies of lighting and shadow betray Stubbs's usual practice of painting the horse first on a neutral background, and afterward painstakingly filling in the landscape between the legs.

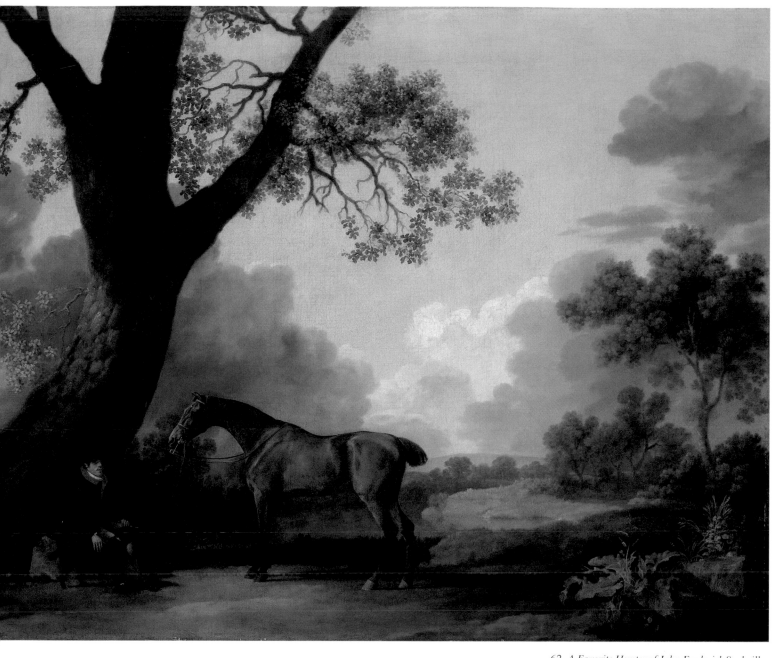

62 *A Favorite Hunter of John Frederick Sackville,*
later Third Duke of Dorset, 1768
George Stubbs
British, 1724–1806
Oil on canvas; 40 x 49¾ in. (101.6 x 126.4 cm.)
Bequest of Mrs. Paul Moore, 1980 (1980.468)

OVERLEAF:

SIR JOSHUA REYNOLDS *(Pages 90–91)*

The Honorable Henry Fane with His Guardians, Inigo Jones and Charles Blair

Sir Joshua Reynolds, the most sought-after portrait painter of his day, has until recently been better rememberèd for his accomplishments as a theorist on art and as founding president of the Royal Academy than for the portraits in the grand manner on which his artistic reputation rests. Apprenticed as a youth to the portraitist Thomas Hudson, he learned painting as a craft rather than an art, yet owing to the sophistication of his subsequent learning and the analytical power of his mind, he overcame his initial difficulty with drawing. With the institution of the Royal Academy, he almost singlehandedly raised the status of artists in England, and it was he who revived the standing of the portrait to

that of great art, as Anthony van Dyck and Peter Paul Rubens had done before him.

This group portrait of the Honorable Henry Fane, the future tenth earl of Westmoreland, and his two trustees was executed in 1766—two years before Reynolds became president of the Royal Academy. He was at an early stage in his career, but his talents were at their highest: His skills of persuasive characterization, evident in this picture, were in full force, and he had not yet adopted the self-consciously Neoclassical style that rarely flattered his sitters. Rather, the perquisites and personalities of the English nobility are here rather imposingly displayed.

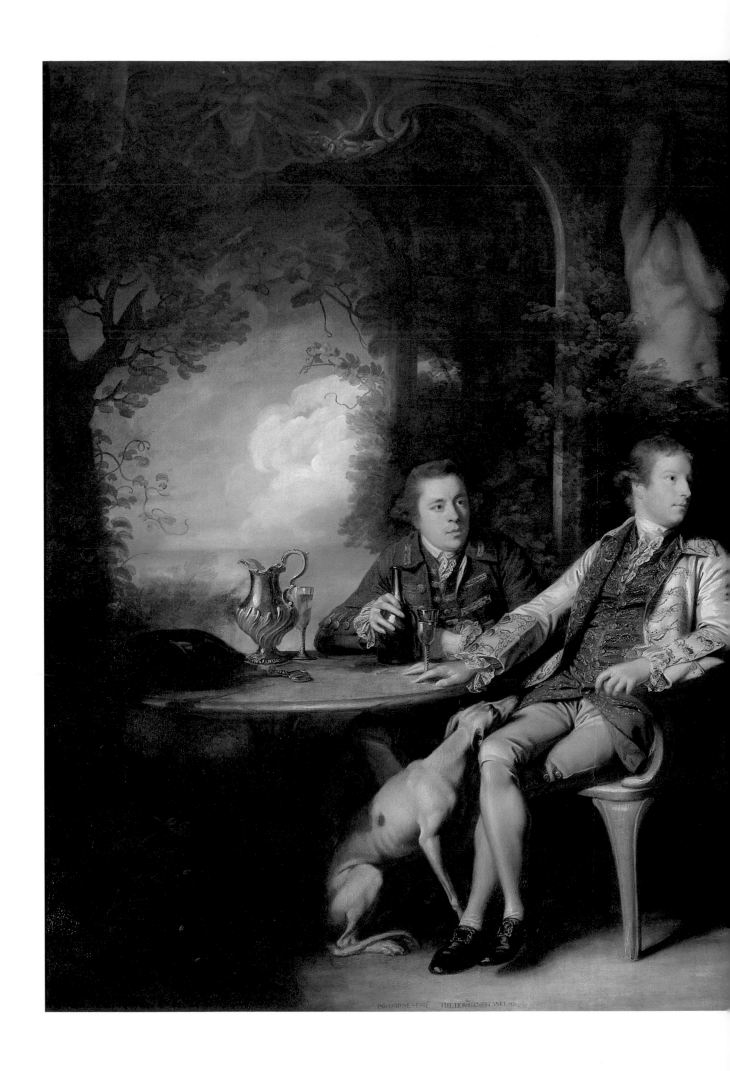

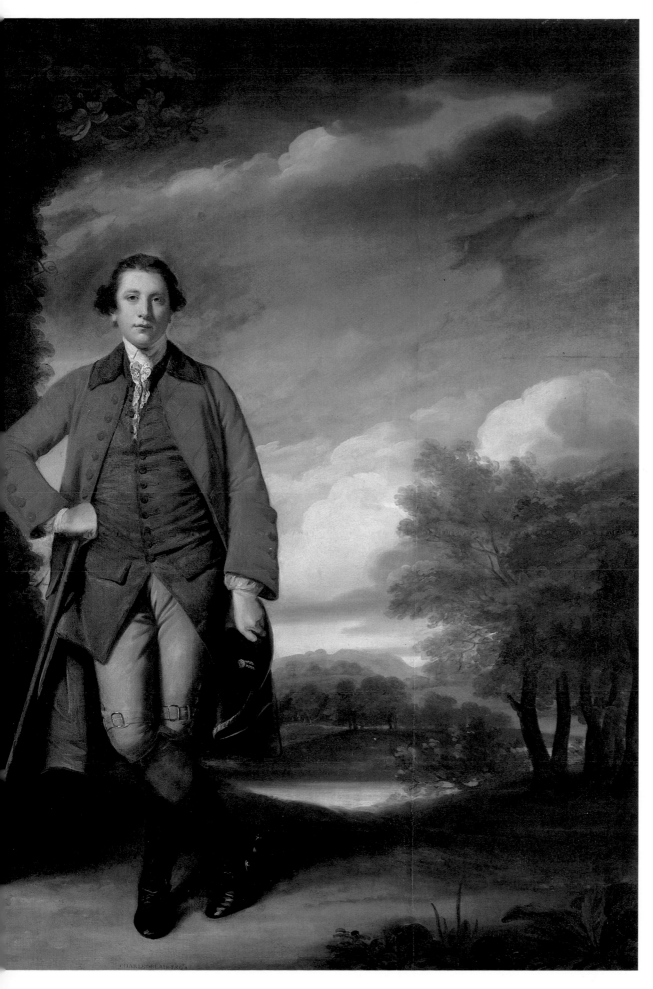

63 *The Honorable Henry Fane
(1739–1802) with His Guardians,
Inigo Jones and Charles Blair*, 1766
Sir Joshua Reynolds
British, 1723–92
Oil on canvas; 100¼ x 142 in.
(254.6 x 360.7 cm.)
Gift of Junius S. Morgan, 1887
(87.16)

Page 89: text

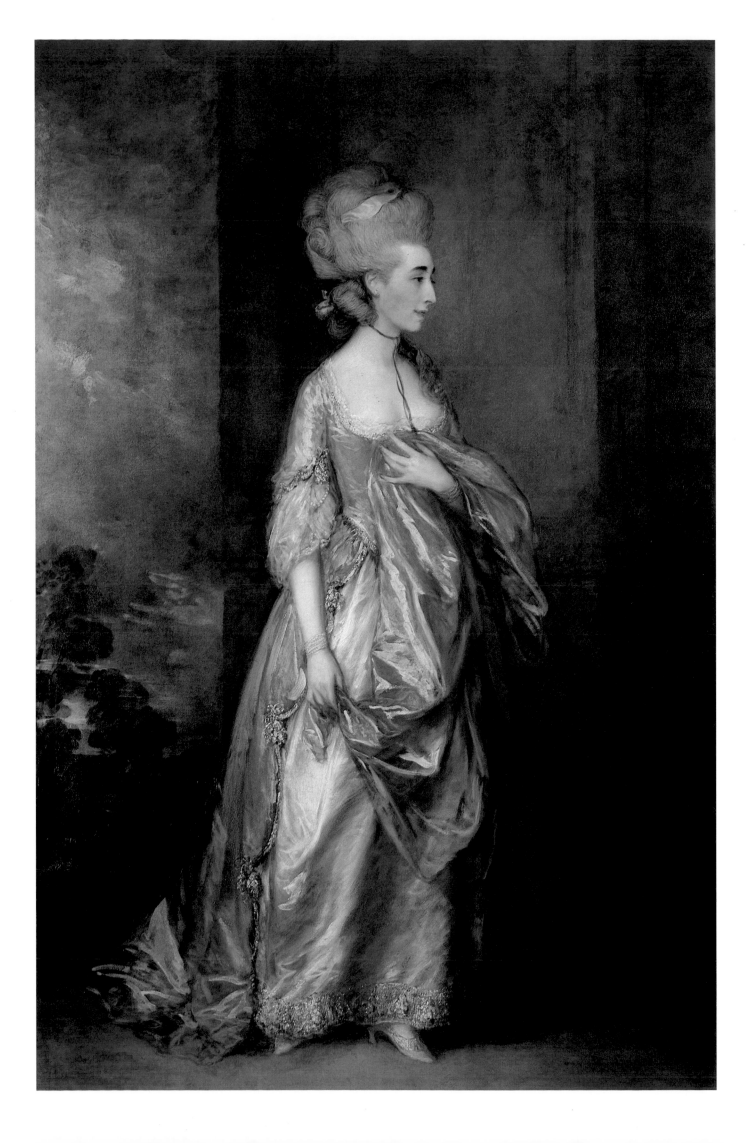

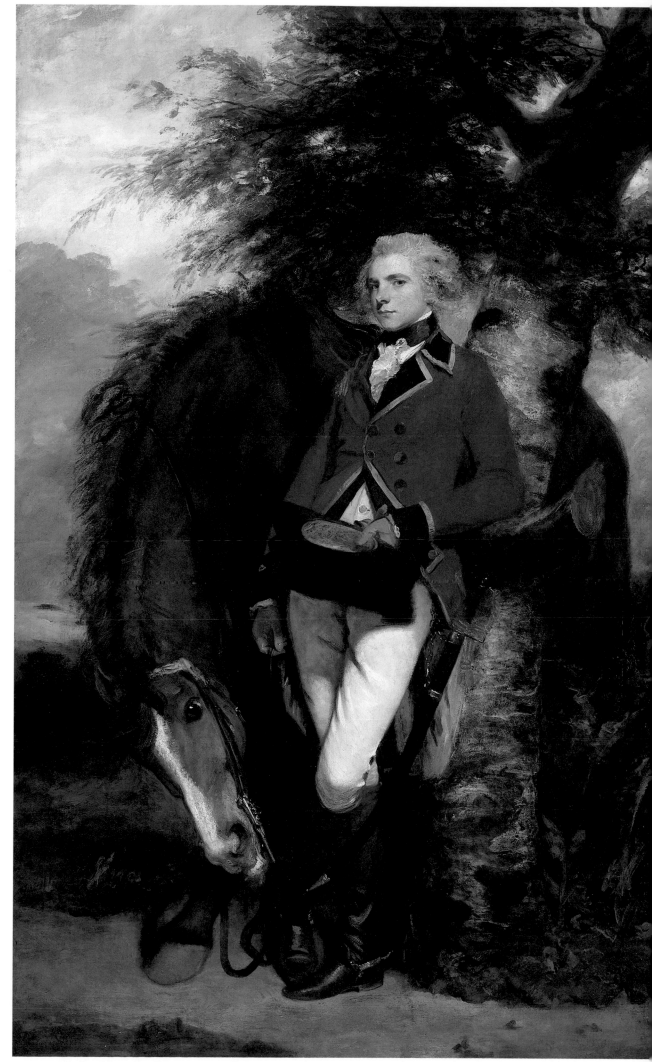

*64 Mrs. Grace Dalrymple Elliott,
(1754?–1823)*
Thomas Gainsborough
British, 1727–88
Oil on canvas; 92¼ x 60½ in.
(230.6 x 151.2 cm.) Bequest of
William K. Vanderbilt, 1920
(20.155.1)

Page 94: text

*65 Colonel George K. H. Coussmaker
(1759–1801), Grenadier Guards,*
Sir Joshua Reynolds
British, 1723–92
Oil on canvas; 93¾ x 57¼ in.
(238.1 x 145.4 cm.) Bequest of
William K. Vanderbilt, 1920
(20.155.3)

Page 94: text

THOMAS GAINSBOROUGH *(Page 92)*
Mrs. Grace Dalrymple Elliott

By the time Thomas Gainsborough moved to London from the provinces in 1774, he had evolved his portrait style from the small-scale, French-influenced, conversation pieces of his days in Ipswich and Bath to the commanding lifesize portraits in the grand manner that brought him fame. The first of many royal commissions came in 1777, and from this time on his position, with Reynolds, as one of the leading painters of his day was assured.

The daughter of an Edinburgh lawyer, Grace Dalrymple married the elderly Dr. Elliott at age seventeen, the first step in a remarkable amorous career. Three years later she eloped to Paris with Lord Valentia but returned to England as the mistress of the marquess of Cholmondeley, who commissioned the present painting. Gainsborough exhibited the portrait at the Royal Academy exhibition of 1778, and the sitter's history did not escape notice. One newspaper commented that the artist's subjects "consist chiefly of *filles de joie*, and are all admirable likenesses, no. 114 particularly, being that of the beautiful Mrs. E." The prince of Wales subsequently saw the portrait at Cholmondeley's country house, Houghton, and asked to meet Mrs. Elliott; later, the prince claimed paternity of her child. Mrs. Elliott was introduced by the prince to Philippe Egalité, duke of Orléans, with whom she moved back to Paris in 1786, living there through the Revolution. She died in 1823.

SIR JOSHUA REYNOLDS *(Page 93)*
Colonel George K. H. Coussmaker, Grenadier Guards

One of the masterpieces of Sir Joshua Reynolds's late career, this portrait of 1782–83 required some sixteen sittings of Colonel Coussmaker, and several more for the horse. While the artist no doubt enjoyed in his composition a reference to van Dyck's portrait of Charles I in hunting costume (Paris, Louvre), the subject's ease of pose and casual regard are Reynolds's own. Nevertheless, the brighter tonality of this late work and the more sensuous application of paint may be his response to the rising popularity of Thomas Gainsborough's painting.

66 The Wood Gatherers
Thomas Gainsborough
British, 1727–88
Oil on canvas; 58⅛ x 47⅜ in.
(147.6 x 120.3 cm.) Bequest of
Mary Stillman Harkness, 1950
(50.145.17)

THOMAS GAINSBOROUGH
The Wood Gatherers

This work is one of some twenty "Fancy Pictures" executed by Thomas Gainsborough in his last eight years of his life. Based on similar subjects by Murillo—Gainsborough's favorite painter after van Dyck—these genre scenes were widely admired by the artist's contemporaries. Reynolds called one, *Girl with Pigs*, "the best picture he ever painted, or perhaps ever will." *The Wood Gatherers* is among the latest and most confidently painted of the series, notable for the romantic landscape lit by the last rays of sun, and the masterful grouping of figures.

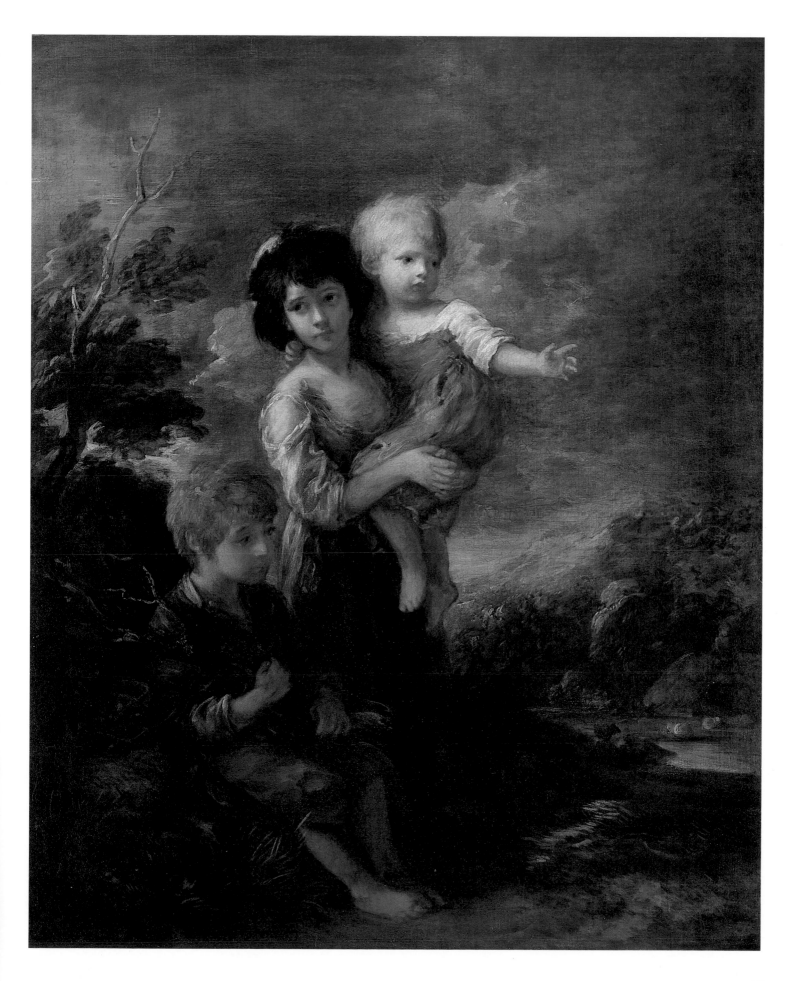

95

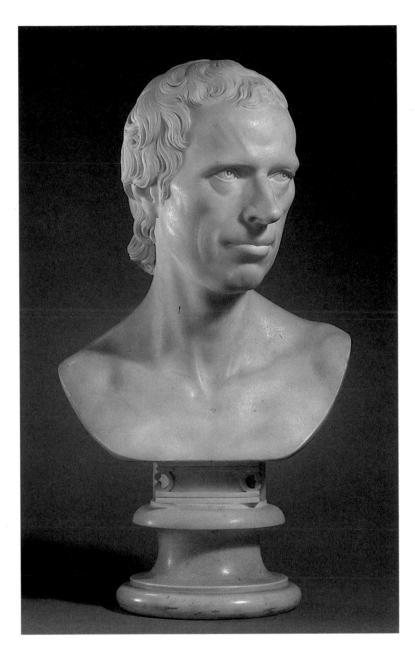

67 *Bust of Laurence Sterne*, ca. 1765–66
Joseph Nollekens
English, 1737–1823
Marble; H. (incl. socle) 21¾ in. (55.2 cm.)
Purchase John T. Dorrance, Jr. Gift,
in memory of Elinor Dorrance Ingersoll,
1979 (1979.275.2)

68 *Vauxhall Gardens*, 1785
Design by Thomas Rowlandson (British, 1757–1827),
etching by Robert Pollard (British, 1755–1838),
aquatint by Frances Jukes [?] (British, 1747–1812)
Etching and aquatint; 20⅞ x 29⅞ in. (53 x 75.9 cm.)
The Elisha Whittelsey Collection, The Elisha Whittelsey
Fund, 1959 (59.533.975)

JOSEPH NOLLEKENS
Bust of Laurence Sterne

The Neoclassical portrait bust, crisply white and bare of shoulder, became an essential property in the English home. Joseph Nollekens was one of the most prolific suppliers of such busts. This portrait of Sterne has a pendant bust of Alexander Pope. It was with this work, however, that Nollekens first attracted attention; his biographer, J. T. Smith, noted astringently that "with this performance, Nollekens continued to be pleased even unto his second childhood." Nollekens modeled the bust in 1765–66 in Rome, where the greatly lionized author of *Tristram Shandy* was traveling for the sake of his health. A certain ironic play in the set of the mouth perhaps denotes the humorist, but overall a stoic look dominates, obtained from the sculptor's study of Roman Republican portraiture.

THOMAS ROWLANDSON
Vauxhall Gardens

Thomas Rowlandson's prints number over three thousand—it was said that the amount of copper he etched would sheathe the British Navy. *Vauxhall Gardens,* his best-known work and one of his largest, drawn in 1784 and published as a print a year later, demonstrates his appeal. Human ugliness and variety are exposed, but with sympathy and charm. A well-informed contemporary could have identified many of the foreground figures. Near the right, the Prince of Wales (future George IV) speaks into the ear of his beloved Perdita Robinson, whose much older husband, on the other side, seems to be trying to pull her away; the two young women in the center are the duchess of Devonshire and her sister, Lady Duncannon; and tradition has it that the group dining at a table at the far left are Samuel Johnson with Boswell, Mrs. Thrale, and Oliver Goldsmith. The scene was intended as a typical, not a specific, scene at Vauxhall, where concerts in the "orchestra" decorated in Gothic style attracted the fashionable and their followers.

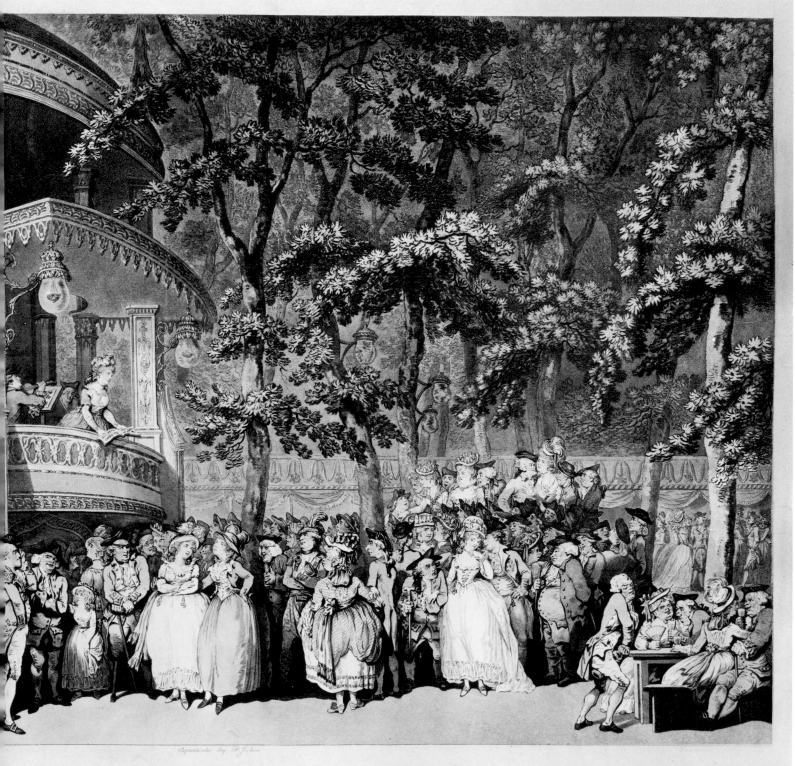

VAUX-HALL

69 *Portrait of Count Joseph Boruwlaski*, 1798
Samuel Percy
Irish, 1750–1820
Colored wax on glass; 7¾ in. x 6⅜ in.
(18.7 cm. x 162 cm.)
The Glenn Tilley Morse Collection,
Bequest of Glenn Tilley Morse, 1950 (50.187.30)

SAMUEL PERCY
Portrait of Count Joseph Boruwlaski

Among the minor arts, wax portrait miniatures developed into a quintessentially English art form. On all counts the most gifted practitioner, however, was an Irishman, Samuel Percy, deft modeler of complex genre scenes in addition to the usual run of lordly statesmen and busty beauties that were the bread and butter of the trade. In this case Percy shows wit to match that of his sitter, the Polish-born dwarf Joseph Boruwlaski, celebrated in his day for a life of international adventure and for his conversational powers. Boruwlaski, who was unusually well proportioned for a dwarf, was to live to the age of ninety-eight. Percy depicts him at forty-eight, alert and keen of eye and shown as if seated in a theater box (suggested by the green swag of curtain). His small stature is emphasized by his placement toward the bottom of the composition with lots of surrounding space.

GEORGE ROMNEY
Self-Portrait

After Sir Joshua Reynolds and Thomas Gainsborough, George Romney was the most popular portrait painter in England during the reign of George III. He began by painting portraits in the provinces, after serving his apprenticeship to an itinerant painter named Christopher Steele. But Romney's style did not coalesce until he moved to London in 1762. There he developed the free-flowing and at times bold manner that informs his best work. When Romney was uninspired, his portraits often had a routine air; when he was given a beautiful young woman, a dashing officer, or a pink-cheeked child, however, he could invest their portraits with an ease and vigor that is rarely found in the work of his better-known contemporaries.

Romney painted self-portraits only infrequently; this introspective work was done fairly late in the artist's career. His son, the Reverend John Romney, described it in his memoirs of his father's life:

> In the winter of 1795 he painted a head of himself, which, though slight, and not entirely finished, being painted at once, shows uncommon power of execution; the likeness also, is strong, but there is a certain expression of languor that indicates the approach of disease.... It is remarkable that it is painted without spectacles, though he had been in the habit of using glasses for many years.

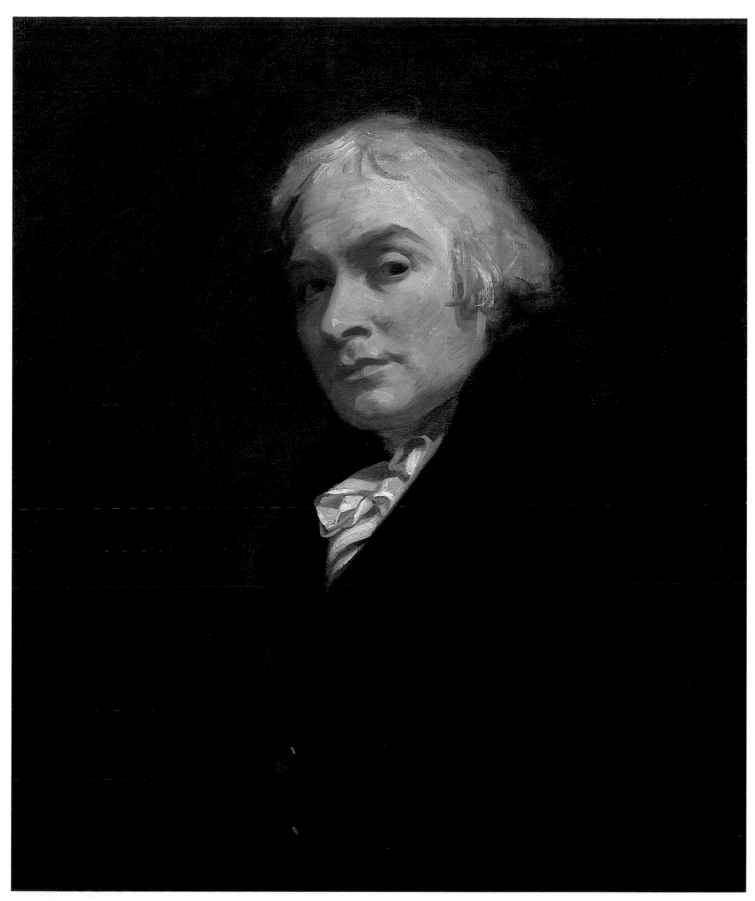

70 Self-Portrait, 1795
George Romney
British, 1734–1802
Oil on canvas; 30 x 25 in. (76.2 x 63.5 cm.)
Bequest of Maria DeWitt Jesup, from the
collection of her husband, Morris K. Jesup,
1914 (15.30.37)

Sir Thomas Lawrence
Elizabeth Farren, later Countess of Derby

Sir Thomas Lawrence, like Mozart, was a child prodigy. And like Mozart's father, Lawrence's subordinated all family priorities to the promotion of his son's talents as a draftsman and portraitist. By the time Thomas was eleven, his family had established him at Bath, where he drew portraits in pastel of local nobles and visiting dignitaries. In 1787 he submitted his first portraits in oil to exhibitions in London, to uncertain reviews. But when, at the age of twenty-one, he exhibited this portrait of Elizabeth Farren at the Royal Academy, it received instant and unanimous acclaim. To an audience accustomed to the stiff Neoclassicism and awkward drawing of Reynolds, the naturalism of Lawrence's portrait —its subject caught seemingly unawares, depicted with brilliant fluency and vibrant brushwork—appeared to create a new vocabulary of style almost overnight. Reynolds himself, always a better critic than artist, was one of the first to acknowledge Lawrence's gifts and paid him the compliment of saying, "In you, sir, the world will expect to see accomplished all that I have failed to achieve."

Most critics remarked on Lawrence's skill in rendering the fine fur, satin, and silky gauze of the gown. But the veracity of the likeness was noticed as well: One critic wrote, "We have seen a great variety of pictures of Mrs. Farren, but we never before saw her mind and character on canvas. It is completely Elizabeth Farren: arch, spirited, elegant and engaging."

The daughter of a surgeon at York, Elizabeth Farren was trained as an actress with a company of itinerant players and made her debut in London as Kate Hardcastle in Goldsmith's *She Stoops to Conquer.* In 1790, when this portrait was painted, she stood at the height of her professional career. The protégée of the earl of Derby, she married him on the death of his first wife in 1797.

71 Elizabeth Farren, later Countess of Derby
(b. ca. 1759–d. 1829)
Sir Thomas Lawrence
British, 1769–1830
Oil on canvas; 94 x 57½ in. (238.8 x 146.1 cm.)
Bequest of Edward S. Harkness, 1940 (50.135.5)

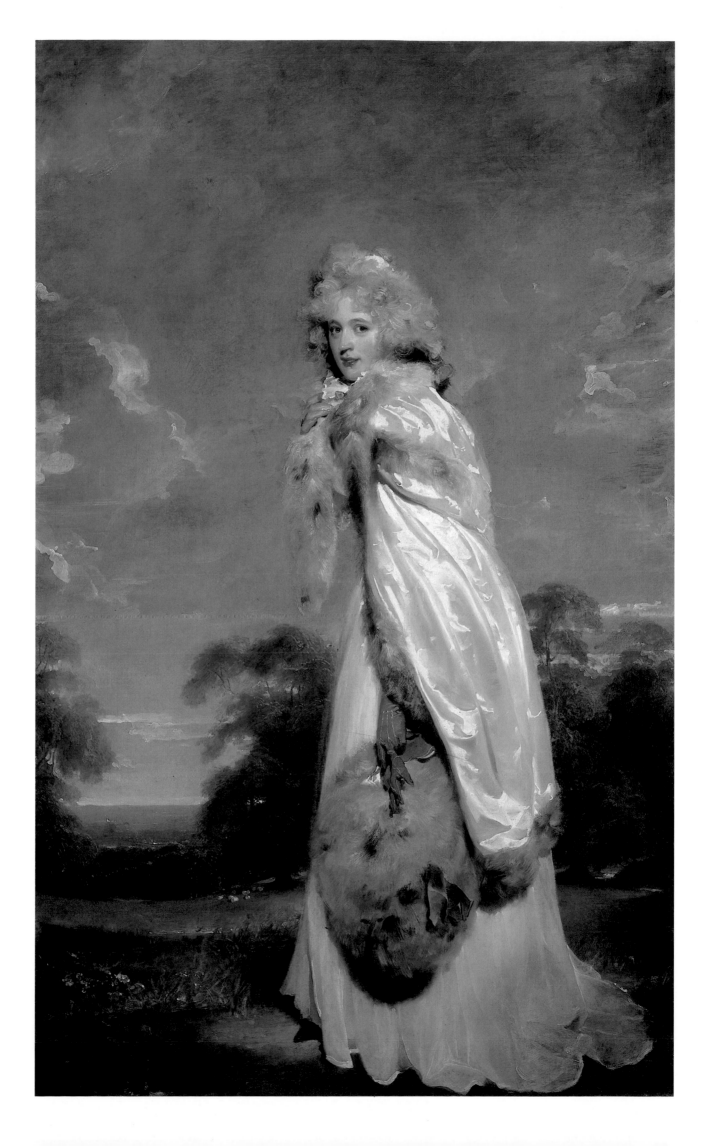

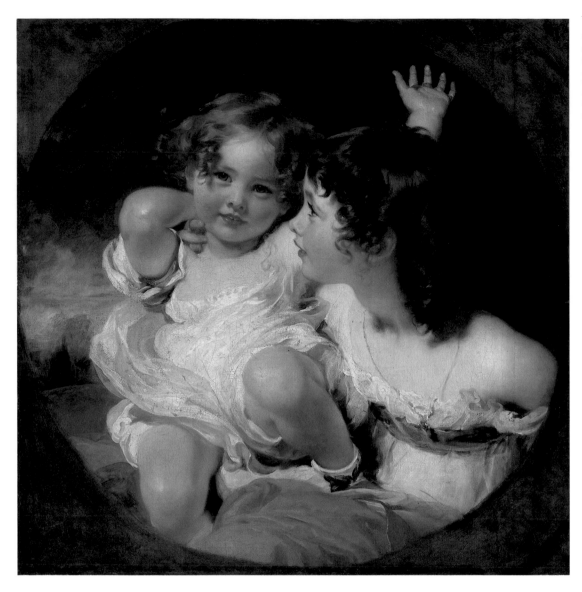

72 *The Calmady Children*
(Emily, 1818–1906,
and Laura Anne, 1820–94)
Sir Thomas Lawrence
British, 1769–1830
Oil on canvas; 30⅞ x 30⅛ in.
(78.4 x 76.5 cm.) Bequest of
Collis P. Huntington, 1900
(25.110.1)

73 *The Drummond Children*
Sir Henry Raeburn
British, 1756–1823
Oil on canvas; 94¼ x 60¼ in.
(239.4 x 153 cm.) Bequest of
Mary Stillman Harkness, 1950
(50.145.31)

SIR THOMAS LAWRENCE
The Calmady Children

Charles B. Calmady of Langdon Court, Devonshire, was introduced to Sir Thomas Lawrence by a common friend, the engraver F. C. Lewis, in 1823; evidently the painter was captivated by the charm of Calmady's eldest children, Emily and Laura Anne, and quickly executed a spirited chalk drawing of them. The finished painting was exhibited at the Royal Academy in 1824, where its success was as sensational as that which had greeted Lawrence's portrait of Elizabeth Farren thirty-four years before. The *Literary Gazette* published a notice in which it was called "a focus of talent.... Powerful and glittering as it is in execution, the playful and beautiful sentiment that shines through all is its greatest charm."

Lawrence declared that this was his "best picture." "I have no hesitation in saying so—my best picture of the kind, quite —one of the few I should wish hereafter to be known by." The artist had the painting sent up to Windsor Castle for the king to see and took it with him to Paris; but it remained with the Calmady family until the last years of the nineteenth century.

SIR HENRY RAEBURN
The Drummond Children

Sir Henry Raeburn, working in Edinburgh, supplied portraits to the leading families of Scotland. In contrast to his contemporary Sir Joshua Reynolds, Raeburn developed a style that depended on thickly applied paint used to create rather abrupt transitions in the modeling of forms, with strong highlights as opposed to careful gradations. In *The Drummond Children*, however, Raeburn created an atmospheric effect through delicate shading and a limited palette. The picture's handsome composition and immediacy of expression combine to make it one of Raeburn's best group portraits.

The children depicted are George Drummond, at left, Margaret Drummond, at right, and a foster brother, in the center. Their father, George Harley Drummond, was portrayed by Raeburn in a pendant of the same size, also in the collection of this museum.

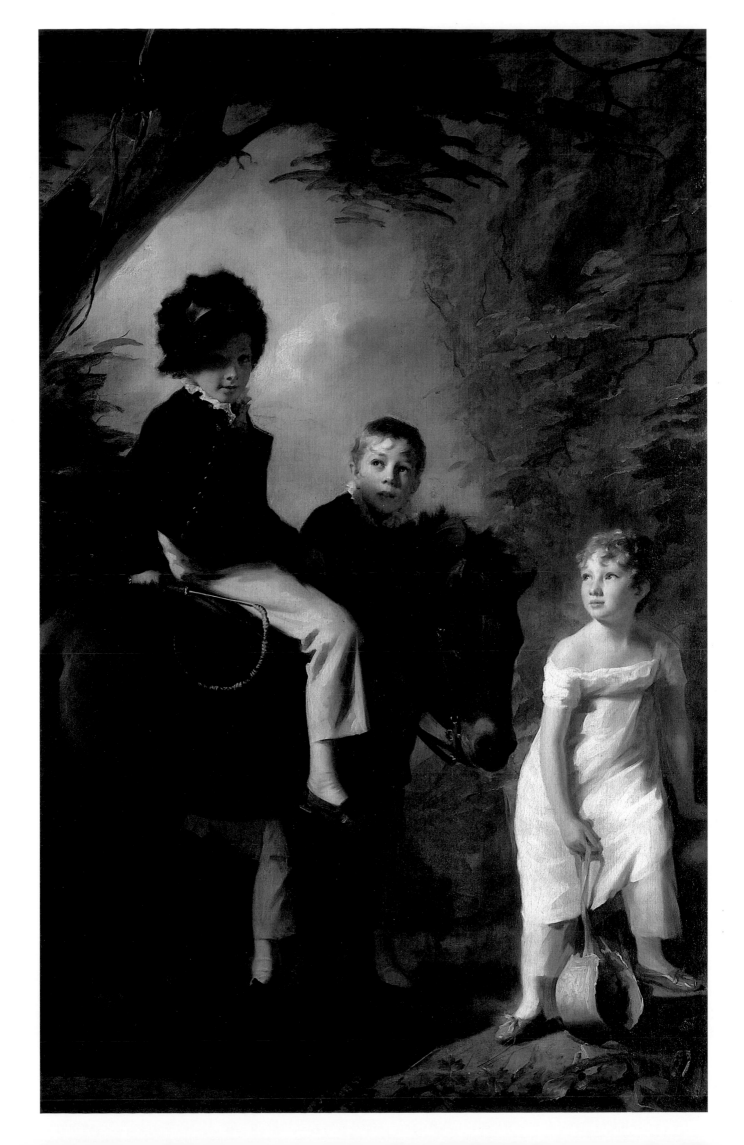

WILLIAM BLAKE

Two Pages from Songs of Innocence

William Blake is the only artist of his rank who is even better known as a poet, and some of his most pleasing works are those he called "illuminated printing," which fuse picture and word, resulting in a completely integrated and completely personal product. *Songs of Innocence* was first published in 1789, and comprised thirty-one illuminated poems; in 1794 it was republished along with *Songs of Experience*, with fifty-four plates in all. Blake used the unusual technique of relief etching, which he claimed was dictated to him by his dead brother in a dream, but the idea of which had been discussed among his acquaintances. In this technique, the background, rather than the lines that create the design, is etched away, leaving the image to be printed—both words and illustration—standing in relief on the plate. Blake's books are thus similar to some of the earliest illus-

trated books, the fifteenth-century blockbooks, so called because for each page the background was cut away from the wooden block, leaving the letters and images to stand in relief. Blake printed his plates in one color only; here it is a bright red-brown, but other copies were done in other colors. The pages were then painted—it is not known by whom in this case, though Blake did color many copies himself—in watercolors and gold. Thus every copy of the book is unique. The colors and the gold are especially brilliant in this copy, which is further distinguished by an ornamental border of tracery in green ink. Blake kept the plates and produced these books over a long period of time, probably as there was demand for them. The watermark on twelve leaves of the Metropolitan's copy includes the date 1825, so it would have been done in or after that year.

74 Title page from Songs of Innocence, 1789
William Blake
British, 1757–1827
Relief etching, hand-painted with watercolor
and gold; sheet 6 x 5½ in. (15.2 x 14 cm.)
Rogers Fund, 1917 (17.10.3)

75 The Shepherd, from Songs of Innocence, 1789
William Blake
British, 1757–1827
Relief etching, hand-painted with watercolor
and gold; sheet 6 x 5½ in. (15.2 x 14 cm.)
Rogers Fund, 1917 (17.10.5)

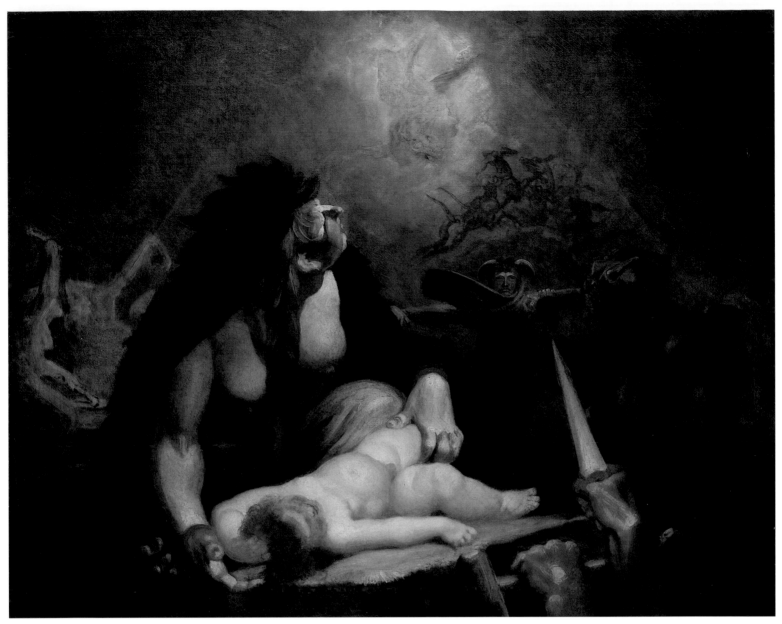

76 *The Night-Hag Visiting the Lapland Witches*
Johann Heinrich Füssli (Henry Fuseli)
Swiss, 1741–1825
Oil on canvas; 40 x 49¾ in. (101.6 x 126.4 cm.)
Purchase, Bequest of Lillian S. Timken, by exchange,
Victor Wilbour Memorial Fund, The Alfred N. Punnett
Endowment Fund, Marquand and Curtis Funds, 1980
(1980.411)

HENRY FUSELI
The Night-Hag Visiting the Lapland Witches

Henry Fuseli left his native Zurich for Berlin in 1763. The next year he went to London, where, except for nine years in Italy, he would spend most of the rest of his life. During the early years in London, Fuseli was occupied with writing and translating; only in the late 1760s did he decide, with much encouragement from Sir Joshua Reynolds, to devote himself to painting. In 1769 Fuseli left for Italy to study the Old Masters; the profound experience of Michelangelo's Sistine Chapel would determine his approach to the human body for the rest of his career. It was also in Rome that Fuseli first adopted literary themes for his works.

The success of John Boydell's Shakespeare Gallery, for which Fuseli produced numerous works, inspired him to form a Milton Gallery on his return to London. He executed forty-seven paintings between 1791 and 1800 for this project, among them his finest and most powerful images. *The Night-Hag Visiting the Lapland Witches* is one of these

works. It illustrates a scene in *Paradise Lost* (II, 662-666), in which Milton compares the hell hounds that surround Satan to those who

> follow the night-hag, when call'd
> In secret, riding through the air she comes,
> Lur'd with the smell of infant blood, to dance,
> With Lapland witches, while the lab'ring moon
> Eclipses at their charms.

Completed by August 1796, *The Night-Hag Visiting the Lapland Witches* did not sell when it was exhibited in 1799. However, it was bought in 1808 by Fuseli's biographer, James Knowles. According to Knowles, Fuseli said to him on this occasion: "Young man, the picture you have purchased is one of my very best—yet no one has asked its price till now—it requires a poetic mind to feel and love such a work."

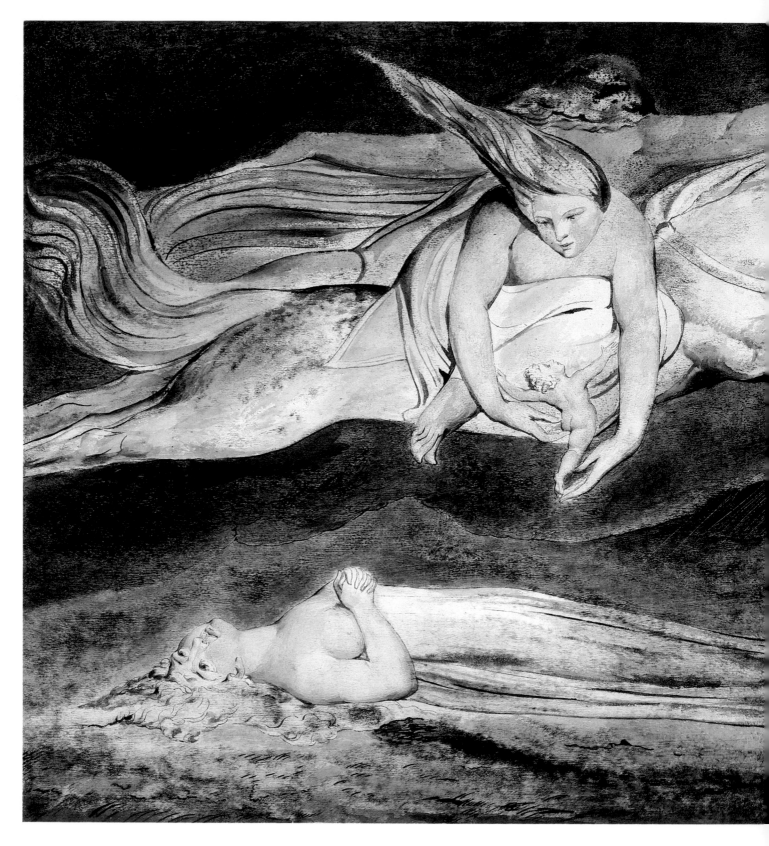

77 *Pity*, 1795
William Blake
British, 1757–1827
Color monotype in tempera touched
with pen, black ink, and watercolor;
15¾ x 20⅞ in. (40 x 53 cm.)
Gift of Mrs. Robert W. Goelet, 1958
(58.603)

Bro. Mel—
It was a pleasure and an
honor interviewing and archiving
for your farewell video. You've
been a great influence.
All my best,
Tiffany Denman

WILLIAM BLAKE

Pity

William Blake was born and died in the same years as
Thomas Rowlandson, but Blake's art depicted the creatures
of his imagination rather than those of the world around
him. *Pity* comes from a series of twelve monotypes Blake
made in 1795 that are as visionary as his poetry. A monotype
is a print made by creating a design, usually in printer's ink,
on a hard, nonporous surface and transferring it to paper
by means of pressure. The name implies that only one im-
pression can be made, and while sometimes enough ink
remains on the surface so that a second or even a third print-
ing of each image can be taken, the number remains very
limited. Although a few monotypes had been made before
Blake's time, he essentially invented the technique for him-
self, calling it "color printed drawing."

Most of the subjects of this series of monotypes are from
the Bible, Milton, or Shakespeare; *Pity* illustrates the lines
from *Macbeth* (I, 7):

> And pity, like a naked new-born babe
> Striding the blast, or heaven's cherubin hors'd
> Upon the sightless couriers of the air,
> Shall blow the horrid deed in every eye....

Blake's subject also refers to his own creation myth, *The
Book of Urizen*, of 1794, a personal retelling of the Creation
and Fall of Man, and the history of man until the Giving of
the Law.

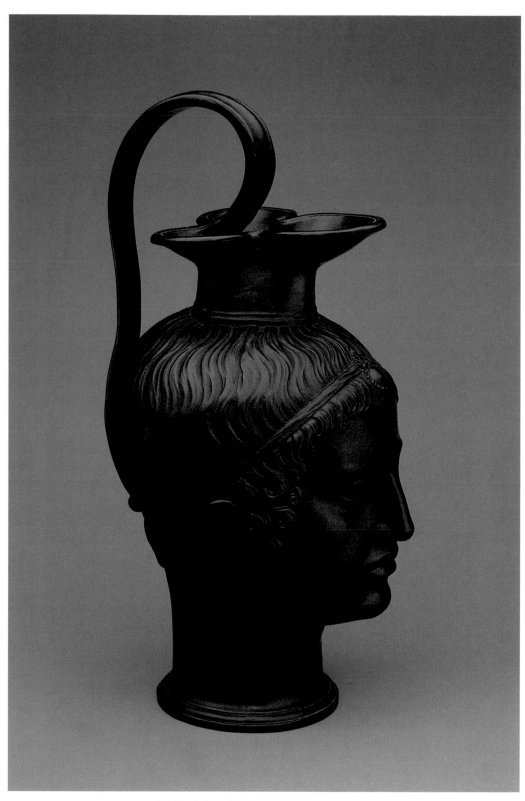

78 Head-shaped Ewer
English
(Staffordshire, Wedgwood), ca. 1780
Black basaltes ware; H. 11½ in. (29.2 cm.)
Gift of Frank K. Sturgis, 1932 (32.95.14)

WEDGWOOD POTTERY

Admiration for the remains of Pompeii and Herculaneum led to widespread attempts at emulation. Scrutiny of the classical remains offered new leads toward greater refinement in domestic design, and artists working with industrialists were not slow to capitalize on the ever-increasing popularity of the antique. Neoclassicism became the primary preoccupation at the pottery established in Staffordshire by Josiah Wedgwood. The most familiar look in the Wedgwood production is blue-gray combined with white, but other colorations were introduced to sustaining the impact made by streamlined Neoclassical shapes. This head-shaped vase, copied from an Etruscan bronze in the Louvre, is of basaltes ware, a deep gray pottery fabricated to evoke Greek vases and ancient bronzes. The other vessel, in which an ancient oil lamp has been adapted, combines Wedgwood's pale cane-colored ware with a relief in tawny jasperware, in imitation of ancient glyptic contrasts. The relief on the lid illustrates three Muses watering Pegasus, after a painting in the Tomb of the Nasonii outside Rome.

79 Vessel Derived from an Ancient Oil Lamp
English
(Staffordshire, Wedgwood), early 19th c.
Cane-colored stoneware with *rosso antico*
applied decoration; L. 4 5/16 in. (12.5 cm.)
Rogers Fund, 1911 (11.202.3)

PAUL STORR
Tea Set

When Paul Storr made this tea set, he was a partner in the firm of Rundell, Bridge and Rundell, the royal goldsmiths. The tea set is in the Neoclassical style, the most widespread of the many quite different styles current in the second decade of the nineteenth century. The form of the teapot is based on a Roman oil lamp, and the masks with serpents twining above are probably meant to refer to Aesculapius, the Greek god of healing. The pieces are engraved with the arms of the countess of Antrim, for whom they were made.

80 Tea Set, 1813–14
Paul Storr
English, 1771–1844
Silver gilt;
greatest W. 10 3/8 in. (26.4 cm.)
Gift of Fernanda Munn Kellog,
1974 (1974.379.1-3)

81 Mrs. James Pulham, Sr. (Frances Amys, ca. 1766–1856)
John Constable
British, 1776–1837
Oil on canvas; 29¾ x 24¾ in. (75.6 x 62.9 cm.)
Gift of George A. Hearn, 1906 (06.1272)

John Constable
Mrs. James Pulham, Sr.

In 1818 John Constable executed more portraits than he had in any year since 1806. He evidently hoped that through such commissions he could secure both his reputation and the finances of his newly enlarged family. The Pulhams already owned several landscapes by Constable when they commissioned the present portrait, and they were immensely satisfied with its appearance on delivery. On April 30, 1818

Mr. Pulham wrote the artist:

the portrait arrived safe on Saturday last, and I cannot but express myself greatly obliged by your masterly execution of it. It will give Mrs. Pulham and myself much pleasure to have you, Mrs. Constable and your little one with us this Summer, when Mrs. P. will feel gratified in being able to return the Compliment which you have so handsomely bestowed on her.

JOHN CONSTABLE
Salisbury Cathedral from the Bishop's Garden

Constable never achieved the overwhelming success of his contemporary Turner, but his naturalist's vision and novel painting technique had, conversely, far greater impact on the history of nineteenth-century painting. Three of Constable's paintings were exhibited to great acclaim at the Paris Salon of 1824; on seeing them Eugène Delacroix was impressed by the spontaneity of Constable's interpretation of natural effects and by the freedom with which he applied paint. Each succeeding generation of French landscape painters—from Corot, to Courbet, to Monet, to van Gogh —drew lessons from Constable's work.

This painting is a full-scale oil study for a painting of 1826 now in the Frick Collection in New York. Like many of Constable's landscapes, it represents a scene redolent with personal associations. John Fisher, bishop of Salisbury, was among Constable's closest friends, and it was he who tried to persuade the artist to complete an oil sketch of the cathedral that had been begun out-of-doors during a stay as the bishop's guest in 1821. Constable chose instead to make a new, slightly larger painting, which he exhibited in 1823. The bishop then commissioned another version, with, he hoped, "a little sunshine," to give as a wedding present to his daughter Elizabeth. Constable made the Museum's painting as a study for this latter commission, but he took pains to bring it to a high state of finish, including, for example, a butterfly just to the left of the open gate.

82 Salisbury Cathedral from the Bishop's Garden
John Constable
British, 1776–1837
Oil on canvas; 34⅝ x 44 in. (88 x 111.8 cm.)
Bequest of Mary Stillman Harkness, 1950
(50.145.8)

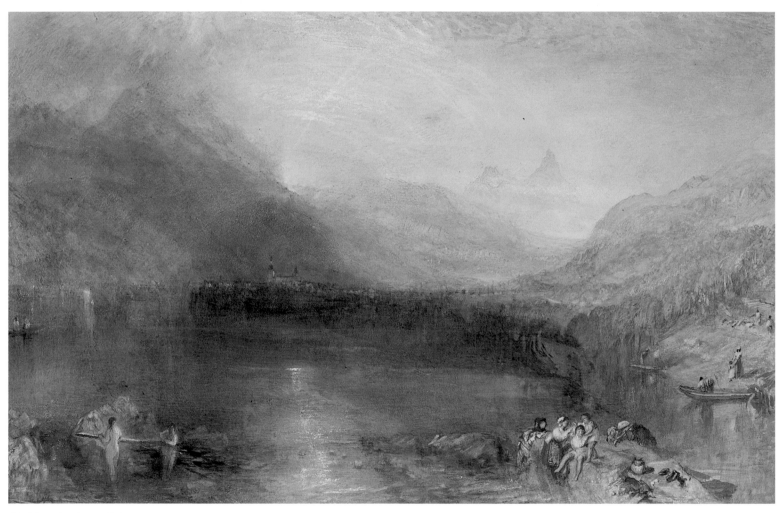

83 The Lake of Zug, 1843
Joseph Mallord William Turner
British, 1775–1851
Watercolor, gouache, and colored chalks,
over traces of graphite; scraping with
penknife; 11¾ x 18⅝₁₆ in. (29.7 x 46.6 cm.)
Marquand Fund, 1959 (59.120)

JOSEPH MALLORD WILLIAM TURNER
The Lake of Zug

Turner made his first visit to Switzerland in 1802 at the age of twenty-seven, when the Treaty of Amiens, negotiated with Napoleon, opened the Continent to English visitors once again. His desire to see the Swiss alps may have been inspired by the alpine drawings of John Robert Cozens that Turner copied as a young artist. Turner did not return to Switzerland until 1836; this was followed by visits in 1841, 1842, and 1844.

The spectacular panoramas Turner admired on these trips clearly stirred his imagination. Early in 1842, he presented his agent, Thomas Griffith, with a novel idea for soliciting patrons to buy his Swiss watercolor views. Collectors chose from a selection of sample studies made by Turner that for 80 guineas a piece would be worked up into large finished watercolors. He produced ten on commission that year. This magnificent watercolor, depicting the Lake of Zug in the early morning light, is one of six produced in 1843. The sample study for this work, dated 1842, is preserved in the Turner Bequest housed in the British Museum, London; on the reverse, it bears the name of Turner's Scottish friend and patron, H. A. J. Munro of Novar, who accompanied the artist to Switzerland in 1836 and who commissioned this watercolor as well as two others from the set. John Ruskin, Turner's most vocal defender, commissioned two views from the same series and eventually obtained the Metropolitan sheet from Munro, who, according to Ruskin, found it to be "too blue."

By 1840, Turner had become a controversial figure. His landscape paintings—visionary expressions of the sublime and powerful forces of nature—were beyond the grasp of his patrons. For the same reason, Turner's Swiss watercolors of the 1840s were not the financial success he had expected.

JOSEPH MALLORD WILLIAM TURNER *(Pages 114-115)*
The Grand Canal, Venice

Turner quickly grew from a young art student trained in executing topographical watercolors to the creator of some of the most remarkable and original landscapes of his time. While in Venice in September 1833, he created a series of views of the city that betray on the one hand an ardent interest in recording what he saw, and on the other a Romantic sensibility that suffused his pictures with a sense of the grandeur of nature, and of its magnificent light and color. For the Venice series, which is often seen as anticipating Monet's later developments, Turner drew on Claudian spatial structure and on the lessons of Canaletto and Guardi, who so vividly memorialized the historic city in paint.

The present picture, which is based in part on a sketch executed during Turner's first trip to Venice in August 1819, combines two viewpoints along the Grand Canal: The buildings on the left are seen from the corner of Santa Maria della Salute; those on the right are seen from a vantage point across the canal, approximately one hundred yards farther back, near the Campo del Traghetto de Santa Maria del Giglio. Turner has also extended the height of the Campanile (the tower in the background at left) and added a building at the right.

The Grand Canal, Venice was shown with five other works by Turner in May 1835 at the Royal Academy, where it was largely well received. A critic writing for the *Literary Gazette* commented on "its general gaiety," the *Times* considered it one of "his most agreeable works," and the *Spectator* called it a "superb painting." Yet a dissenting voice came from the writer of *Fraser's Magazine:* Referring to the picture as "a piece of brilliant obscurity," he cautioned Turner not to think "that in order to be poetical it is neccessary to be almost unintelligible."

The painting was commissioned by H. A. J. Munro of Novar, who is said to have financed the artist's 1833 trip to Venice. Munro, who had expected a watercolor, was at first so disappointed by the oil painting that Turner almost declined the sale.

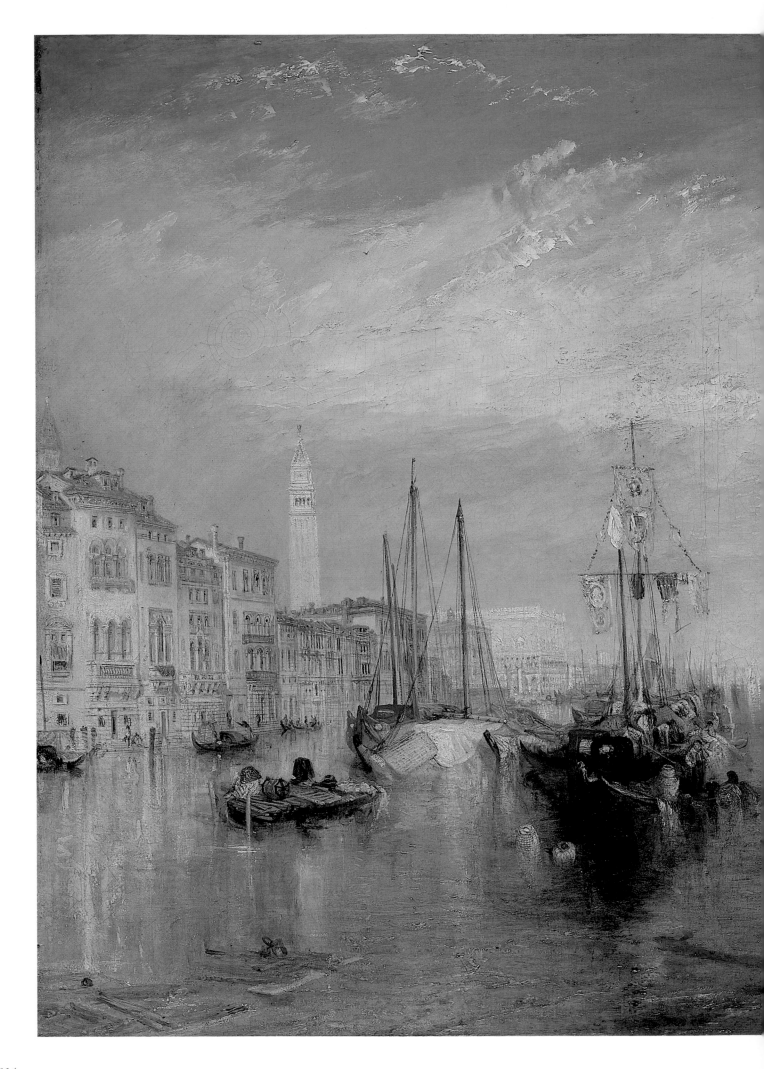

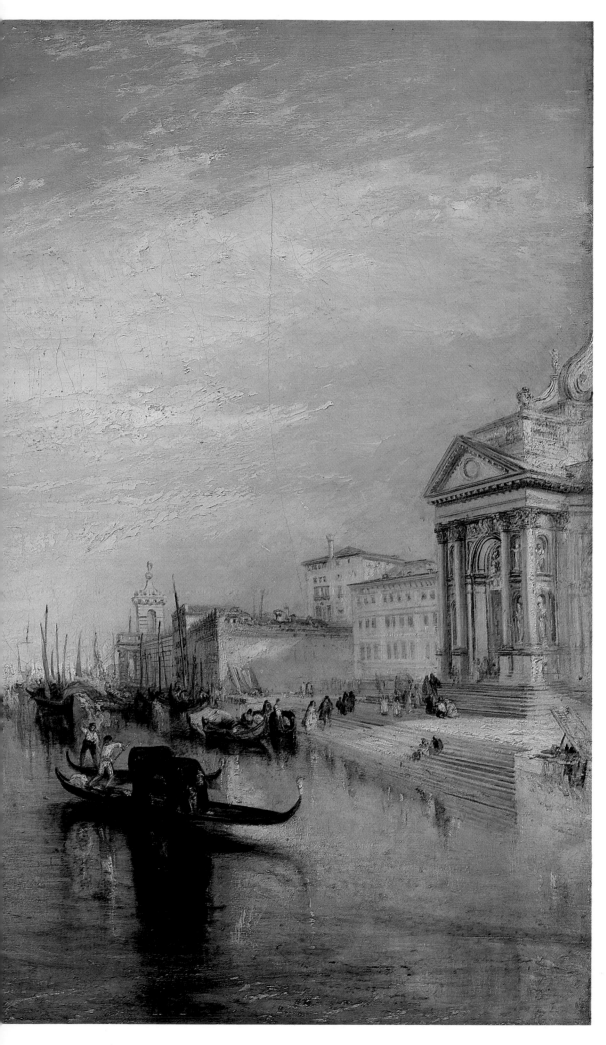

84 *The Grand Canal, Venice*
Joseph Mallord William Turner
British, 1775–1851
Oil on canvas;
36 x 48⅛ in. (91.4 x 122.2 cm.)
Bequest of Cornelius Vanderbilt,
1899 (99.31)

Page 113: text

PIANO

The London branch of Erard, the famous Parisian firm of harp and piano makers, built this magnificent piano for the wife of the third Baron Foley. The keys and pedals seem scarcely to have been touched, so we can surmise that this fine instrument was kept merely as an emblem of culture and status. No other piano so richly decorated is known from the period. The marquetry of dyed and natural woods, engraved ivory, mother-of-pearl, abalone, and wire illustrates many musical scenes and trophies as well as animals, grotesque figures, floral motifs, dancers, Greek gods, and the Foley arms. This decor was executed by George Henry Blake, of whom nothing is known. The mechanism, patented by Erard, is the direct ancestor of the modern grand "action," which allows great power and rapidity in technique; hence, Erard's pianos were favored by virtuosi such as Franz Liszt.

85 Piano, ca. 1840
Erard and Company
English (London)
Wood, metal, various other materials;
L. 97¼ in. (247 cm.)
Gift of Mrs. Henry McSweeney, 1959
(59.76)

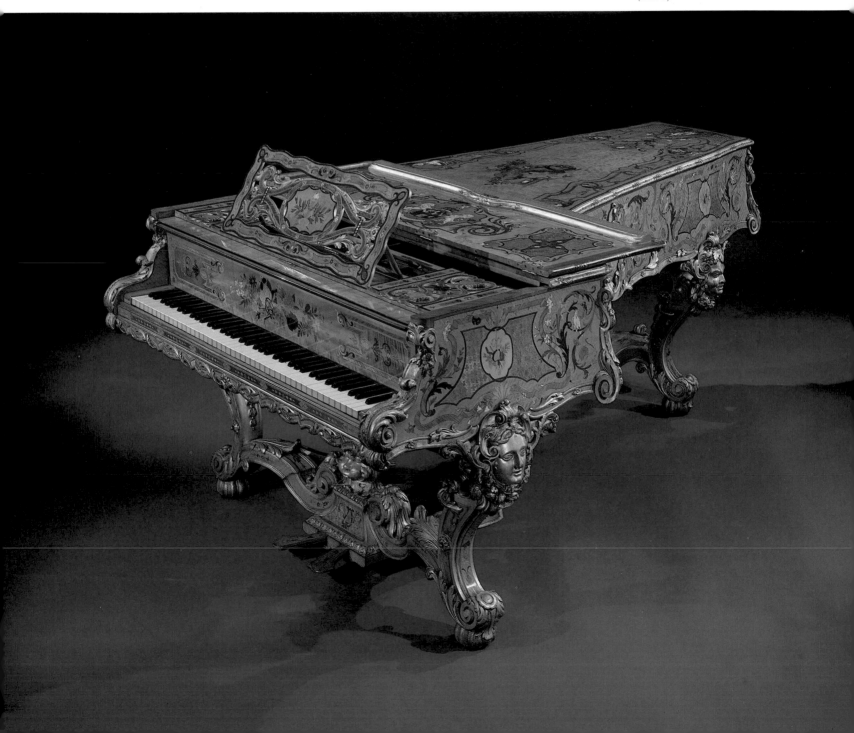

86 *Medal Commemorating the
Opening of the Coal Exchange*, 1849
Benjamin Wyon
English, 1802–58
Bronze; 3½ in. (8.9 cm.)
Gift of the Corporation of the
City of London, 1908 (08.53.6)

Right: Obverse

BENJAMIN WYON

Medal Commemorating the Opening of the Coal Exchange

Diestruck medals reached unsurpassed heights of clarity and perfection in the mid-nineteenth century, never more so than in the sure hands of the Wyon family. The dedications of bridges and other public works proved especially popular in medallic commemorations and were limned with exhaustive, graphic pursuit of perspective and detail. On behalf of Queen Victoria, whose portrait is in the center of the obverse of this medal, Prince Albert, accompanied by their children, the Prince of Wales and the Princess Royal, inaugurated the Coal Exchange in 1849. In arcs between the portraits are small vignettes of the royal family arriving by barge and being greeted by the Lord Mayor. On the reverse is the eye-opening vision of the new Coal Exchange. James Bunstone Bunning's tiered circular building stood until the 1960s.

87 *Tazza*, 1851
Firm of Charles Asprey
English (London)
Gilt bronze with malachite;
H. 5 in. (12.7 cm.) Purchase,
Gifts of Irwin Untermyer, Loretta
Hines Howard and Charles Hines,
in memory of Mr. and Mrs. Edward
Hines, and J. Pierpont Morgan,
by exchange, 1982 (1982.88.7)

TAZZA

One of a pair, this tazza—an Italian word referring to a shallow cup on a high, footed stem—belonged to a desk set made of gilt bronze and malachite, of which the Metropolitan Museum conserves eight pieces. The whole is described in some detail in the *Official Descriptive and Illustrated Catalogue* of the 1851 Crystal Palace Exhibition. To leave no doubt as to his firm's authorship, Charles Asprey had each of the pieces engraved underneath with his name and address in Bond Street and the number of his section at the Crystal Palace. The eclectic aggregations of style that proliferated at that international showing are evidenced in the desk set: The Italian Renaissance is clearly the chief influence in the tazza shape of this vessel, but Greco-Roman and Celtic overtones are also discernible throughout the set. The firm took advantage of the latest industrial progress in using techniques such as electroplating.

FURNISHING CHINTZ

From the early eighteenth century the English repeatedly rediscovered and revived the Gothic style in art, architecture, and literature. Interest in the art of the Middle Ages—at least its appearance—further increased after the Church Building Act was passed in 1818; in the following fourteen years 174 churches were built in Gothic style. The 1830s witnessed a developing concern for ecclesiology—the correctness of religious ornament in design, type, and use—and Augustus Pugin began to publish his definitive works on ornament of the Middle Ages.

This furnishing chintz, with its pattern of church windows replete with pointed arches and tracery, was intended to be used as a window blind, and demonstrates that the Gothic style was also popular for domestic use. The arms are those of the Campbell family, but like the Tudor rose, they are probably used here strictly as a decorative element.

88 Furnishing Chintz of Gothic Windows
English, 1830–35
Cotton, roller printed in red and black with
blue and yellow added by surface roller;
84 x 25¼ in. (213.3 x 64.2 cm.)
Rogers Fund, 1963 (63.55.2)

89 Cabinet with The Backgammon Players
English, 1861
Designed by Philip Webb (British 1831–1915);
painting by Sir Edward Coley Burne-Jones
(British, 1833–98); made by Morris, Marshall,
Faulkner and Company Painted and gilded wood,
the doors decorated with an oil painting on leather;
H. 73 in. (185.4 cm.) Rogers Fund, 1926 (26.54)
Below: detail

Cabinet with *The Backgammon Players*

This early masterpiece of the Arts and Crafts Movement exemplifies the collaborative endeavors of William Morris and his circle to improve standards of design. Morris believed that a return to the principles of medieval production, involving fine artists in the creation of functional objects, could help to overcome the evils of industrialization. This cabinet, one of several in which Morris enlisted the participation of Sir Edward Burne-Jones, is an attempt to erase the distinction between the fine and applied arts. Moreover, the painting itself is on leather with a punched background, itself a craftsman's medium.

Although the cabinet is usually described as in the "Medieval Style," in fact it is a vivid example of the ability of the Morris firm to convert the eclecticism that marked much of the art of the latter nineteenth century into an original and modern style. Indeed, while Burne-Jones's painted figures are in medieval costume, much of the decoration is as Oriental as it is medieval in inspiration. Philip Webb's straightforward design, however, which boldly displays the casework skeleton on the exterior, anticipates the emphasis on structural elements that would inform the design revolution of the next century.

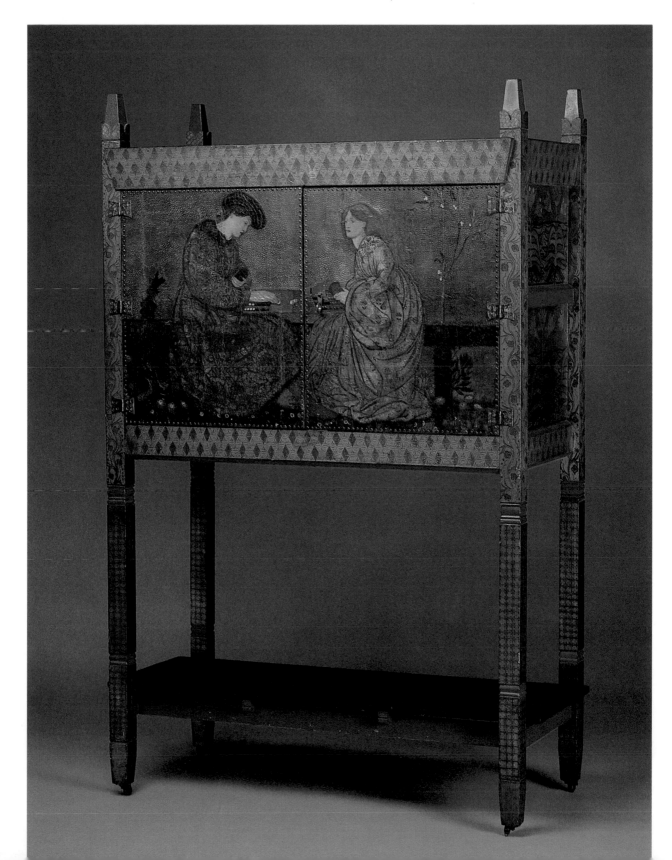

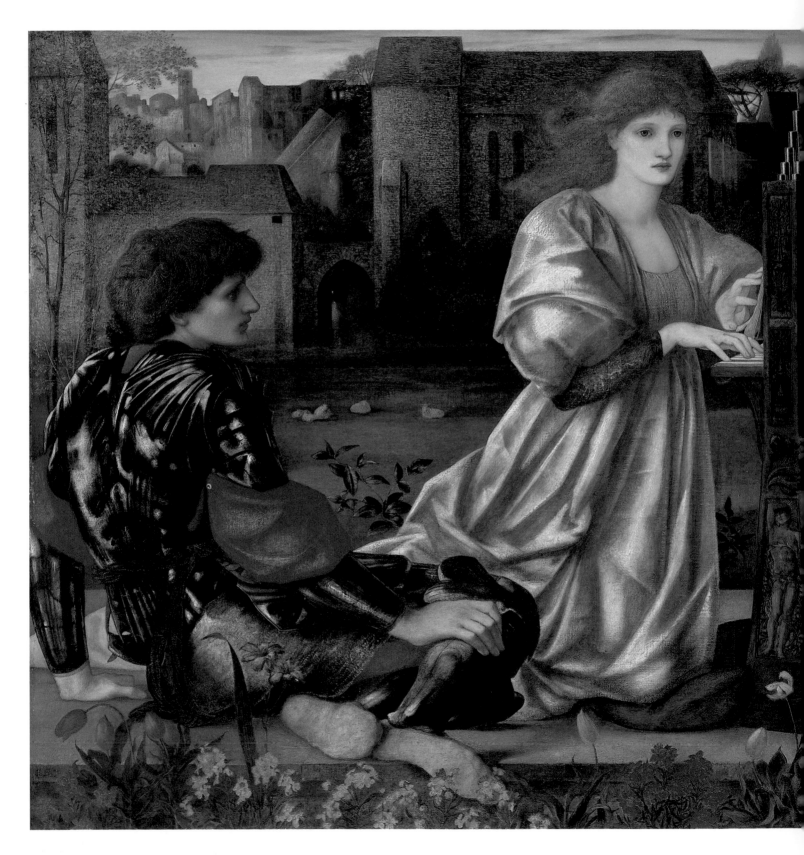

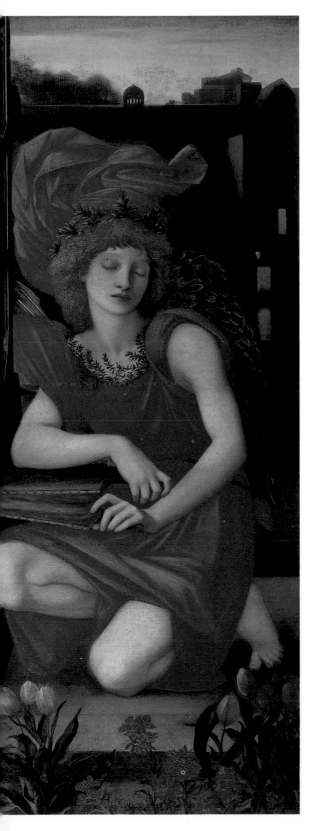

90 *The Love Song (Le Chant d'Amour)*
Sir Edward Coley Burne-Jones
British, 1833–98
Oil on canvas; 45 x 61⅜ in. (114.3 x 155.9 cm.)
The Alfred N. Punnett Endowment Fund,
1947 (47.26)

SIR EDWARD COLEY BURNE-JONES
The Love Song (Le Chant d'Amour)

In 1857 Dante Gabriel Rossetti, who in 1848 had been a founding member of the circle of artists known as the Pre-Raphaelite Brotherhood, assembled a group of seven friends to help him decorate the Oxford Union Building with scenes from Sir Thomas Malory's *Morte d'Arthur.* Edward Burne-Jones was one of the driving forces of this "second Brotherhood," and his *Love Song*, with its figures reminiscent of the quattrocento Venetian painter Carpaccio and its "Arthurian" landscape bathed in evening light, reflects the profound influence of both the Italian Renaissance and the gothicizing Pre-Raphaelite movement.

This painting was begun in 1868 and completed in 1877. It is the definitive version of several works by Burne-Jones based on the following refrain from an old Breton song: *Hélas! je sais un chant d'amour,/Triste ou gai, tour à tour.* (Alas, I know a love song,/Sad or happy, each in turn.)

Perhaps one of Burne-Jones's most famous and lyrical paintings, *The Love Song* was exhibited, for the first time, alongside seven other of his works, at London's Grosvenor Gallery in 1878. There it received a certain amount of publicity. Henry James, for example, in a review for the American magazine *The Nation*, remarked that the color was "a brilliant success . . . like some mellow Giorgione or some richly-glowing Titian . . . full of depth and brownness, the shadows . . . warm, the splendour subdued."

91 Portrait of Eugène Delacroix, 1828
Pierre Jean David d'Angers
French, 1788–1856
Bronze medallion; D. 4¼ in. (10.8 cm.)
Gift of Samuel P. Avery, 1898 (98.7.36)

PIERRE JEAN DAVID D'ANGERS
Portrait of Eugène Delacroix

David d'Angers emerges more and more clearly as a titan of sculpture. Museum goers, at some remove from his monuments or the array of models displayed by his native city of Angers, may know him best for his more accessible portrait medallions, often seen in sets. At their best, they seem like lightning flashes illuminating the artist's fellow members of the Romantic movement. Delacroix, seen here at thirty, is modeled in a few strokes with determined speed, befitting the brilliant promise of the young painter.

EUGENE DELACROIX
Horse and Tiger

Delacroix's fascination with animals is manifested in this depiction of a tiger attacking a horse. During the 1820s Delacroix drew more studies of horses than of any other animal, but he also went with the sculptor Antoine Barye to the Jardin des Plantes to draw more exotic species. Delacroix was interested in the idea, much discussed at this period, that similarities between animal and human physiognomies were analogous to similarities in their natures, and a telling entry in his *Journal* describes humans as "tigers and . . . wolves conspired one against the other for mutual destruction."

Delacroix was the third major artist to work in lithography —after Goya and Théodore Géricault—which had been invented in the last decade of the eighteenth century. The Museum's impression of *Horse and Tiger* is a very rare, very fresh first state—before any lettering—of a print that is rare in any of its four states. It precedes the artist's more famous *Royal Tiger* and *Atlas Lion*, and it is about one third their size, but Delacroix's masterful focusing of violent energy gives the lithograph a monumentality despite its relatively small size and apparent haste of execution.

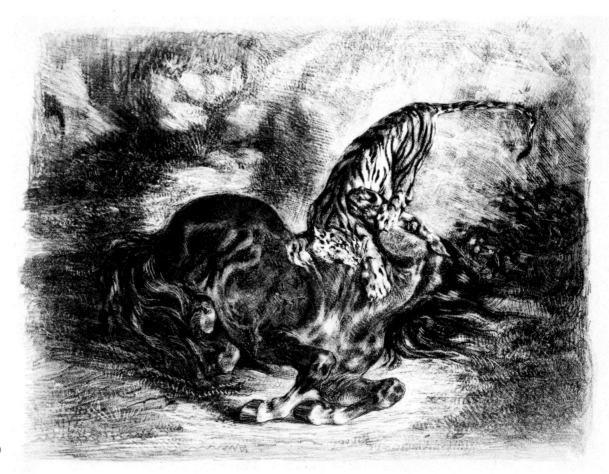

92 Horse and Tiger, 1828
Eugène Delacroix
French, 1798–1863
Lithograph; 8¼ x 11 in.
(21 x 27.8 cm.)
Rogers Fund, 1922 (22.63.43)

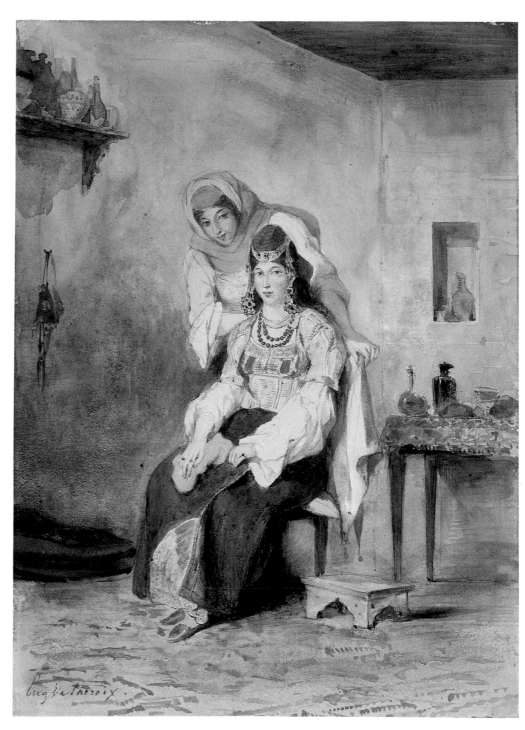

*93 The Daughter of Abraham-ben-Chimol
and Her Servant, 1832
Eugène Delacroix
French, 1798–1863
Watercolor over pencil; 8¾ x 6⅜ in.
(22.3 x 16.2 cm.) Bequest of
Walter C. Baker, 1971 (1972.118.210)*

EUGENE DELACROIX

The Daughter of Abraham-ben-Chimol and Her Servant

Eugène Delacroix painted this sumptuous watercolor in 1832, when he accompanied the comte de Mornay to Morocco on his mission as goodwill ambassador to the sultan, Abd-ar-Rahmān. The artist filled several sketchbooks and a diary with his excited impressions of North African life. It was probably during the two-week quarantine at Toulon on the mission's return to France that Delacroix produced this and seventeen other highly finished watercolors; they were signed and presented to the count as a souvenir of the trip. Abraham-ben-Chimol, the father of the sitter, was the dragoman assigned to the delegation.

94 *The Abduction of Rebecca*, 1846
Eugène Delacroix
French, 1798–1863
Oil on canvas; 39½ x 32¼ in. (100.3 x 81.9 cm.)
Wolfe Fund, Catharine Lorillard Wolfe Collection,
1903 (03.30)

95 *Christ on the Lake of Gennesaret*
Eugène Delacroix
French, 1798–1863
Oil on canvas; 20 x 24 in. (50.8 x 61 cm.)
Bequest of Mrs. H.O. Havemeyer, 1929,
H.O. Havemeyer Collection (29.100.131)

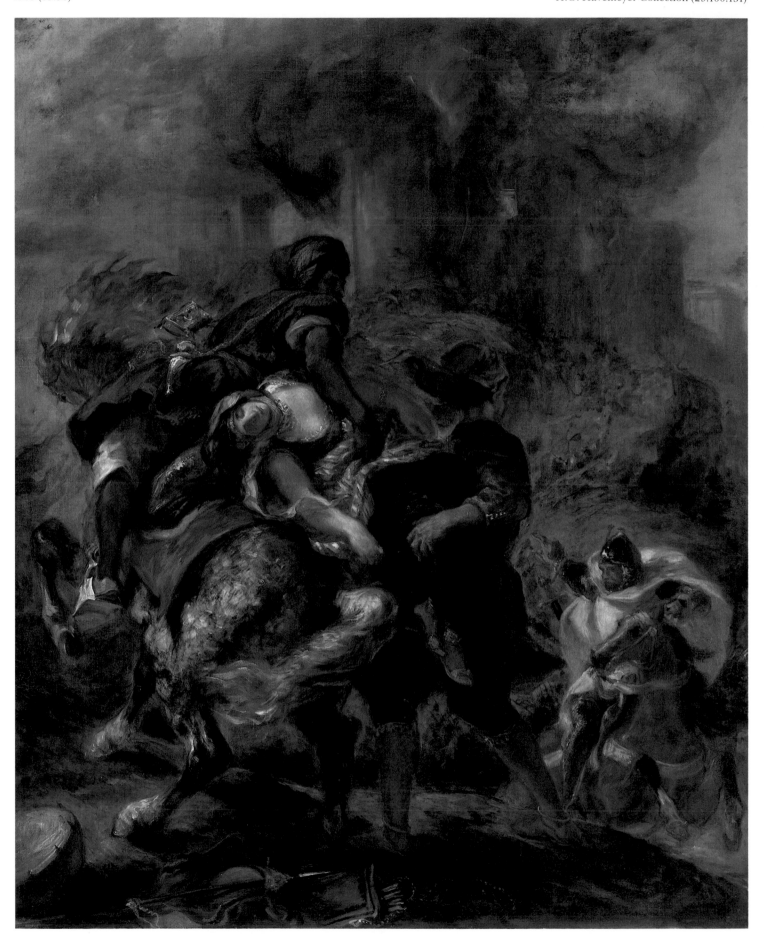

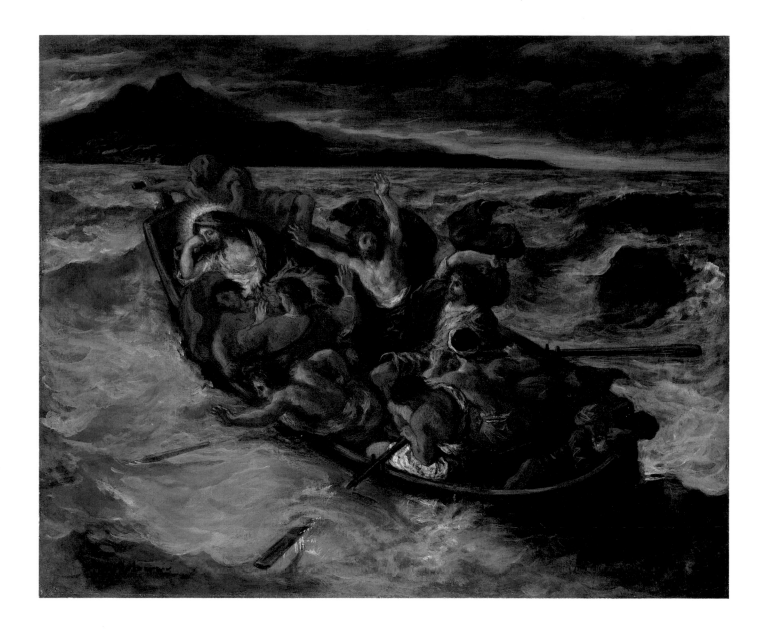

EUGENE DELACROIX
The Abduction of Rebecca

As a rich source for exotic and dramatically violent themes, the novels of Sir Walter Scott, especially his famous historical romance *Ivanhoe*, were immensely popular with Romantic painters. Eugène Delacroix, despite his reservations about their literary merit, repeatedly found inspiration in these writings.

This painting, executed in 1846 and exhibited in the Salon of that year, illustrates a scene from Chapter XXXI of *Ivanhoe:* During the sack and burning of the castle of Front-de-Boeuf (seen in flames in the background), the beautiful Rebecca was carried off by two Saracen slaves at the command of the Christian knight Bois-Guilbert, who had long coveted her. Intense drama is created as much by the contorted poses and compacted space as by the artist's use of vivid color. Contemporary critics praised the work's spontaneity and power, its harmony of color and pathos of movement. The painting was much admired by Théophile Thoré and Charles Baudelaire, two of the most perceptive critics of the nineteenth century. Baudelaire wrote that "Delacroix's painting is like nature; it has a horror of emptiness."

EUGENE DELACROIX
Christ on the Lake of Gennesaret

Eugène Delacroix was perhaps the last great French painter to treat convincingly subjects taken from the Old and New Testaments. Just as Delacroix's approach to color and composition resembled that of Rubens, so did his complete acceptance of Christianity enable him, like Rubens, to render palpable and persuasive lessons of human faith and endurance. Delacroix took as the subject of this picture the lesson recorded in Mark 4:35-41, in which Jesus demonstrated his divine powers by calming the waters and rebuked his followers for lack of faith.

The image of a storm-tossed boat recurs throughout Delacroix's oeuvre, appearing earliest in 1822 in the *Bark of Dante* (Paris, Louvre), which was the first work he exhibited publicly. *Christ on the Lake of Gennesaret*, one of fourteen representations of the subject executed in the last decade of the artist's career, is among the later works in the series. The figures in the boat form a remarkably cohesive group, despite the diversity of the poses, and the composition as a whole seems to refer to Théodore Géricault's 1819 *Raft of the Medusa* (Paris, Louvre).

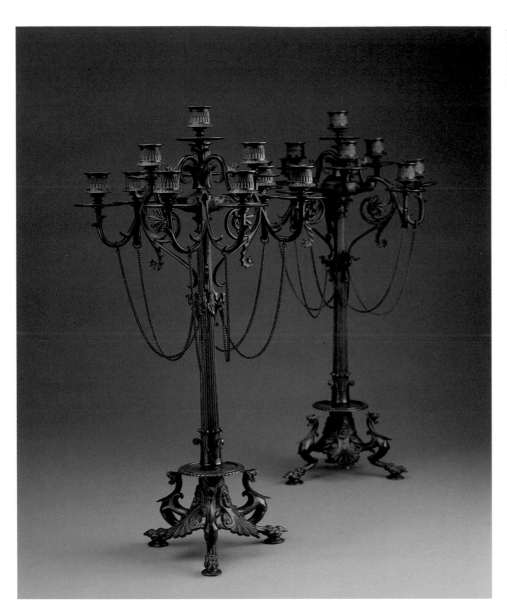

96 *Pair of Ten-Light Candelabra*, ca. 1857–65
Antoine Louis Barye
French, 1796–1875
Bronze; H. of both 24¾ in. (63 cm.) Gift of
Maria A. S. de Reinis, 1976 (1976.425.1,2)

97 *Theseus Fighting the Centaur Bianor*
Antoine Louis Barye
French, 1796–1875
First modeled in 1849, cast ca. 1867
Bronze; H. 50 in. (127 cm.)
Gift of Samuel P. Avery, 1885 (85.3)

ANTOINE LOUIS BARYE
Pair of Ten-Light Candelabra

Rising prosperity and the expansion of the middle class in nineteenth-century France created a wide demand for works of applied art. About 1835 Antoine Louis Barye established his own foundry, and the catalogues he issued between 1847 and 1865 list not only the small sculptures for which he is justly famous, but also decorative cups, incense burners, fireguards, ink bottles, and so on. The firm employed a number of founders who were supplied with the sculptor's models. The fine finish and detailing of the bronzes produced under this system are a tribute to the skill of the best French founders of the period.

In designing these objects, Barye drew upon his wide familiarity with the decorative vocabularies of the past. This design, described as "Greek candelabrum with ten lights" in one of Barye's catalogues issued between 1855 and 1865, reflects the increasing concern with archaeological correctness that characterizes the Neoclassical style of the nineteenth century. This concern was due in part, no doubt, to the growing body of publications illustrating artifacts from archaeological excavations in Italy, Greece, and Asia Minor.

ANTOINE LOUIS BARYE
Theseus Fighting the Centaur Bianor

Barye became the animal sculptor par excellence during the Romantic period, inspiring a school of imitators known as the *animaliers*, yet his thorough grounding in classical prototypes is evident in this highly charged representation of an incident from the battle between the Lapiths and Centaurs described in Book XII of Ovid's *Metamorphoses*. Barye surely knew the series of metopes from the Parthenon in the British Museum depicting the Greek legend of the Lapiths and Centaurs. But the cool perfection of the fifth-century Greek bas-reliefs are, in fact, greatly removed in spirit from the essentially Romantic vision of the nineteenth-century French sculptor, who chose to focus on the raging violence of close combat between the two adversaries. In the elemental struggle for survival, the rugged Greek hero bestrides the centaur, savagely gripping the half-human, half-equine creature by the throat in order to deliver the death blow with his club. It is a gesture recently recognized as having been borrowed from the sixteenth-century marble *Hercules and a Centaur* by the Mannerist sculptor Giambologna that stands in the Loggia dei Lanzi in Florence.

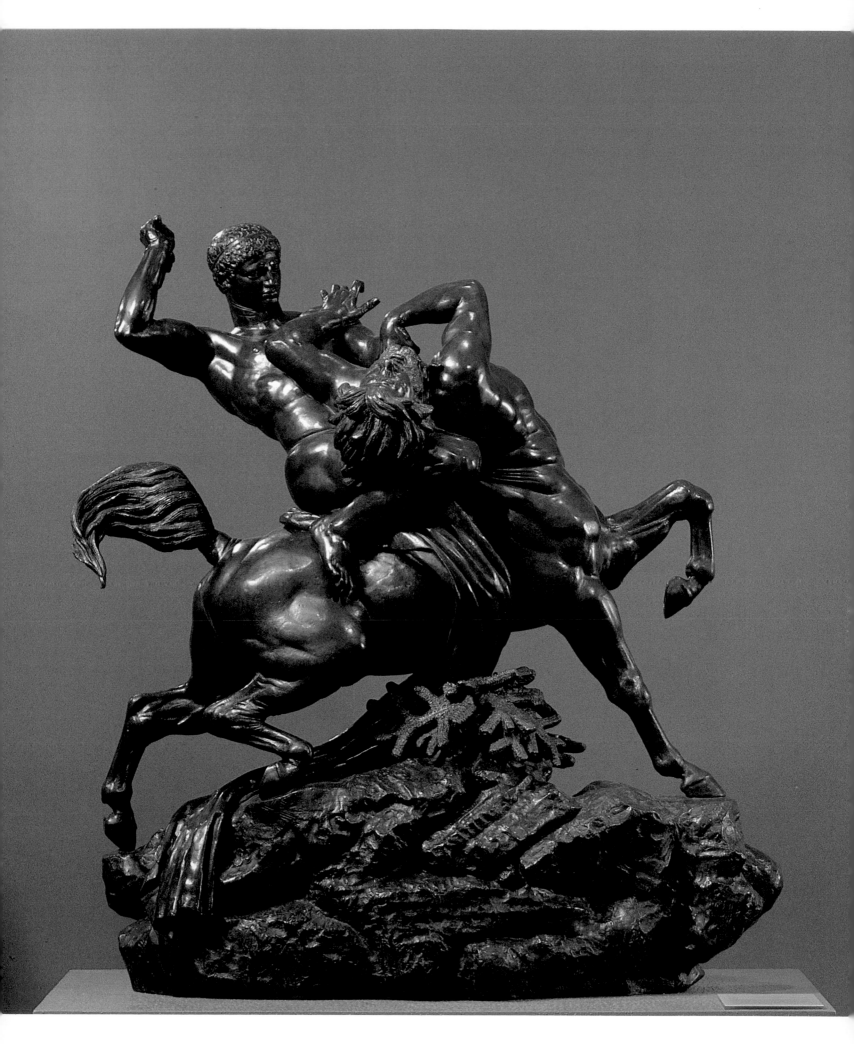

98 Hagar in the Wilderness, 1835
Jean Baptiste Camille Corot
French, 1796–1875
Oil on canvas; 71 x 106½ in.
(180.3 x 270.5 cm.)
Rogers Fund, 1938 (38.64)

Jean Baptiste Camille Corot
Hagar in the Wilderness

This picture, shown at the Salon of 1835, is the earliest of four large, ambitious biblical works that Corot was to exhibit in the Salon over the next ten years. As with the Museum's *Destruction of Sodom,* 1843–44, this painting illustrates a particular episode in the story of the family of Abraham, the father of Israel (Genesis 21:16–17):

> And she went, and sat down [over against] *him* a good way off, as it were a bowshot: for she said, Let me not see the death of the child. And she sat [over against] *him*, and lifted up her voice and wept.
> And God heard the voice of the lad; and the angel of God called to Hagar out of Heaven, and said unto her, What aileth thee, Hagar? Fear not; for God hath heard the voice of the lad where he *is*.

Corot began this work just before his second trip to Italy in May of 1834 and finished it upon his return to Paris; the general character of the landscape appears to be inspired by memories of his trip. However, the rocky cliffs that dominate the middle ground depend upon studies made at Civita Castellana on an earlier visit to Italy, in 1825–28, and the trees and great boulders in the foreground come from sketches made in the forest of Fontainebleau in the early 1830s. The large tree in the background is based on Corot's study *Fontainebleau: Oak Trees at Bas-Bréau*, also in the Museum's collection.

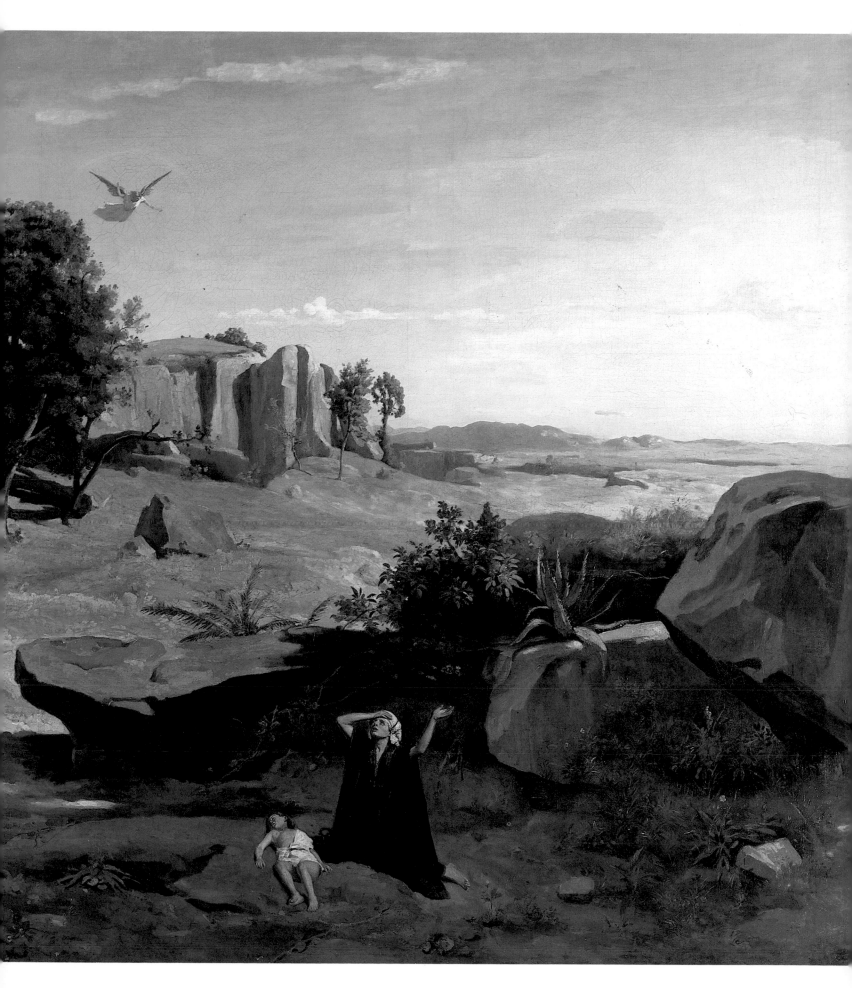

Jean Baptiste Camille Corot
The Destruction of Sodom

One of Camille Corot's most ambitious compositions, this painting shows Lot and his daughters fleeing from the burning city of Sodom, which God had condemned to flames for its wickedness (Genesis 19:15-26). Angels had warned them: "Escape for thy life; look not behind thee . . . lest thou be consumed." But Lot's wife, here shown at the right, did not heed the warning: She looked back and was turned into a pillar of salt.

Corot's original conception, painted in 1843, was rejected by the Salon jury of that year but accepted in 1844. The picture found few admirers among critics, who censured the effort severely. Even Corot was dissatisfied; in a telling comment characteristic of his self-effacing humor, the artist remarked that he had wept over Lot's wife, hoping to melt her. In 1857, Corot reworked the entire composition: He cut it at the top and at the right side and introduced considerable changes to the figures and landscape. The resulting composition, seen here, was exhibited to mixed reviews in the Salon of 1857.

By the turn of the century, critics and historians acknowledged the expressive and dramatic power of Corot's *The Destruction of Sodom*, aspects of the work that, like its unusually prominent figures, depart from Corot's generally gentler and subtler treatment of landscape themes.

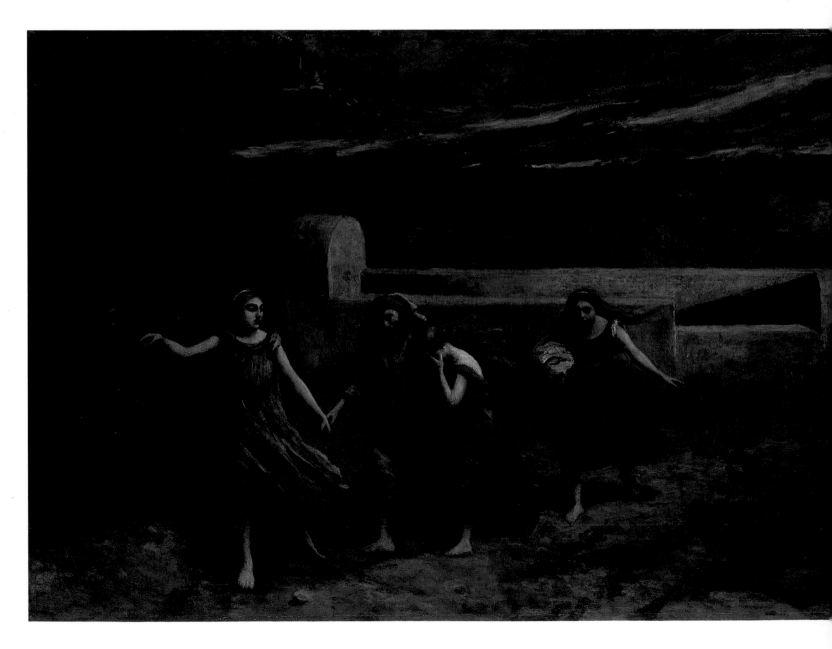

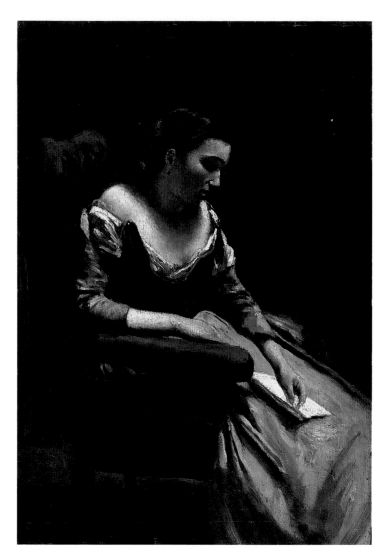

99 *The Destruction of Sodom*
Jean Baptiste Camille Corot
French, 1796–1875
Oil on canvas; 36⅜ x 71⅜ in.
(92.4 x 181.3 cm.)
Bequest of Mrs. H.O. Havemeyer, 1929,
H.O. Havemeyer Collection (29.100.18)

100 *The Letter*
Jean Baptiste Camille Corot
French, 1796–1875
Oil on wood;
21½ x 14¼ in. (54.6 x 36.2 cm.)
Gift of Horace Havemeyer, 1929,
H.O. Havemeyer Collection
(29.160.3)

JEAN BAPTISTE CAMILLE COROT
The Letter

In the 1860s and 70s, Corot painted a number of lyrical studies of female figures. Few were exhibited during his lifetime, however, and it was not until the early twentieth century that they began to receive the kind of admiration critics and collectors had reserved for his landscapes. Yet as Corot admitted: "I have derived as much pleasure painting these women as in painting my landscapes. On their flesh I have seen the power of the hours unroll—as beautiful, as enchanting as on the earth, the water, the hills, the leaves."

Corot's figure pieces—such as *The Letter,* which probably dates to about 1865—typically evoke a quiet moment of daydreaming, reading, or reverie. Here, a simply dressed woman, her white chemise opened to expose her shoulders, sits holding a letter. The motif, mood, gentle harmony of tones, and broad treatment of light in clearly divided planes seem to reflect Corot's awareness of seventeenth-century Dutch painting, particularly that of Vermeer and de Hooch.

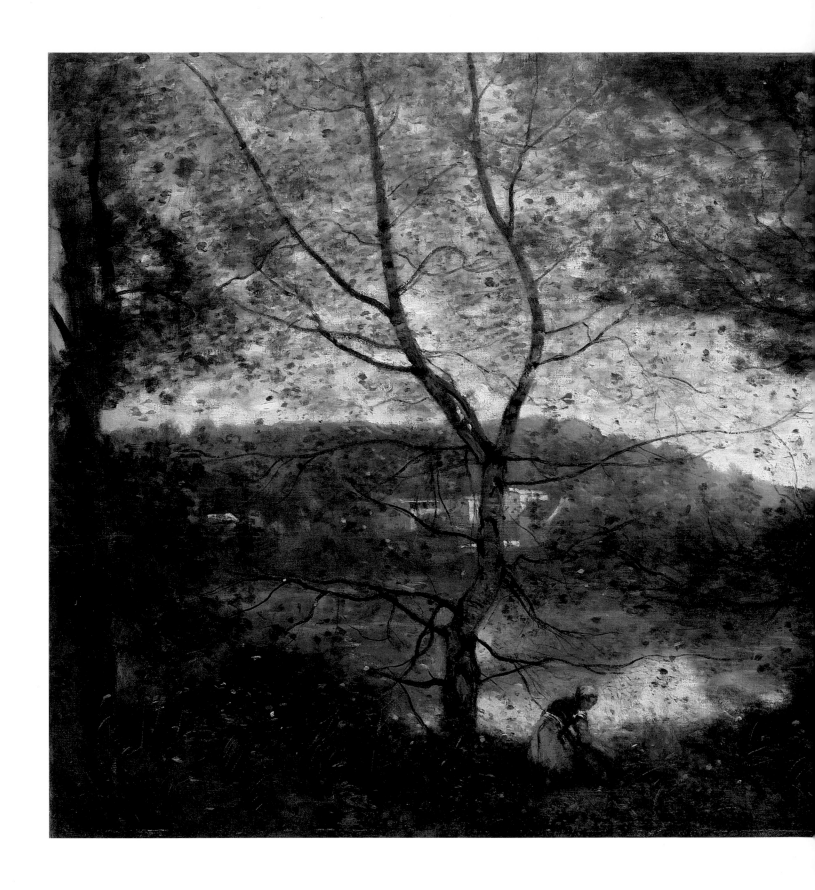

101 Ville d'Avray
Jean Baptiste Camille Corot
French, 1796–1875
Oil on canvas;
21⅝ x 31½ in. (54.9 x 80 cm.)
Bequest of Catharine Lorillard
Wolfe, 1887, Catharine Lorillard
Wolfe Collection (87.15.141)

JEAN BAPTISTE CAMILLE COROT
Ville d'Avray

After the mid-1840s, Corot spent the majority of each year in the environs of Paris, especially at the family property in Ville d'Avray. The landscapes painted here—views of wooded glades delicately modulated in dull greens, browns, and an exquisite range of silvery grays, all veiled in misty light—won him considerable success during his lifetime. The popularity of such works as *Ville d'Avray* may be related, in part, to the nostalgia for an arcadian past that was so much a part of contemporary poetry, literature, and painting. Indeed, when Corot exhibited *Ville d'Avray* at the Salon of 1870, the painting inspired comments by the Salon critic Camille Lemonnier that help explain the significance Corot's late landscapes held for the public:

> . . . I salute that smooth master, that Virgilian poet—no, even better, that peasant's soul, Corot. Before the enchantment of his work one forgets what one has seen in art and what one knows about criticism. It is no longer a canvas, and he no longer a painter. . . . I open a window and I am at home in a poet's nature.

Quite typically, Corot's late works reflect a vision of nature that at once reflects a classicist's sense of proportion and serene order, a romantic's revery, and a naturalist's sense of detail. Elegant in its simplicity of statement, *Ville d'Avray* may be seen as a summation of the leading tendencies of nineteenth-century landscape painting to date, and a platform for the later Impressionist developments.

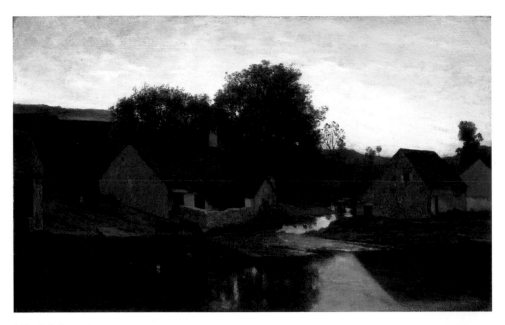

102 Gobelle's Mill at Optevoz
Charles François Daubigny
French, 1817–78
Oil on canvas; 22¾ x 36½ in. (57.8 x 92.7 cm.)
Bequest of Robert Graham Dun, 1900 (11.45.3)

CHARLES FRANÇOIS DAUBIGNY
Gobelle's Mill at Optevoz

Following the practice of landscapists such as Corot and
Théodore Rousseau, Charles François Daubigny painted
many of his early works from studies made on extended
trips through the French provinces. In 1849 he made his
first visit to Optevoz, a town in the Rhône Valley east of
Lyons, and during the following decade he painted views of
many of the motifs there. This peaceful evening scene is
thought to have been painted about 1852 from drawings
—like the large charcoal study in the Museum's collection
—that were made during a stay that year.

103 The Forest in Winter at Sunset
Pierre Etienne Théodore Rousseau
French, 1812–67
Oil on canvas;
64 x 102⅜ in. (162.6 x 260 cm.)
Gift of P.A.B. Widener, 1911 (11.4)

PIERRE ETIENNE THEODORE ROUSSEAU
The Forest in Winter at Sunset

One of Théodore Rousseau's most poetic and personal landscapes, this forest scene vivifies the intimate dialectic between artist and nature to which the painters of the Barbizon movement aspired. In this picture, Rousseau concerned himself less with recording the natural appearance of the trees than with conveying "the echoes they have placed in our soul." The result is an imposing vision of the life of growing things, indestructible in their chaotic vitality and majestically dwarfing humanity. Symbolic of the grandeur of nature, the oaks tower above the tiny figures of two old peasant women bent beneath their bundles of wood.

Rousseau considered *The Forest in Winter at Sunset* to be his most important painting, and he refused to sell it during his lifetime. According to his friend and biographer, Alfred Sensier, the artist began this ambitious canvas in the winter of 1845–46 while at Isle-Adam, a town on the River Oise, with a fellow Barbizon painter, Jules Dupré. The subject, however, is not a scene from the region of Isle-Adam, but a recollection of the gnarled trees in Bas-Bréau in the forest of Fontainebleau. Although Rousseau may have exhibited the painting in Paris in 1847, he continued to work on it, off and on, until the end of his life.

104 Le Repas des Cantonniers
Jean Francois Millet
French, 1814–75
Black crayon, heightened with
white gouache, on buff paper;
10⅞ x 8⅞ in. (27.6 x 22.5 cm.)
Rogers Fund, 1926 (26.243.1)

JEAN FRANÇOIS MILLET
Le Repas des Canionniers

From the time Jean François Millet joined the artistic community in Barbizon in 1849, he devoted himself almost exclusively to the portrayal of peasants and their life in the village and countryside. His paintings and prints enjoyed enormous success—even in America. Millet was also a prolific draftsman and left nearly twenty-five hundred drawings, of which the largest group, numbering some five hundred, is preserved in the Louvre. This fine study depicts three roadworkers who have stopped to rest and eat their meal. Their tools lie in the ditch in the foreground, well below the high horizon line on which the animated figures are placed.

105 Woman with a Rake, ca. 1856–57
Jean François Millet
French, 1814–75
Oil on canvas; 15⅝ x 13½ in.
(39.7 x 34.3 cm.)
Gift of Stephen C. Clark, 1938 (38.75)

JEAN FRANÇOIS MILLET
Woman with a Rake

In addition to his exhibition pictures of the 1850s, Millet painted a number of intimate studies of peasant life. *Woman with a Rake* is typical of these smaller-scale works, which, as a rule, are confined to one or two figures who dominate their pastoral or interior setting, and who, by virtue of the composition's simple, massive forms and quiet mood, take on an emblematic aspect. The idealized but unsentimental view of peasants in these works appealed to a widely felt nostalgia for a rural past that was undisturbed by the onslaught of industrialization.

Millet first treated the subject of *Woman with a Rake* in a woodcut, one of a series of ten *Labors of the Fields* pub-

lished in a popular periodical *L'Illustration* on February 5, 1853. In 1889, this same series would inspire a number of painted copies by van Gogh, including one (present location unknown) based on the present work.

Woman with a Rake, which dates to about 1856–57, was included in a show held in 1860 by the Parisian dealer Martinet, in whose gallery avant-garde artists such as Gustave Courbet and Edouard Manet also exhibited. The picture was well received by critics: Zacharie Astruc praised *Woman with a Rake* as a "masterpiece of light and feeling"; and Théophile Gautier noted Millet's truth, tenderness, and above all, his deep feeling for the subject.

106 *Haystacks: Autumn*
Jean François Millet
French, 1814–75
Oil on canvas; 31⅞ x 39 in. (81 x 99.1 cm.)
Bequest of Lillian S. Timken, 1959 (60.71.12)

Jean François Millet
Haystacks: Autumn

This picture is from a series representing the four seasons that the industrialist Frederick Hartmann commissioned from Millet in March 1868. At that time, Hartmann had apparently been shown pastel studies of some, if not all of the projected scenes. The pastel version of the present picture, completed in 1867–68 and now in the Rijksmuseum H.W. Mesdag, The Hague, is identical in composition to the painting that was not completed until some seven years later. In addition to the pastel rendering, Millet made several drawings in preparation for this canvas, both for the entire composition and for the haystacks.

In 1864–65 Millet had treated the subject of the four seasons as a decorative scheme for the Hôtel Thomas in Paris. These panels were carried out in a traditional classicizing manner, imbued with Millet's naturalistic spirit. In the later programme, principally executed between 1873 and 1874, Millet, unburdened by the requisites of a specific architectural setting, had free reign in subject and approach. As in *Haystacks: Autumn,* he relied on a characteristic repertoire of rustic scenes to highlight the labors of the year; a vivid sense of the season and time of day was further carried by weather, quality of sunlight, and color. Here, in the light of late afternoon, yellow haystacks—the culmination of summer harvest—are juxtaposed against dark, purple storm clouds—harbingers of the threatening winter ahead.

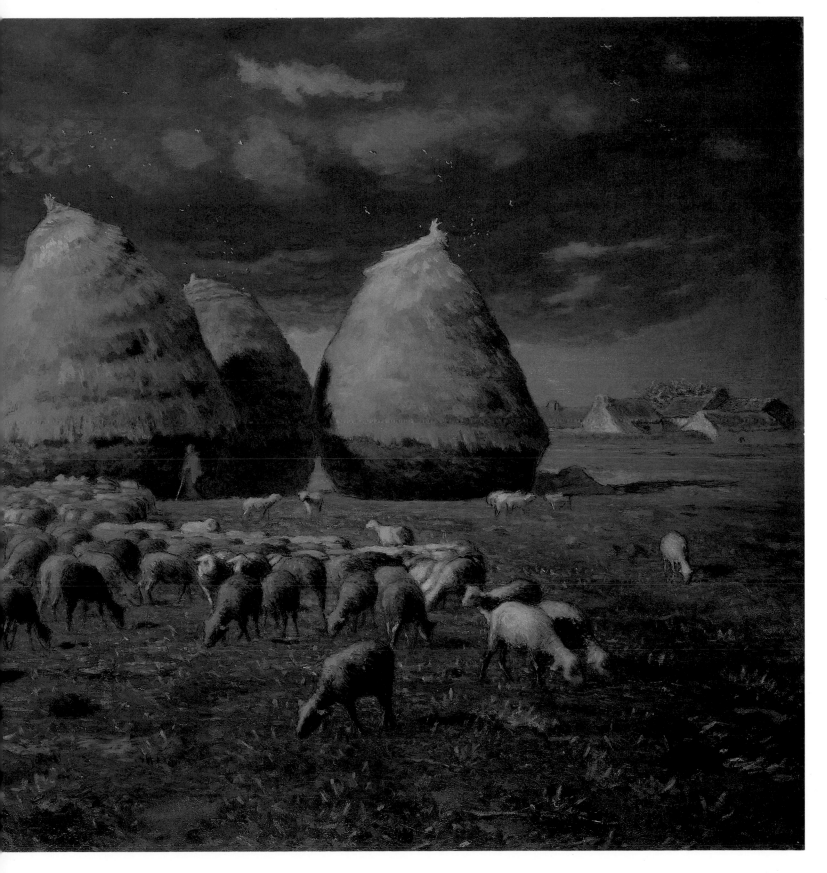

HONORÉ DAUMIER
The Third-Class Carriage

In 1839 Daumier began to depict groups of people in public conveyances and waiting rooms, and for more than two decades he treated these themes in lithographs, watercolors, and oil paintings. His characterizations of travelers document the period in the mid-nineteenth century when the cities of France and their inhabitants were undergoing the immense changes brought about by industrialization. A lifelong social critic, Daumier, like Rembrandt, was able to infuse his renderings of contemporary life with a broad significance that touched on the inner character of mankind.

Many of Daumier's paintings seem to have been executed between 1860 and 1863, when he stopped producing lithographs for the satirical newspaper *Le Charivari*, ostensibly to devote himself to painting. *The Third-Class Carriage* is believed to have been painted between 1863 and 1865.

HONORÉ DAUMIER
King Louis Philippe, Past, Present, and Future

This lithograph was published in *La Caricature*, a political weekly begun by Charles Philipon in 1830 and closed by the government in 1835. Published "by the young, for the young," according to its announcement, this journal included among its writers Honoré de Balzac (under a *nom de plume*) and among its artists Honoré Daumier. Daumier produced about four thousand lithographs in over forty years of working for Philipon's publications, first *La Caricature* and then *Le Charivari*, a four-page satirical daily founded in 1832, which continued to be published into the twentieth century.

After the revolution of July 1830 that deposed Charles X, Louis Philippe had come to the throne, with the support of the bourgeoisie, monarchists, and liberals. His pledged reforms did not materialize, and in May 1831 Philipon cartooned government promises as so many soap bubbles van-

107 The Third-Class Carriage
Honoré Daumier
French, 1808–79
Oil on canvas; 25¾ x 35½ in. (65.4 x 90.2 cm.)
Bequest of Mrs. H.O. Havemeyer, 1929,
The H.O. Havemeyer Collection (29.100.129)

ishing into air. It was Philipon who hit upon the idea of satirizing Louis Philippe as a pear. The head of the "Citizen King" did have heavy jowls and a small crown, and since in French slang the word "pear" also meant "fool" or "simpleton," the caricature was too clever to resist. Philipon was arrested and fined for this witticism (and he was jailed for other "crimes against the king"), but the cartoonists continued to use the symbol. Daumier, who had also served a prison term—for a cartoon of 1831 depicting Louis Philippe as Rabelais's Gargantua—drew *Past, Present, and Future* for the issue of January 9, 1834. The accompanying explanation was mildly threatening, characterizing the "face that will be" as "dejected and decrepit" and ending with a two-line verse: "For the guard that watches the barricade of the Louvre/Is not there to protect the King."

108 King Louis Philippe, Past, Present, and
Future, 1834
Honoré Daumier
French, 1808–79
Lithograph; 10¼ x 8 in. (26 x 20.2 cm.)
Harris Brisbane Dick Fund, 1941 (41.16.1)

OVERLEAF:

JEAN BAPTISTE CARPEAUX *(Pages 142–143)*
Ugolino and His Sons

Romantic preoccupation with extreme physical and emotional states reached a zenith in this work. The subject is taken from Canto XXXIII of the *Inferno*, in which Dante described the cruel death by starvation of the thirteenth-century Pisan count Ugolino della Gherardesca, a suspected traitor who was condemned to die imprisoned in a tower with his sons and grandsons. Carpeaux chose to depict the moment at which the count, yielding to hunger and despair, contemplates cannibalism.

Completed in the last year of the sculptor's residence at the French Academy in Rome, the work caused a public sensation, and indeed, the boldness and vigor of Carpeaux's plaster model contrasted sharply with the prevailing formulas for sculpture propounded by the Academy. It immediately established Carpeaux as the heir of the French Romantic sculptors of the 1830s, sculptors such as Auguste Préault and especially François Rude, whom Carpeaux admired deeply and with whom he had studied.

In Rome, Carpeaux developed a special reverence for Michelangelo, and much of the power of the *Ugolino* derives from prototypes for the central figure that the young sculptor found in the work of the sixteenth-century master. The anatomical realism of the children is the result of direct observation of nature, however, and Carpeaux's sketches of dying children survive as evidence of his painstaking preparatory studies. By his own admission, the antique *Laocoön* group in the Vatican served as inspiration for the overall composition.

Cast in bronze at the order of the French Ministry of Fine Arts, in 1863 *Ugolino and His Sons* was appropriately placed in the gardens of the Tuileries in Paris as a pendant to a copy of the *Laocoön*. The Museum's marble was executed in Paris by the practitioner Bernard under Carpeaux's supervision. It was completed in time for exhibition by the owner of the Saint-Béat marble quarry at the Paris Exposition Universelle of 1867.

109 Ugolino and his Sons
Jean Baptiste Carpeaux
French, modeled ca. 1860–61, executed 1865–67
Saint-Béat marble; H. 77 in. (195.5 cm.) Purchase,
Josephine Bay Paul and C. Michael Paul Foundation,
Inc. Gift, Charles Ulrick and Josephine Bay
Foundation, Inc. Gift and Fletcher Fund, 1967 (67.250)

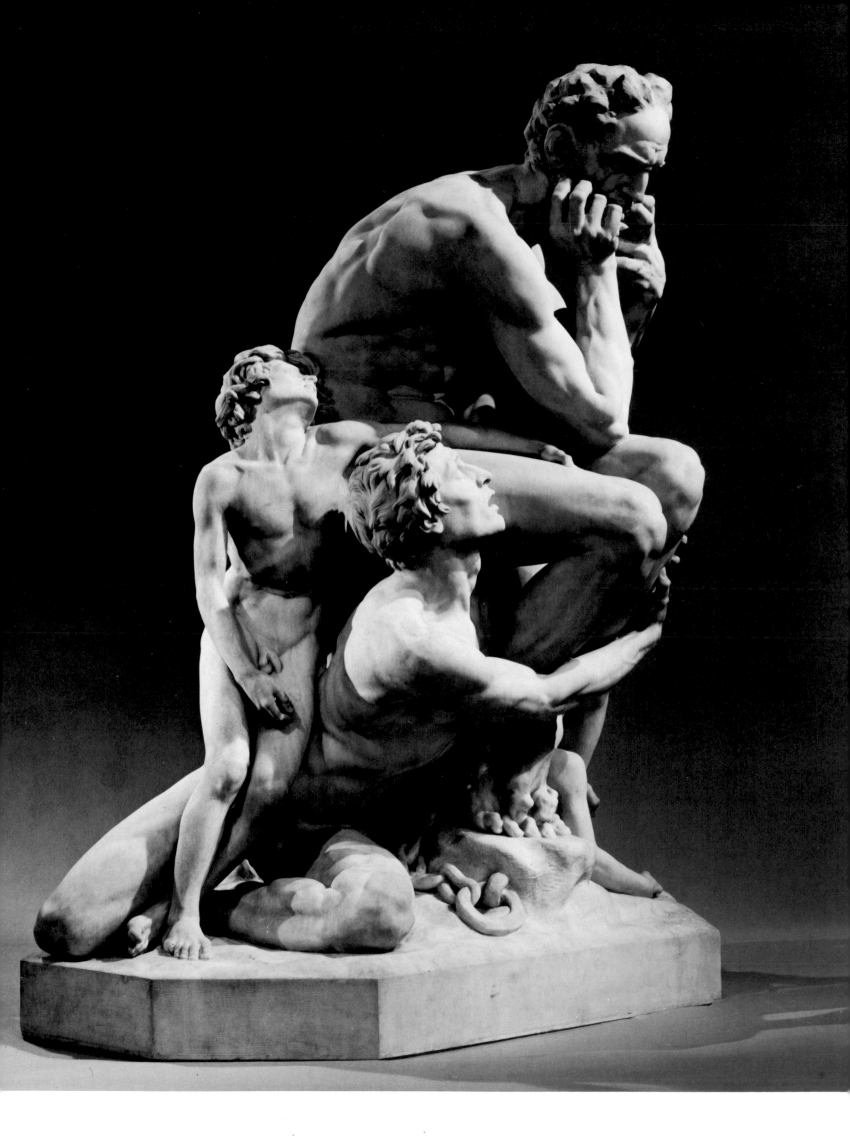

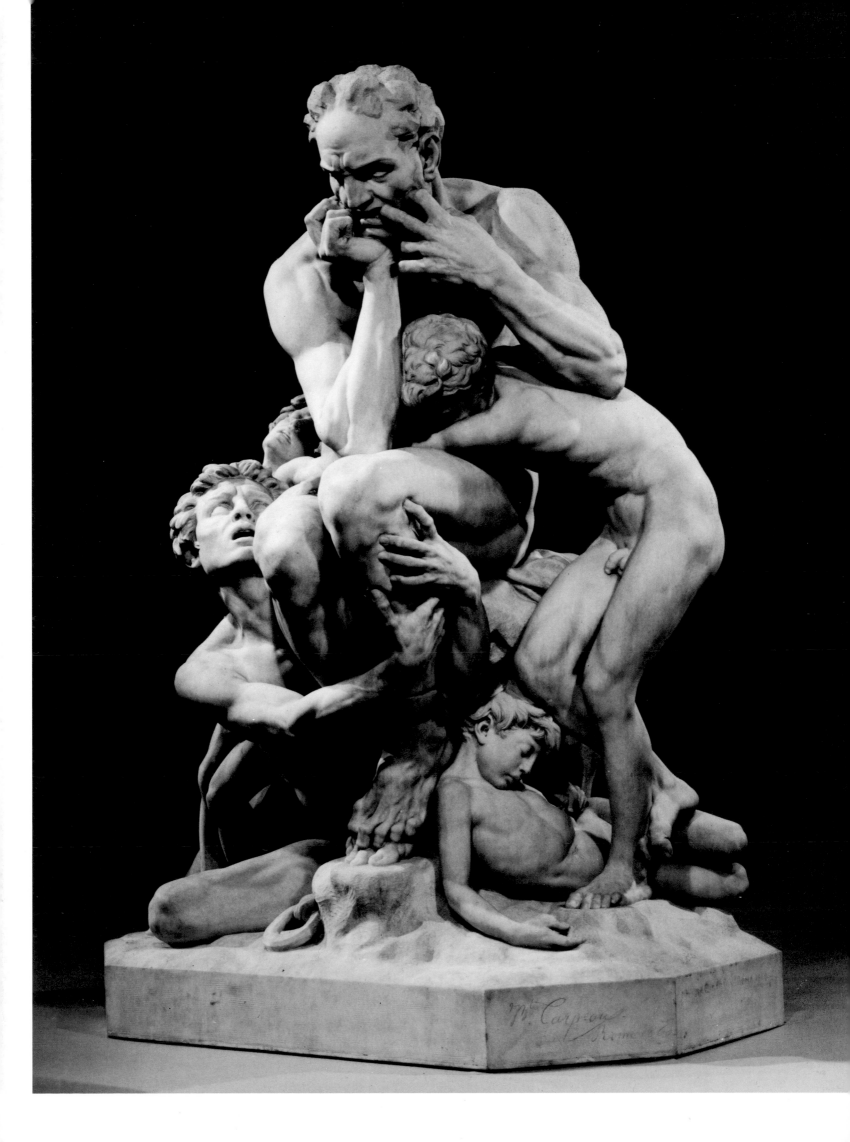

ROSA BONHEUR
The Horse Fair

When Rosa Bonheur exhibited *The Horse Fair* in the Salon of 1853, her reputation as an artist was fairly well established by the paintings, drawings, and sculpture she had shown in the annual Salons since 1841. Yet the recognition won by these prior efforts could hardly have anticipated the resounding success of *The Horse Fair*. Though her oeuvre, as a whole, was characterized by a preference for movement, dramatic lighting, and fresh and direct observation— with almost anatomical precision in the treatment of animals —few works attained the dash and grandeur of *The Horse Fair*. And none achieved the same degree of acclaim. Vastly

admired on the Continent, where it was exhibited in Paris, Ghent, and Bordeaux, the painting was subsequently shown in England and the United States, becoming one of our best-known works of art.

Rosa Bonheur had conceived the idea for *The Horse Fair* in 1851 but did not begin work until 1852. Twice a week, for a year and a half, she made sketches at the horse market in Paris, on the Boulevard de l'Hôpital near the asylum of the Salpêtrière, dressed as a man in order to attract less attention from the horse dealers and buyers. The picture, originally called *Le Marché aux Chevaux de Paris (The Horse*

Market in Paris), shows with accuracy the trees lining the boulevard and the cupola of the old hospital. Certain passages of the landscape, however, were criticized for their summary treatment when the work was first shown at the Salon. A comparison of the picture in its present state with an engraving made at the time of the Salon, shows that in response to criticism the artist repainted areas of the ground, trees, and sky. Apparently these changes were made in 1855, as is suggested by the numeral 5, which follows the date 1853 at the lower right.

The Horse Fair was preceded by numerous drawings and at least three painted studies that document the artist's exploration of various compositional solutions to the subject. In arriving at the final scheme, she drew inspiration from the Parthenon frieze, from the noted animal painters Stubbs and Delacroix, and especially from Géricault's *Cour de Chevaux à Rome (Horse Race in Rome)*. Later, Bonheur referred to *The Horse Fair* as her own "Parthenon frieze."

110 The Horse Fair
Rosa Bonheur
French, 1822–99
Oil on canvas; 96¼ x 199½ in.
(244.5 x 406.8 cm.) Gift of
Cornelius Vanderbilt, 1887 (87.25)

AUGUSTE PRÉAULT
Jupiter and the Sphinx

Préault occupies a central position among French artists who in the 1830s revolted against what they considered to be the outworn conventions of Neoclassical art. Like much sculpture of the Romantic movement, his work was rejected by the jurors of the Salons throughout the 1830s and 40s and thus denied public exhibition. Official recognition came after the Revolution of 1848, and Préault began to receive commissions from the government. One, granted in 1867, was for a pair of pendant sculptures for the garden of the imperial palace at Fontainebleau. This plaster group is the sculptor's working model for one of two monumental stone groups completed in 1870 and still at Fontainebleau.

The sculpture, marvelous for its unity of human and animal form, represents the lord of heaven and father of the gods seated on a horned sphinx of somewhat ambiguous sex. The rugged head of the god, specific in character rather than archetypal, can be recognized as that of Mausolus, the Persian satrap whose fabulous tomb at Halicarnassus had been discovered only a few years before the sculpture was commissioned. Like Venus in the companion sculpture, Préault's enigmatic Jupiter has no precedent in antique iconography and is apparently the original product of the sculptor's deeply Romantic imagination, embodying some private allegorical meaning.

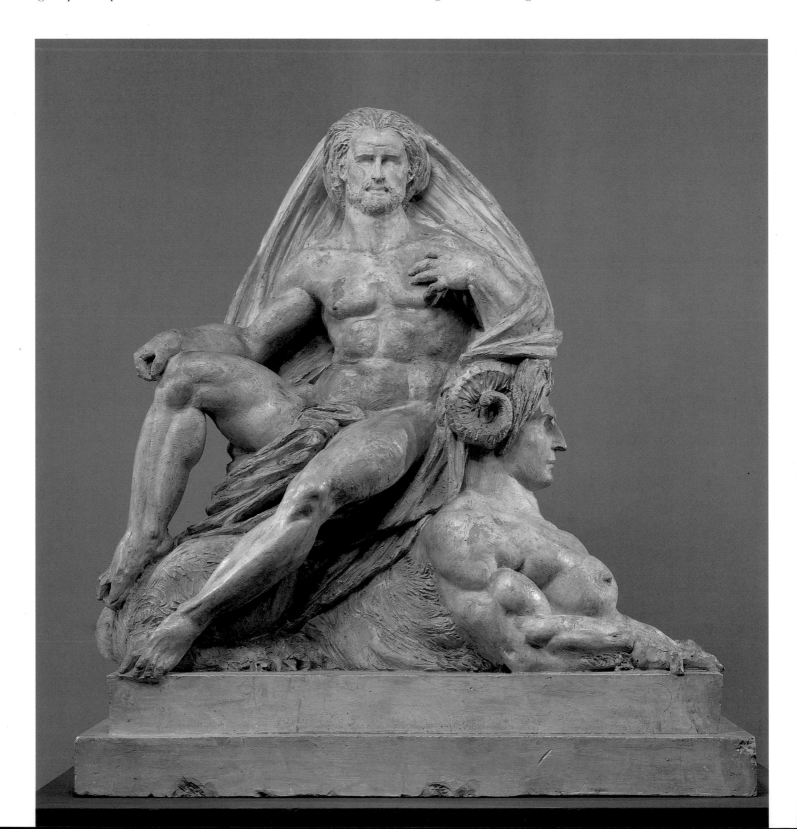

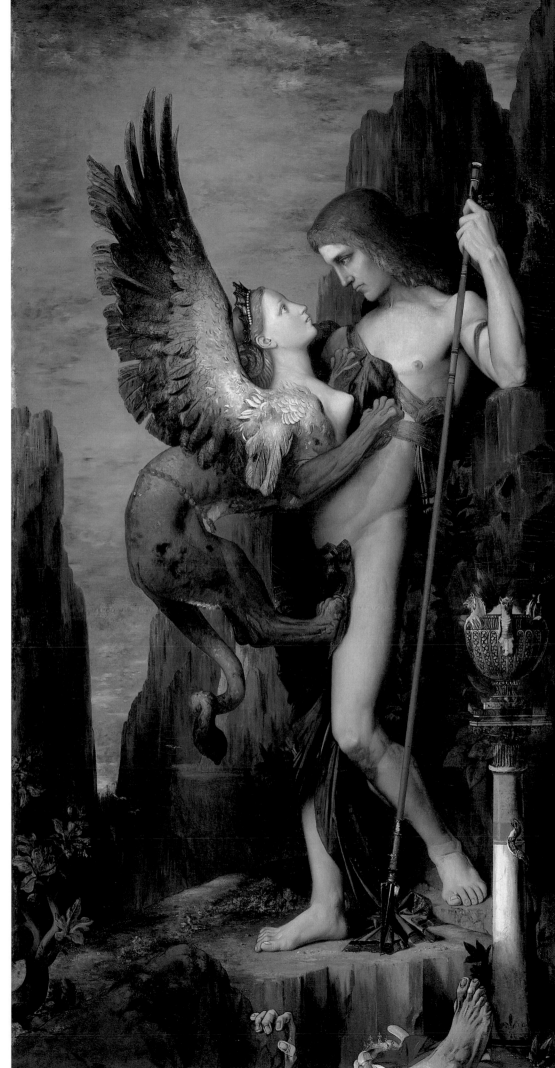

111 Jupiter and the Sphinx, 1868
Antoine Augustin (called Auguste) Préault
French, 1809–79
Tinted plaster;
H. 46⅛ in. (117 cm.) Purchase,
Lita Annenberg Hazen Charitable Trust
Gift, in honor of Ambassador Walter H.
Annenberg, 1981 (1981.319.2)

112 Oedipus and the Sphinx, 1864
Gustave Moreau
French, 1826–98
Oil on canvas; 81¼ x 41¼ in.
(206.4 x 104.8 cm.) Bequest of
William H. Herriman, 1921
(21.134.1)

Page 148: text

GUSTAVE MOREAU
Oedipus and the Sphinx (Page 147)

Gustave Moreau's interpretation of the Greek myth of Oedipus draws heavily on Ingres's *Oedipus and the Sphinx* (Paris, Louvre). Both artists chose to represent the moment when Oedipus confronted the winged monster in a rocky pass outside the city of Thebes. Unlike her other victims, Oedipus could answer the Sphinx's riddle, thus saving himself and the besieged Thebans.

Moreau's painting was extremely successful at the Salon of 1864, where it won a medal and established the artist's reputation. Although it inspired some sarcastic criticism and was the subject of one of Honoré Daumier's cartoons, it was generally well received. Edgar Degas, usually acerbic in his criticism, defended it as a work of art; he was at this time a close friend of Moreau, however, and he may have defended the friend more than the picture. Other contemporary critics offered a variety of interpretations of the theme: Oedipus was thought to symbolize contemporary man, and the confrontation between the Sphinx and Oedipus was believed to symbolize the opposition of female and male principles, or possibly the triumph of life over death.

Moreau's dark vision of an antiquity crowded with archaeological detail, in which scenes of suffering or passion transpire in dreamlike states, is a most remarkable example of the eclecticism of the mid-nineteenth century. His work, in turn, served as an important source for the Neoromantic writers and Symbolist painters of the end of the century.

GUSTAVE COURBET
The Source of the Loue

The rocky grotto at the source of the river Loue, a famed natural wonder in the area of Courbet's native village of Ornans, served as the subject for a number of the artist's paintings. In the spring of 1864 he wrote to his friend the dealer Luquet, "I've been to the source of the Loue these days and made four landscapes about 1 meter 40." The Metropolitan picture, painted on this scale, seems to be among the group of four. In the others (Hamburg, Kunsthalle; Washington, D.C., National Gallery of Art; Buffalo, Albright-Knox Art Gallery), Courbet focused on the cavern itself, whereas in the present work he shows the scene from farther away, including the old mill at the left and the wooden scaffolding that leads the eye into the somber depths beyond.

Though often repeated by Courbet, the many landscapes painted at this site retain their freshness and originality of vision. This is due in part to the different vantage points from which he observed the cavernous grotto, but equally, to the great variety in his palette, ranging from a subtle key of cool green or warm pinks and browns to dramatic complementary color contrasts.

113 *The Source of the Loue*
Gustave Courbet
French, 1819–77
Oil on canvas; 39¼ x 56 in.
(99.7 x 142.2 cm.) Bequest of
Mrs. H.O. Havemeyer, 1929,
H.O. Havemeyer Collection
(29.100.122)

O V E R L E A F :

GUSTAVE COURBET
(Pages 150–151)
Young Ladies from the Village

This painting, which initiated a series of pictures devoted to the lives of women, shows Gustave Courbet's three sisters out for a walk in the Communal, a small valley near his native village of Ornans.

Painted during the winter of 1851–52, *Young Ladies from the Village* was preceded by several preparatory studies, including an oil sketch (Leeds, City Art Gallery) in which he established the leading features of the Metropolitan picture, from the grouping of figures to the landscape setting. However, in the final work he gave the figures a more prominent role; they are larger in size and, moved closer to the foreground, dominate the scene. He also altered the landscape, choosing not to include the two large trees silhouetted against the sky in the study. Traces of a large tree that Courbet had deliberated incorporating into the final composition are still visible in the sky of the Metropolitan picture. It is also evident that he repainted and enlarged the cattle.

Shortly after completing *Young Ladies from the Village,* Courbet wrote to Champfleury, the author who had championed Realism, of his confidence that this "graceful" picture would win the favor of critics who had treated him so harshly in the past. However, when the painting was exhibited in the Salon of 1852 critics bitterly attacked the work, finding it tasteless and clumsy, and berating the common features and countrified costumes of the three girls, the "ridiculous" little dog and cattle, and the painting's overall lack of unity, as well as traditional perspective and scale. Ironically, the very effects that Courbet worked hardest to achieve were those that proved most disturbing.

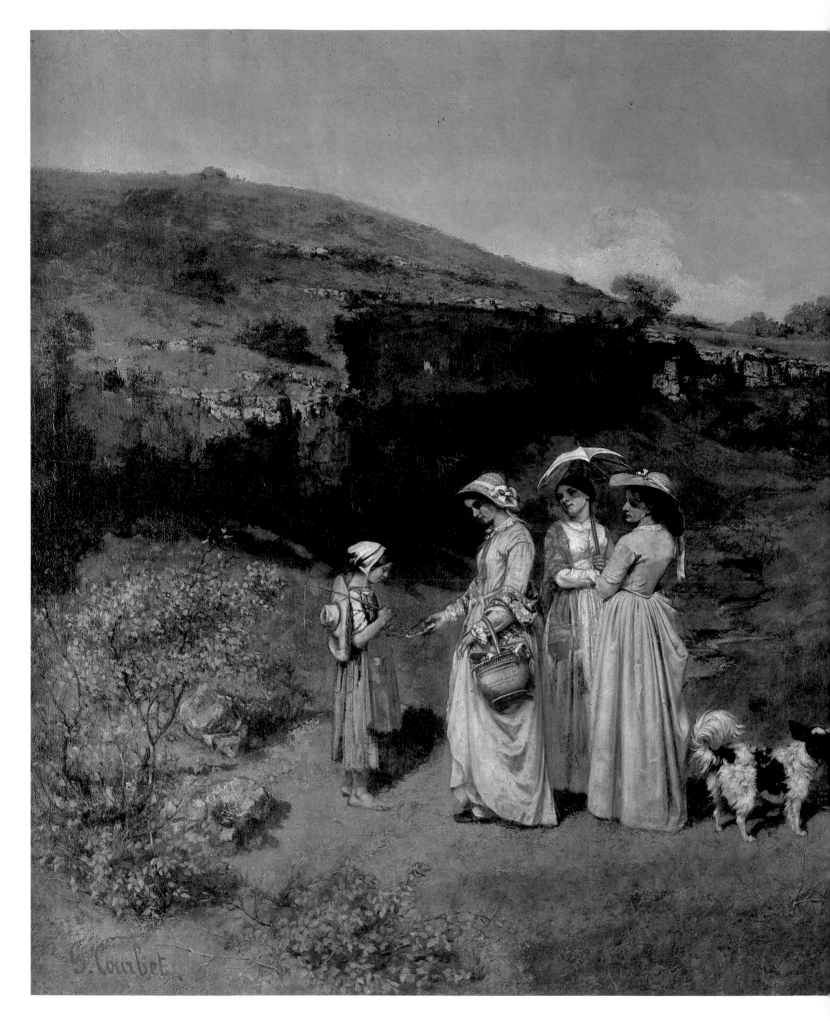

114 *Young Ladies from the Village (Les Demoiselles de Village)*, 1851–52
Gustave Courbet
French, 1819–77
Oil on canvas; 76¾ x 102¾ in. (195 x 261 cm.)
Gift of Harry Payne Bingham, 1940 (40.175)

Page 149: text

GUSTAVE COURBET
Woman with a Parrot

Painted in 1865–66 in Gustave Courbet's Paris studio on the rue Hautefeuille, *Woman with a Parrot* is said to have been inspired by the Realist critic Théophile Thoré. The critic, admiring the reclining figure in Courbet's *The Awakening* (or *Venus and Psyche*) of 1864 (formerly Berlin, Gerstenberg collection, now destroyed), supposedly remarked: "Ah, if you were to wake her up and stretch out her legs and make her lift up her arm with a flower or a bird perched on it, or something like that, what a charming picture it would be!" Although Courbet has clearly adopted from his 1864 picture the pose of the reclining nude and also such motifs as the canopy and one of the twisted columns, it should be noted that he had already, in 1861, introduced a striking macaw into his *Portrait of a Woman* (Paris, private collection).

Like the odalisques in seraglios, Bacchantes, Venuses, and classical nymphs made fashionable by official artists such as Paul Baudry and Alexandre Cabanel, the erotic content of Courbet's *Woman with a Parrot* appealed to Second Empire taste. Yet Courbet's mastery of flesh—his use of subtly varied pigments in the modeling of the female body—added an illusion of reality that left behind frigid academicism while

it approached the sensuosity of Renoir's nudes. This sense of realism was, in the eyes of some contemporary critics, Courbet's failing. When the painting was shown in the Salon of 1866, critics censured Courbet's "lack of taste," as well as the model's "ungainly" pose and "disheveled" hair, comments that make clear that Courbet's *Woman with a Parrot* was seen as a real type, a courtesan of the demimonde.

These reactions aside, Courbet continued to regard *Woman with a Parrot* as one of his great successes, and in 1867 he included it in his second private exhibition. The work also seems to have made quite an impression on contemporary artists: In 1866 Edouard Manet set to work on his version of the subject, *Woman with a Parrot* (also in the collection of this museum), which, when it was exhibited in the Salon of 1868, led one critic to remark that Manet "has borrowed the parrot from his friend Courbet and placed it on a perch next to a young woman in a pink peignoir. These realists are capable of anything!" Paul Cézanne appears to have been another admirer: Apparently he owned a small photograph of Courbet's painting that he carried around with him in his wallet.

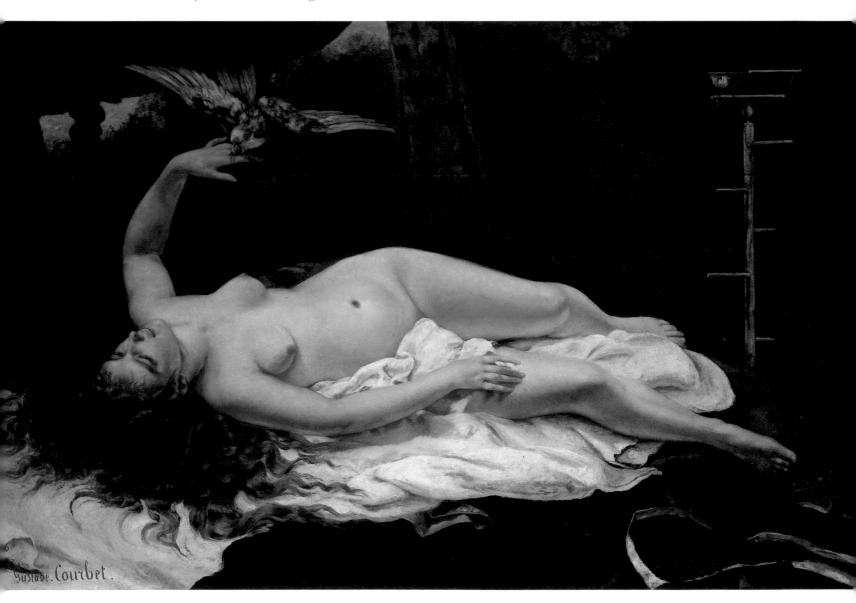

116 Portrait of Jo (La Belle Irlandaise), 1866
Gustave Courbet
French, 1819–77
Oil on canvas; 22 x 26 in. (55.9 x 66 cm.)
Bequest of Mrs. H.O. Havemeyer, 1929,
H.O. Havemeyer Collection (29.100.63)

115 Woman with a Parrot, 1865–66
Gustave Courbet
French, 1819–77
Oil on canvas; 51 x 77 in. (129.5 x 195.6 cm.)
Bequest of Mrs. H.O. Havemeyer, 1929,
H.O. Havemeyer Collection (29.100.57)

GUSTAVE COURBET
Portrait of Jo (La Belle Irlandaise)

This "beautiful Irish woman" is Joanna Hefferman, who for many years was the model and mistress of the American painter James McNeill Whistler; among other works, she posed for his famous painting *The White Girl* of 1862 (Washington, D.C., National Gallery of Art), which caused quite a sensation when it was shown in the Salon des Refusés of 1863. Two years later, in 1865, Gustave Courbet and Whistler painted together at the seaside resort of Trouville. It was there that Jo—as she was called by the artists—agreed to sit for Courbet. Greatly taken by her beauty, Courbet confessed to a friend, "Among the two thousand women who have come to my studio, I admired a superb redhead, whose portrait I have begun."

From the original portrait of Jo with a mirror, which Courbet claimed to have painted in a single sitting, he executed several repetitions. Three other versions are known, in the National Museum of Stockholm, The Nelson-Atkins Museum of Art in Kansas City, and a private collection in Zurich. The chronology of the four pictures is still a subject for debate, with opinion divided as to whether the Stockholm or Paris version represents Courbet's first conception.

The theme of a woman admiring herself in a mirror—which has its origin in traditional representations of Vanity—had been explored earlier by Courbet in *Woman with a Mirror* of 1860 (Basel, Kunstmuseum).

GUSTAVE LE GRAY
La Grande Vague

Initially trained as a painter in Paris in the 1840s, Gustave Le Gray had mastered the intricacies of photographic technique and published an important treatise on the subject by 1850. Many of the best photographers of the Second Empire were his students. This fact, together with Le Gray's large artistic ambitions and his important official commissions, made him the most acclaimed French photographer of his day.

His most famous pictures, both at the time and today, are his seascapes of 1856–57, and of these far and away the great favorite was *La Grande Vague*, taken in the Mediterranean port of Sète, probably in 1857. The photograph is a composite, printed from at least two separate negatives, one for the sky and another, joined at the horizon, of the sea. The reasons for the photograph's success are not difficult to discover, for the solidity of the pictorial composition, with its broad horizontal bands of tone, the instantaneity of the breaking waves, and the rich cloud formations (that together would have been impossible in a single exposure) all appealed to current taste for scenes of nature described with the "truth" of Realism flavored with a touch of Romantic drama.

117 La Grande Vague, ca. 1857
Gustave Le Gray
French, 1820–82
Albumen print from at least two collodion-on-glass negatives; 13¼ x 16⁵⁄₁₆ in. (33.6 x 41.4 cm.)
Gift of John Goldsmith Phillips, 1976 (1976.646)

GUSTAVE COURBET
The Calm Sea

Painted in Etretat in 1869, this seascape reflects Courbet's continued fascination with the atmospheric and tonal variations of sea and sky in different weather conditions, seasons, and times of day. Distinct from the historical or narrative concerns that inform many of Courbet's landscapes, the seascapes are largely chromatic exercises, which, in their treatment of water and clouds, belong more to the tradition established by eighteenth-century British watercolorists, and extended by Turner, than to a native French one. In particular, such works as *The Calm Sea* show the influence of Whistler, whom Courbet met in 1865. During that late summer and early fall, Courbet—in a series of "25 seascapes, autumn skies, each one more free and extraordinary than the last"—had largely developed the pictorial vocabulary he would use, through the early 1870s, for a host of seascapes painted on the Atlantic and Channel coasts.

Courbet was usually drawn toward serene, rather than harsh aspects of narrative. Here a quiet mood is achieved through subtle transitions in color as well as the flat surface, achieved by smoothing the paint on with a palette knife. Against this nearly monochromatic expanse, the two small boats serve as incidental visual punctuation rather than focal points; like the smaller craft on the horizon, they help to establish a convincing illusion of spatial recession that is enhanced by the gradual diminution of the towering clouds as the sky approaches the sea.

118 The Calm Sea, 1869
Gustave Courbet
French, 1819–77
Oil on canvas; 23½ x 28¾ in. (59.7 x 73 cm.)
Bequest of Mrs. H.O. Havemeyer, 1929,
H.O. Havemeyer Collection (29.100.566)

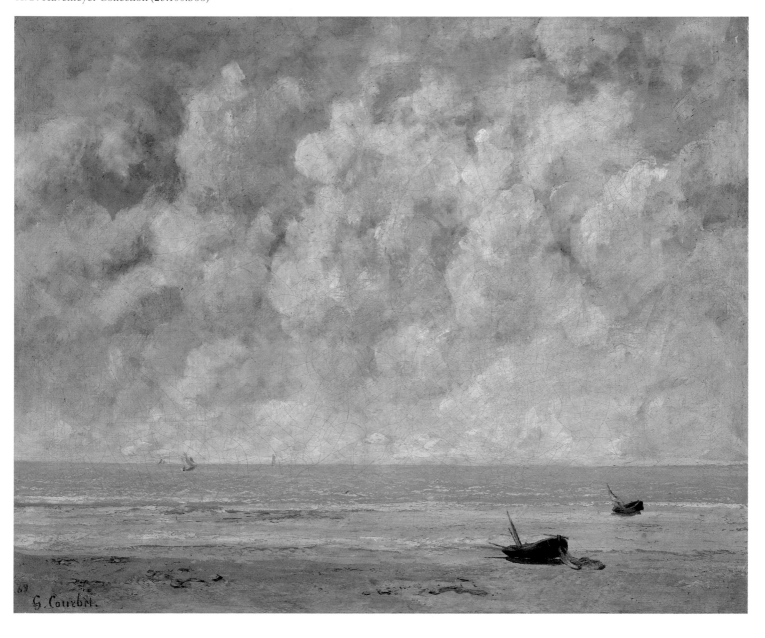

SÈVRES TEA-AND-COFFEE SERVICE

This Sèvres hard-paste porcelain cabaret or tea-and-coffee service, was viewed by the crowds of visitors to the Paris Exposition Universelle of 1867. High praise was bestowed upon the manufacture in the exhibition catalogue:

> It is needless to state that all the appliances of the Empire are at the disposal of the Director [of the manufacture]; the aid of the best artists and chemists is evoked; the artisans are 'the select' of the country; in a word, 'cost' is of no consideration. It is just to say, the issues of Sèvres have answered the expectations of France.

When the designer Jean Marie Ferdinand Regnier planned for this cabaret in 1832, the manufacture was under the progressive leadership of Alexandre Brongniart, director from 1800 to 1847, who revolutionized hard-paste porcelain technology and production during a period of great political and social change. Artists and designers at Sèvres were inspired and challenged by these advances as well as by the ideas and images summarized at mid-century by the great exhibitions.

This virtuoso production, made between 1851 and 1860 after Regnier's design, illustrates well the eclecticism that characterized nineteenth-century high-style taste. Essentially Islamic in character, the service incorporates painted decoration, bamboo handles, and pierced ornament that derive from traditional Chinese decoration.

119 Cabaret
French (Sèvres), 1851–60
Designed in 1832 by Jean Marie Ferdinand
Regnier (French, act. 1812–48)
Hard-paste porcelain; greatest D. of stand
19⅝ in. (49.9 cm.) Gift of
Helen Boehm, in memory of her husband,
Edward Marshall Boehm, 1969 (69.193.1-11)

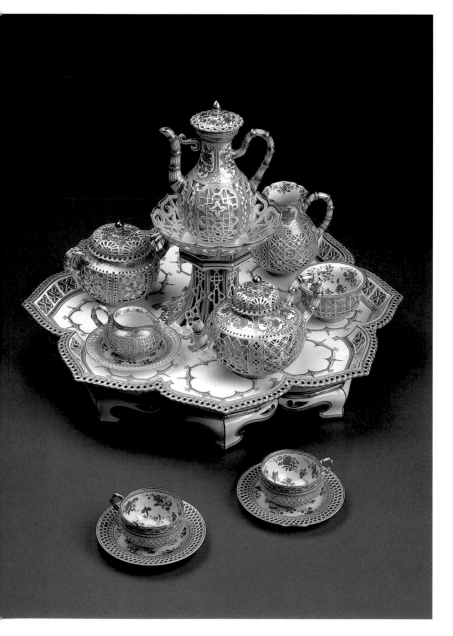

FRANZ XAVER WINTERHALTER
The Empress Eugénie

In 1853, Eugénie de Montijo, daughter of Don Cipriano Guzmán y Porto Carrero, count of Teba and later count of Montijo, married Napoleon III, emperor of France. An official portrait of the new empress was begun by Franz Xaver Winterhalter, the most conspicuous society painter of the day, soon after the marriage. This painting, dated 1854, was thus executed while Winterhalter was completing his large state portrait of the empress, as well as the even grander group portrait *The Empress Eugénie Surrounded by Her Ladies in Waiting*, now in Compiègne. By contrast with those pictures, the present portrait is intimate and, with its garden setting, informal. The empress is shown in a contemporary adaptation of a late-eighteenth-century gown: The dress is cut in a recognizable Second Empire pattern, but its trimmings of ribbon, lace, and ropes of pearls are a blend of Louis XV and Louis XVI styles. As if the costume were insufficient reference to the *ancien régime*, Winterhalter's verdant, pastoral landscape clearly evokes the idyllic settings of eighteenth-century courtly portraiture.

Eugénie was famous for her adoration Marie Antoinette, a fascination considered retrograde even by such aristocrats as Princess Mathilde. Jules and Edmond de Goncourt reported that Mathilde once exclaimed, "This cult for Marie Antoinette! It is absolutely mad, ridiculous, and indecent!" But the Goncourt brothers themselves were kinder; after meeting the empress for the first time, they wrote:

> The woman is charming after all. She has eyes that seem to smile, grace and prettiness of gesture, and indescribable loveliness in the way she passes before you. Neither a queen nor a princess—an empress of others, not the French, [but rather] of some romantic [resort] like Baden."

120 The Empress Eugénie (Eugénie de Montijo, 1826–1920, Condesa de Teba), 1854
Franz Xaver Winterhalter
German, 1805(?)–73
Oil on canvas, 36½ x 29 in. (92.7 x 73.7 cm.)
Purchase, Mr. and Mrs. Claus von Bülow Gift,
1978 (1978.403)

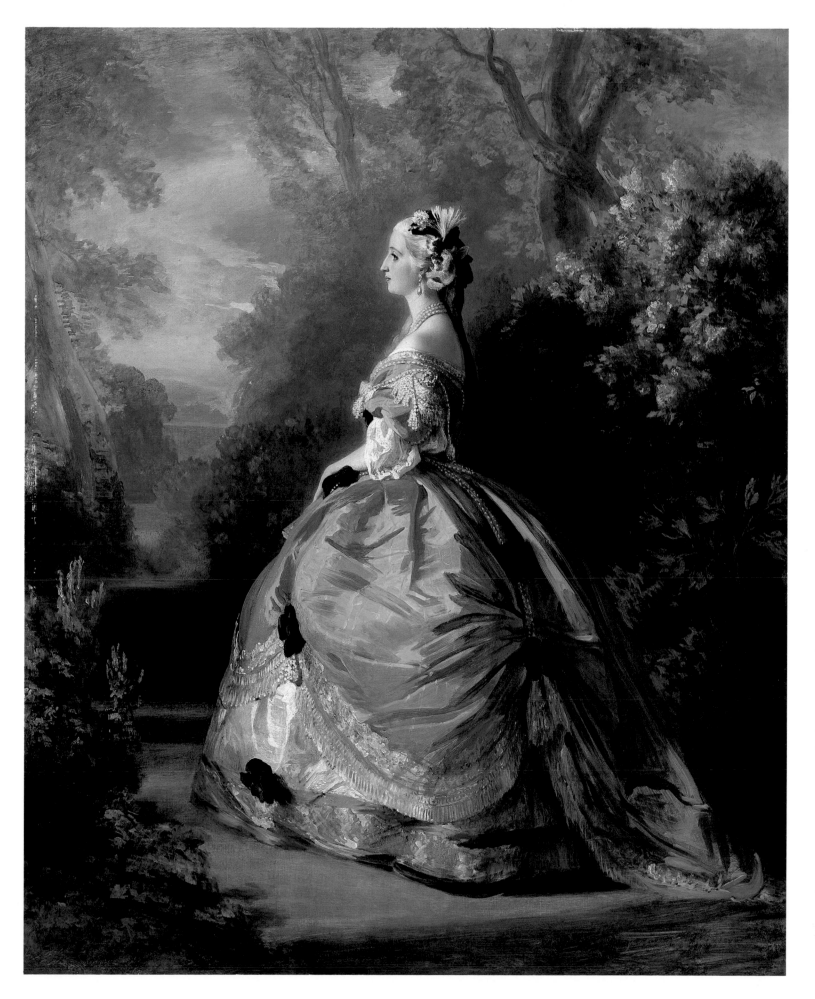

MAYER AND PIERSON
La Comtesse de Castiglione

Born of Italian nobility, Virginia Oldoïni, comtesse de Castiglione, went to Paris in 1856 to advance the nationalist cause of her cousin Camillo Cavour. Her diplomatic efforts and, especially, her seductive beauty made her the envy of the French court and, before long, mistress to the emperor, Napoleon III.

Considered at the time to be the most beautiful woman of the century, the countess felt she deserved the acclaim and, elevating vanity to a virtue, she enlisted the aid of numerous photographers in her quest to preserve her beauty for posterity. The firm of Mayer and Pierson, photographers to the emperor, served her autoidolatry most imaginatively. They photographed her in the lavish ball gowns that commemorate her *succès de scandale,* and in tableaux of her own devising. Her obsession with herself together with photography's necessary selectivity also led them to focus on certain details of her body or wardrobe, for example, just her bare ankles and feet, or in this case, her famous shoulders and eyes.

This photograph, in which the countess holds a picture frame to her eye, suggests the knowing artifice of photographers and their complicity with their sitter's fantasies. While the artists frame her within the edges of their photograph, the countess both masks herself from and frames herself for their regard. In this way Mayer and Pierson point up the duplicity and self-consciousness of the posed portrait. Moreover, her isolated eye in its dark frame mimics the lens on the big stand camera that faced her. This confusion of the role of observer and observed reminds us that a good portrait is not of someone *or* by someone, but both.

121 *La Comtesse de Castiglione*, ca. 1860
Mayer and Pierson
French, firm act. ca. 1855–73
Gelatin silver print from collodion-on-glass negative;
7⅜ x 5⅞ in. (18.7 x 12.5 cm.)
Gift of George Davis, 1948 (48.189)

JEAN BAPTISTE CARPEAUX
Bust of Napoleon III

This late, elegiac work testifies to Carpeaux's prodigious powers as portraitist. The pomp of the Second Empire is fully present in the erect carriage of Napoleon III's head, his proud gaze, and his resplendent hairstyle. Yet the cut of the bust is extremely simple, so that the spectator's attention is drawn straight to the emperor's eyes, keen and commanding but immensely sad in their setting of wrinkled flesh. In 1871, after the fall of the Second Empire and during the emperor's exile at Chislehurst in England, the imperial family requested that Carpeaux begin a portrait. He resumed his task the following year, but Napoleon was already too ill to sit for him, and Carpeaux could only finish the composition after his subject's death on January 9, 1873, making final reference to the features during the lying-in-state. The date of January 13 on the marble is the day of the model's completion. In only two years Carpeaux himself would die, and he already gives here every sign of personal identification with the end of an era in its most tragic aspects.

122 *Bust of Napoleon III*, 1873
Jean Baptiste Carpeaux
French, 1827–75
Marble; H. 20½ in. (52 cm.)
Purchase, Ann and George Blumenthal Fund,
Munsey and Fletcher Funds, Funds from
various donors, Agnes Shewan Rizzo Bequest
and Mrs. Peter Oliver Gift, 1974 (1974.297)

INDEX

Page

MID-18TH CENTURY EUROPE

Dear Brother Neil,
You are a true Christian
in your warm hospitality
and genuine ecumenism.
We shall miss you.

Maria Rimm
Senior Warden
St. Giles' Episcopal Church

Dear Brother Neil.
You've certainly taken
care of the Geissberger Boys
we really appreciate all that you
have done. Best wishes,
Norm & Jean Geissberger

SCOTLAND

GREAT BRITAIN

IRELAND

ENGLAND

London •

ATLANTIC

OCEAN

NORTH
SEA

KINGDOM OF
NORWAY

Christiania •

KI

Sto

KINGDOM OF
DENMARK • Copenhagen

UNITED
NETHERLANDS HANOVER
Amsterdam •

AUSTRIAN
NETHERLANDS • Brussels

Elbe R.

BRANDENBURG
• Berlin

THE
SAXONY SIL

Rhine R.

HOLY ROMAN

• Prague

EMPIRE

KINGDOM OF
FRANCE

Paris •

LORRAINE

• Bern
SWITZERLAND

SAVOY

PIEDMONT

BAVARIA
• Munich

TYROL

AUSTRI

Vienna •

STYRIA

VENETIAN REPUBLIC

KINGDOM OF SPAIN

Madrid •

Lisbon •

KINGDOM OF
PORTUGAL

REPUBLIC
OF GENOA

GR.
DUCHY OF
TUSCANY PAPAL
STATES

CORSICA

Rome •

REP
OF R

KINGDOM OF
SARDINIA

Naples •

KINGDO
OF THE
TWO SICIL

M E D I T E R R A N E A N

Tangier •

SICILY

FEZ AND MOROCCO

ALGERIA

TUNIS

1776–88	Gibbon's *Decline and Fall of the Roman Empire*
1776	Smith's *Wealth of Nations*
1781	Kant's *Kritik der reinen Vernunft*
1782	Reynolds's *Colonel George K. H. Coussmaker*
1782	Laclos's *Les Liaisons dangereuses*
1784	Clodion's model for *A Monument to Commemorate the Invention of the Balloon*
1786	Frederick the Great succeeded by Frederick William II
1786	Mozart's *Nozzi di Figaro*
1787	Schiller's *Don Carlos* (revised)
1787	David's *Death of Socrates*
1788	Charles III of Spain succeeded by Charles IV
1789	Lavoisier's *Traité élémentaire de chimie*
1789	French Revolution begins
1789	Blake's *Songs of Innocence*
1789	Bentham's *Introduction to the Principles of Morals and Legislation*
1790	Burke's *Reflections on the Revolution in France*
1791	de Sade's *Justine*
1791	Boswell's *Life of Samuel Johnson*
1791	Haydn's *Symphony No. 94 in G* ("Surprise")
1791–92	Paine's *The Rights of Man*
1792	First French Republic proclaimed
1792	French stop Austrian and Prussian invaders in Battle of Valmy
1792	Wollstonecraft's *Vindication of the Rights of Women*
1793	Louis XVI and Marie Antoinette executed
1793–95	Reign of Terror in France under Robespierre
1793	Second Partition of Poland
1793	Louvre becomes a national museum
1795–99	Robespierre executed, Directory rules in France

1796	Laplace's *Exposition du système du monde*
1796	Catherine II of Russia succeeded by Paul I
1798	Stanislas II, last king of Poland, dies
1798	Wordsworth and Coleridge's *Lyrical Ballads*
1798	Malthus's *An Essay on the Principle of Population*
1799	Napoleon overthrows Directory, becomes First Consul
1800	European pop. (in millions): Italy 17; Spain 10; Britain 10

Mantel Clock
(see Plate 21)

1776	American Continental Congress issues Declaration of Independence
1779	Cook killed in Hawaii
1779	First Kaffir War between Boers and native Africans
1781	British surrender to Americans at Yorktown
1781	Articles of Confederation adopted by American colonies
1782	Rama I establishes Chakkri dynasty in Siam, with Bangkok as capital
1786	Ieharu, shogun of Japan, succeeded by Ienari
1787	U.S. Constitution drafted
1789	First U.S. congress meets; George Washington inaugurated as president
1789	Abd al-Hamid I, sultan of Turkey, succeeded by Selim III
1791	Vermont, 14th U.S. state
1792	Kentucky, 15th U.S. state
1796	Aga Muhammad becomes shah of Persia, founds Kajar dynasty
1795	Park explores Niger River
1796	Hung Li, emperor of China, succeeded by Yung-yen (r. as Chia-ch'ing)
1797	Aga Muhammad of Persia succeeded by Fath Ali
1797	Adams, 2nd U.S. president
1798	Napoleon defeats Mamluks in Battle of the Pyramids
1799	Rosetta Stone found in Egypt
1800	Washington, D.C. becomes U.S. capital

KITAGAWA UTAMARO
Courtesan Holding a Fan
(Japanese, ca. 1793)

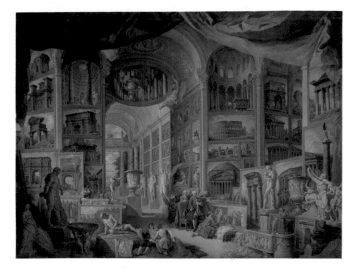

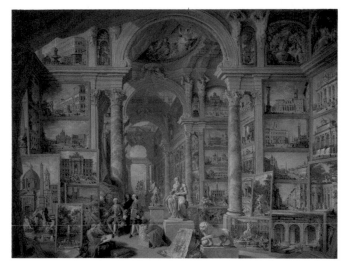

GIOVANNI PAOLO PANNINI
Ancient Rome *and* Modern Rome
(see Plates 1,2)

a PAUL REVERE
The Bloody Massacre
(American, 1770)

b CHEST ON CHEST
(American [Philadelphia], 1770–73)

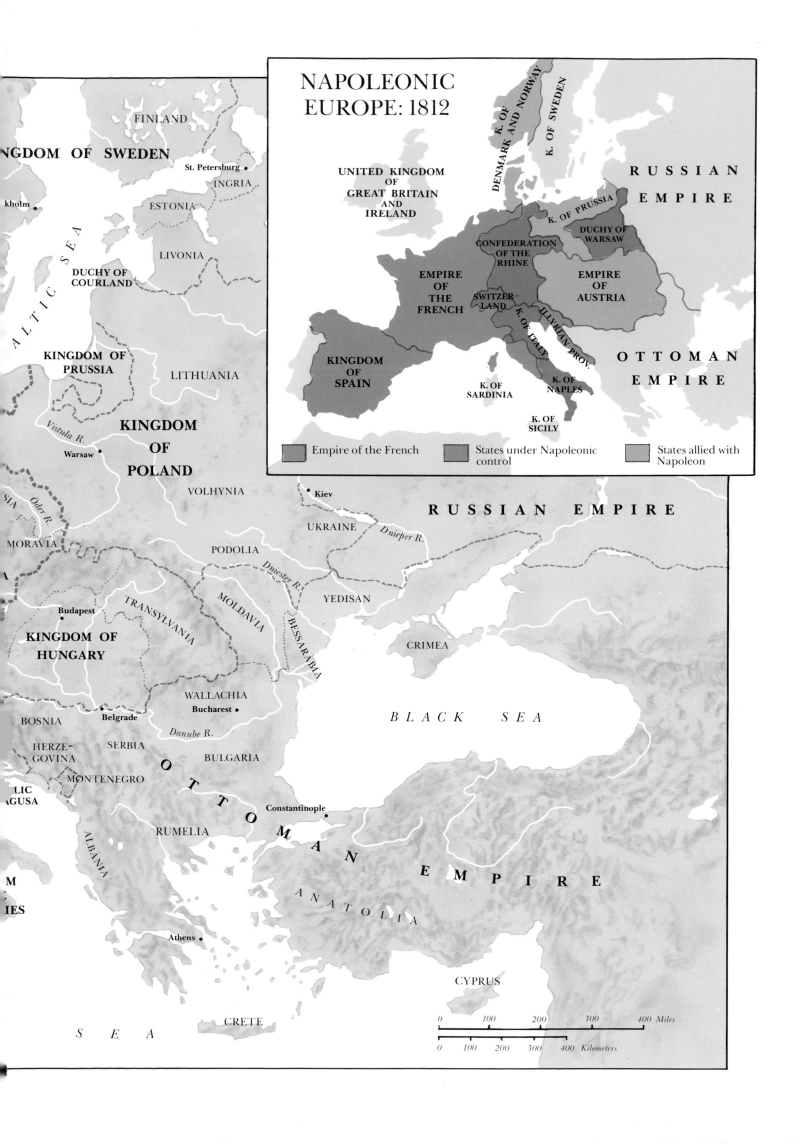

NAPOLEONIC EUROPE: 1812

FINLAND

KINGDOM OF SWEDEN

St. Petersburg •

INGRIA

...kholm

ESTONIA

BALTIC SEA

LIVONIA

DUCHY OF COURLAND

KINGDOM OF PRUSSIA

LITHUANIA

Vistula R.

Oder R.

Warsaw •

KINGDOM OF POLAND

...SIA

MORAVIA

VOLHYNIA

• Kiev

RUSSIAN EMPIRE

UKRAINE

Dnieper R.

PODOLIA

Dniester R.

YEDISAN

TRANSYLVANIA

MOLDAVIA

BESSARABIA

Budapest •

KINGDOM OF HUNGARY

CRIMEA

BLACK SEA

WALLACHIA

Bucharest •

BOSNIA

Belgrade •

Danube R.

HERZE-GOVINA

SERBIA

BULGARIA

MONTENEGRO

...LIC
...AGUSA

O
T
T
O
M
A
N

E
M
P
I
R
E

Constantinople •

RUMELIA

ALBANIA

ANATOLIA

...M

...IES

Athens •

CYPRUS

SEA

CRETE

Inset map

UNITED KINGDOM OF GREAT BRITAIN AND IRELAND

K. OF NORWAY

DENMARK AND NORWAY

K. OF SWEDEN

RUSSIAN EMPIRE

K. OF PRUSSIA

DUCHY OF WARSAW

CONFEDERATION OF THE RHINE

EMPIRE OF THE FRENCH

SWITZER-LAND

EMPIRE OF AUSTRIA

ILLYRIAN PROV.

K. OF ITALY

KINGDOM OF SPAIN

K. OF SARDINIA

K. OF NAPLES

K. OF SICILY

OTTOMAN EMPIRE

■ Empire of the French ▨ States under Napoleonic control ▨ States allied with Napoleon

0 100 200 300 400 Miles

0 100 200 300 400 Kilometers

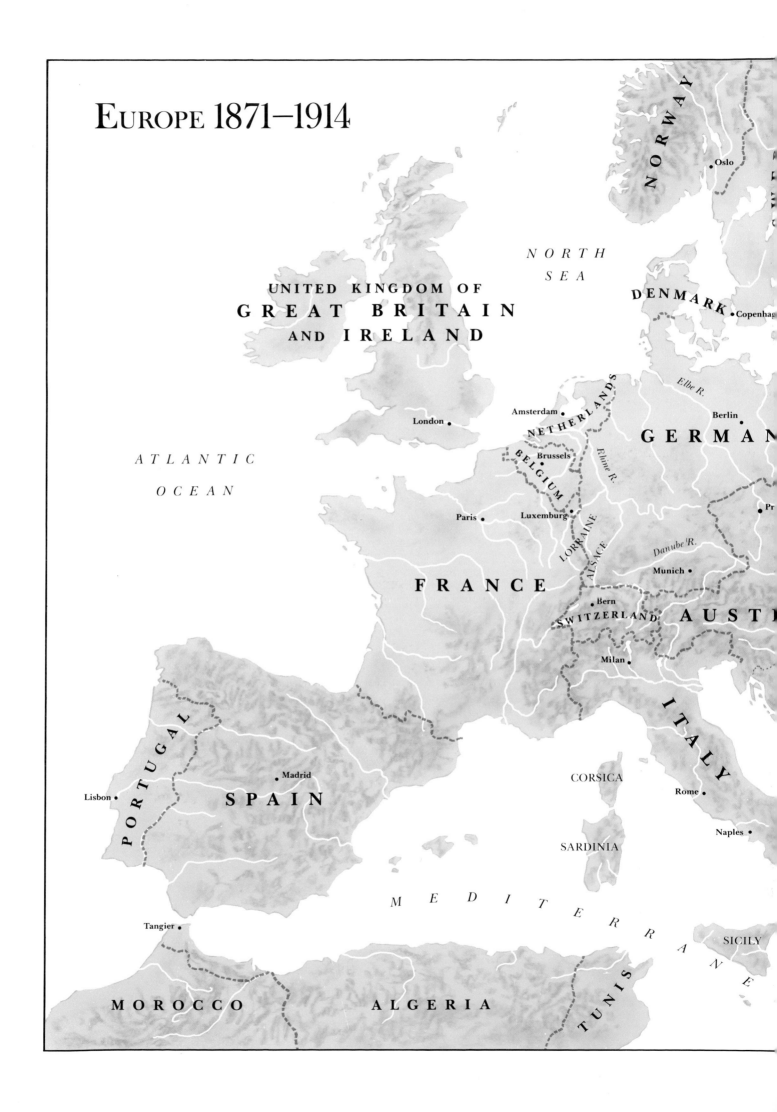

EUROPE 1871–1914

NORWAY

• Oslo

NORTH
SEA

DENMARK

• Copenhag

UNITED KINGDOM OF
GREAT BRITAIN
AND IRELAND

Elbe R.

Amsterdam
•

Berlin
•

GERMAN

NETHERLANDS

• London

BELGIUM

Brussels
•

Rhine R.

Pr
•

ATLANTIC

OCEAN

Paris
•

Luxemburg
•

LORRAINE

ALSACE

Danube R.

Munich
•

FRANCE

Bern
•

SWITZERLAND

AUST

Milan
•

PORTUGAL

ITALY

Madrid
•

CORSICA

Rome •

Lisbon •

SPAIN

Naples •

SARDINIA

M E D I T E R R

A N

E

SICILY

Tangier •

MOROCCO

ALGERIA

TUNIS

J.M.W. TURNER
The Lake of Zug
(see Plate 83)

GEORGE CALEB BINGHAM
Fur Traders Descending the Missouri
(American, ca. 1845)

1801	Peace of Lunéville between Austria and France ends Holy Roman Empire
1801	Paul I of Russia succeeded by Alexander I
1801	Chateaubriand's *Atala*
1803–04	Beethoven's *Symphony No. 3 in E-flat major* ("Eroica")
1804	Napoleon crowned emperor
1804–06	Canova's *Perseus with the Head of Medusa*
1805	Napoleon defeats Austria and Russia in Battle of Austerlitz
1806	"Elgin Marbles" brought to England
1806	Francis II renounces title of Holy Roman Emperor, never restored
1806–08	Arnim and Brentano's *Des Knaben Wunderhorn*
1807	Lamb's *Tales from Shakespeare*
1807	Britain outlaws slave trade
1807	Hegel's *Die Phänomenologie des Geistes*
1808	Goethe's *Faust*, part I
1808	Charles IV of Spain succeeded by Ferdinand VII
1808	Joseph Bonaparte rules Spain
1808–14	Spanish War of Independence
1808–14	Goya's *Majas on a Balcony*
1809	Napoleon annexes Papal States
1809	Metternich becomes foreign minister of Austria
1810	Mme. de Staël's *De l'Allemagne*
1811	George III, insane; Prince of Wales (future George IV) becomes regent
1812	Napoleon invades Russia in June, returns defeated to Paris in December
1812	Byron's *Childe Harold's Pilgrimage*
1812–15	Grimm's *Kinder- und Hausmärchen*
1813	Ferdinand VII restored to Spanish throne
1813	Napoleon defeated in Battle of Nations at Leipzig
1813	Austen's *Pride and Prejudice*
1814	Paris falls, Napoleon exiled to Elba

ANTONIO CANOVA
Perseus with the Head of Medusa
(see Plate 10)

1814	Louis XVIII assumes throne of France
1814	Congress of Vienna opens
1814	Goya's *The Third of May, 1808*
1815	Napoleon's return ("The Hundred Days") ends with his defeat in Battle of Waterloo; exiled to St. Helena
1816	Rossini's *Il Barbiere di Siviglia*
1817–34	Grillparzer's *Der Traum: ein Leben*
1818	Schopenhauer's *Die Welt als Wille und Vorstellung*
1818	Scott's *Heart of Midlothian* and *The Bride of Lammermoor*
1819	Prado Museum inaugurated
1820	Keats's "Ode to a Nightingale"
1820	George III of England succeeded by George IV
1820	Lamartine's *Méditations poétiques*
1821	Shelley's *Adonais*
1821	Weber's *Der Freischütz*
1821	Greek war of independence from Turkey begins
1822	Schubert's *Symphony No. 8 in B minor* ("Unfinished")
1825	Alexander I of Russia succeeded by Nicholas I
1825	Decembrist revolt in Russia crushed
1825	Nash remodels Buckingham Palace

1801	Jefferson, 3rd U.S. president
1802	French crush rebellion in Santo Domingo led by Toussaint-L'Ouverture
1802	Persia loses Georgia to Russia
1803	U.S. concludes Louisiana Purchase from France
1803	Ohio, 17th U.S. state
1805	Muhammud Ali proclaimed pasha of Egypt
1806	British reoccupy Cape of Good Hope
1806–07	Russo-Turkish war
1807	Selim III of Turkey succeeded by Mustafa IV
1807	Fulton powers *Clermont* by steam on Hudson River
1808	U.S. outlaws importation of slaves
1808	Mustafa IV, sultan of Turkey, succeeded by Muhammud II
1809	Madison, 4th U.S. president
1809	Irving's *History of New York*
1811	Venezuela gains independence from Spain
1812	Louisiana, 18th U.S. state
1812	U.S. declares war on Britain ("War of 1812")
1812	Burckhardt rediscovers Petra
1814	Treaty of Ghent ends War of 1812
1814	Cape Province becomes British colony
1816	Argentina declares independence from Spain
1817	Monroe, 5th U.S. president
1819	Singapore ceded to British East India Company
1819	Spain cedes Florida to U.S.

1819	Bolivar becomes president of Greater Colombia (incl. Venezuela, Ecuador, Peru)
1820–21	Missouri Compromise concluded
1821	Yung-yen, emperor of China, succeeded by Min-ning (r. as Tao-kuang)
1821	Mexico gains independence from Spain
1822	Mahmud II suppresses revolt of Ali Pasha and defeats Greeks
1822	Brazil gains independence from Portugal, Pedro I becomes emperor
1822	Ecuador gains independence from Spain
1824	Missouri, 24th U.S. state
1825	Erie Canal between Buffalo and New York opened
1825	J.Q. Adams, 6th U.S. president

d ROOM FROM THE WILLIAMS HOUSE
(American [Richmond, Virginia], 1810)

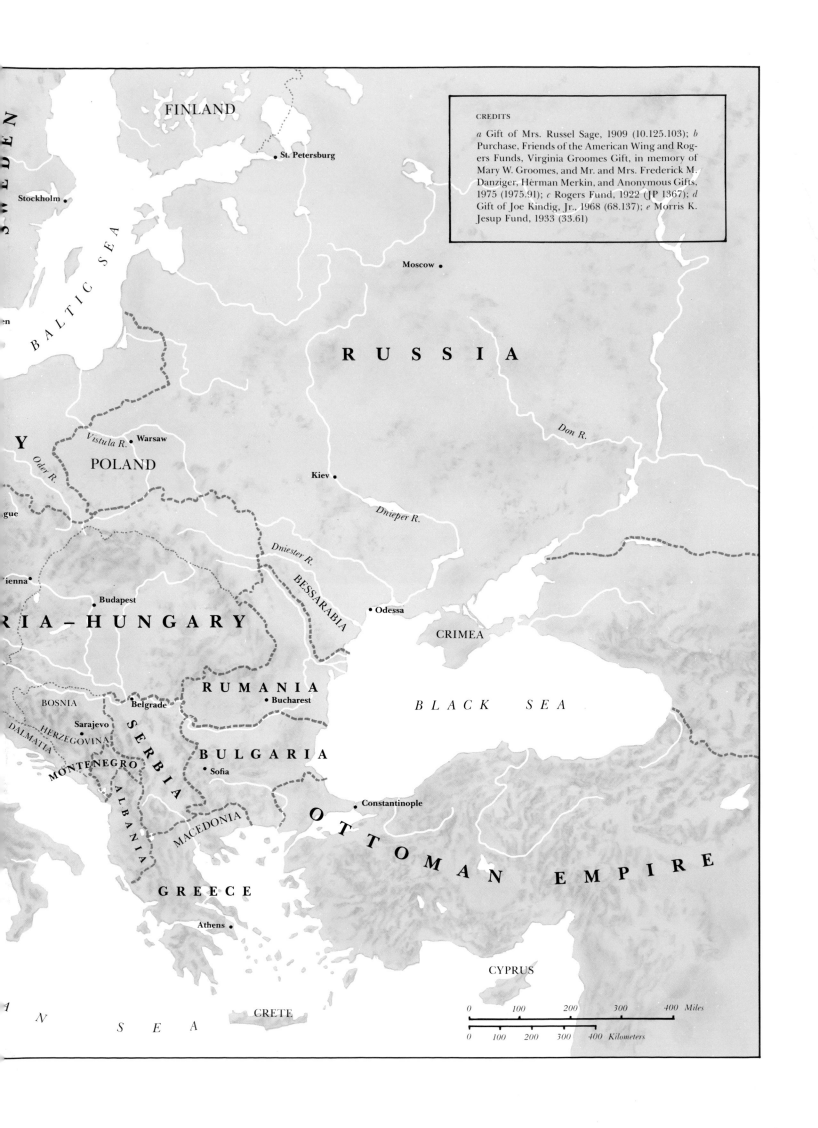

FINLAND

• St. Petersburg

CREDITS

a Gift of Mrs. Russel Sage, 1909 (10.125.103); b Purchase, Friends of the American Wing and Rogers Funds, Virginia Groomes Gift, in memory of Mary W. Groomes, and Mr. and Mrs. Frederick M. Danziger, Herman Merkin, and Anonymous Gifts, 1975 (1975.91); c Rogers Fund, 1922 (JP 1367); d Gift of Joe Kindig, Jr., 1968 (68.137); e Morris K. Jesup Fund, 1933 (33.61)

Stockholm •

SWEDEN

BALTIC SEA

Moscow •

RUSSIA

Don R.

Vistula R. • Warsaw

Oder R.

POLAND

Kiev •

gue

Dnieper R.

ienna •

Dniester R.

BESSARABIA

RIA–HUNGARY

Budapest •

Odessa •

CRIMEA

RUMANIA

Belgrade • • Bucharest

BLACK SEA

BOSNIA

Sarajevo •

HERZEGOVINA

DALMATIA

SERBIA

BULGARIA

• Sofia

MONTENEGRO

ALBANIA

MACEDONIA

Constantinople •

OTTOMAN EMPIRE

GREECE

Athens •

CYPRUS

CRETE

N SEA

0 100 200 300 400 Miles

0 100 200 300 400 Kilometers

THE METROPOLITAN MUSEUM OF ART NEW YORK · THE METROPOLITAN MUSEUM OF ART NEW YORK · THE METROPOLITAN MUSEUM OF ART NEW YORK · THE METROPOLITAN MUSEUM OF ART NEW YORK · THE METROPOLITAN MUSEUM OF ART NEW YORK · THE METROPOLITAN MUSEUM OF ART NEW YORK · THE METROPOLITAN MUSEUM OF ART NEW YORK · THE METROPOLITAN MUSEUM OF ART NEW YORK · THE METROPOLITAN MUSEUM OF ART NEW YORK · THE METROPOLITAN MUSEUM OF ART NEW YORK · THE METROPOLITAN OF ART NEW YORK · THE METROPOLITAN MUSEUM OF ART NEW YORK · THE METROPOLITAN MUSEUM OF ART NEW YORK · THE METROPOLITAN MUSEUM OF ART NEW YORK · THE METROPOLITAN MUSEUM OF ART NEW YORK · THE METROPOLITAN MUSEUM OF ART NEW YORK · THE METROPOLITAN MUSEUM OF ART NEW YORK · THE METROPOLI